KAMALA HARRIS

SELECTIONS FROM

THE OFFICIAL WHITE HOUSE PHOTOGRAPHY

MARINER BOOKS

New York Boston

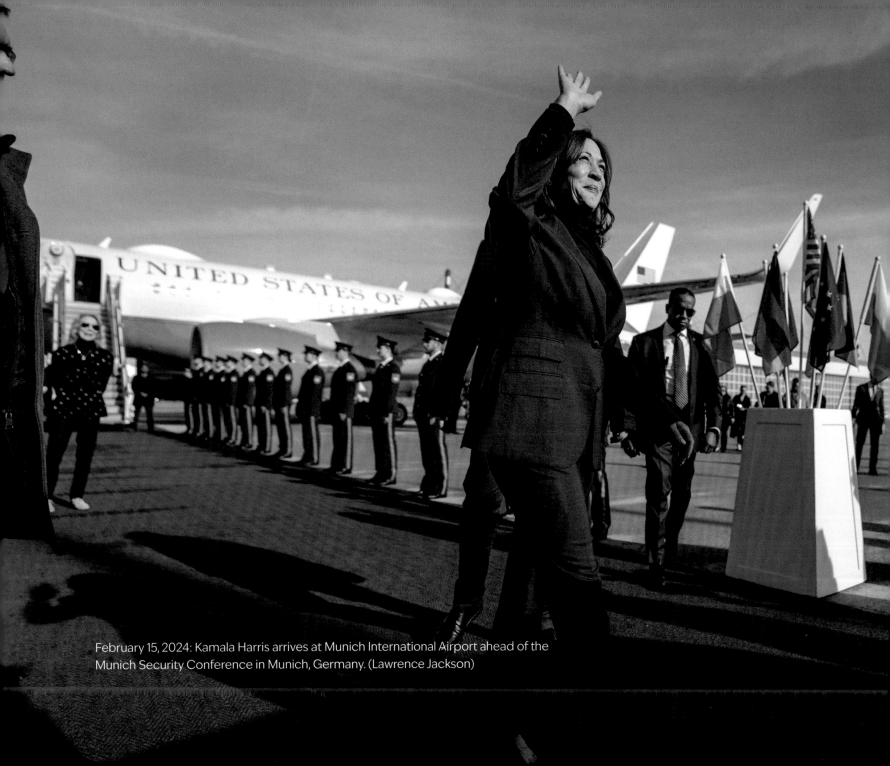

February 15, 2024: Kamala Harris arrives at Munich International Airport ahead of the Munich Security Conference in Munich, Germany. (Lawrence Jackson)

INTRODUCTION

THE ROAD TO A MORE PERFECT UNION

JOY-ANN REID

When the history of American politics is written, the steady, hard-fought progress of women toward political equality deserves a special place in the opening chapters. From Victoria Woodhull's 1872 run for the presidency (as a member of the pro-suffrage Equal Rights Party) to the political power wielded by former First Lady Hillary Rodham Clinton as a senator and as secretary of state, to Nancy Pelosi's tenure as arguably America's most skilled and successful House Speaker, and to America's first woman vice president, Kamala Harris—women have been on a revolutionary march to power in the United States for more than a century. It has culminated in Harris's historic bid to become America's first woman, first Black woman, and first Asian American president.

Because Black Americans have faced a uniquely vicious history of exclusion in this country, Kamala Harris's rise necessitated another revolutionary change: the dramatic transformation of her party—the Democratic Party—from rejectionism to inclusion.

The battle for women's and racial progress has never been separate from the racism and sexism endemic to America's original Constitution, which deemed both African-descended people and women of all races to be mere property, accounted for in the households of the white Christian men who were full citizens. Yet this same

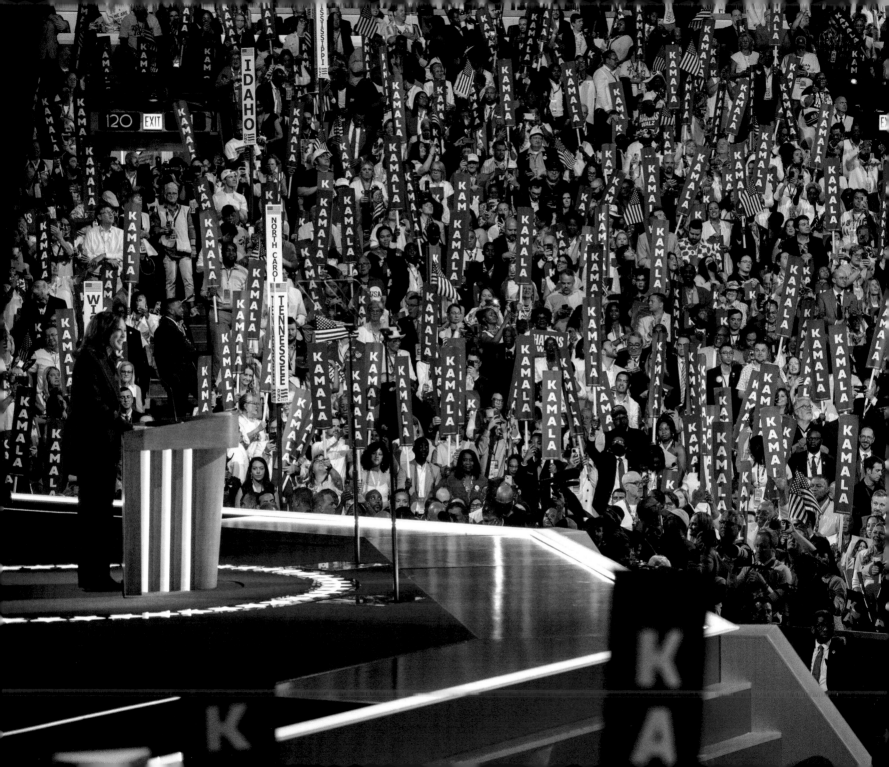

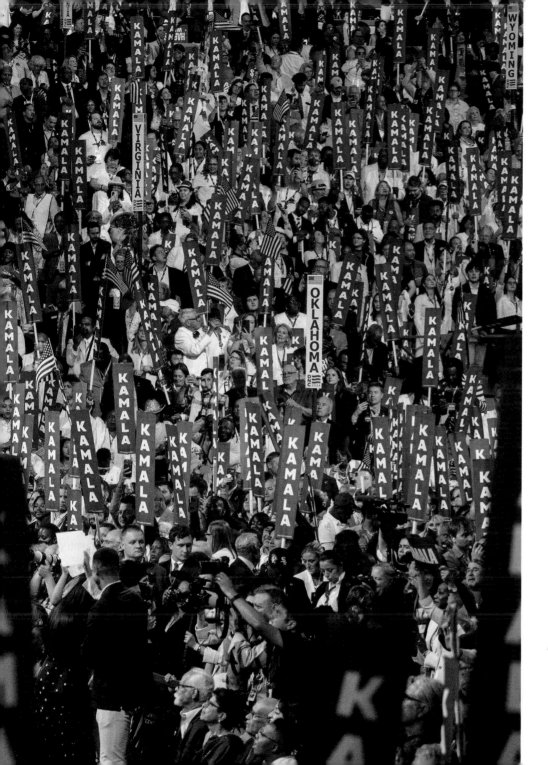

August 22, 2024: Harris speaking on the final day of the Democratic National Convention in Chicago, Illinois. (dpa picture alliance / Alamy)

country has matured enough by the twenty-first century to elect Barack Obama as the nation's first Black president in 2008 and Kamala Harris as the first woman vice president in 2020.

Harris's rise to the White House is unprecedented, but other brave and extraordinary women have paved her way. Fannie Lou Hamer was born in 1917 to a family who had been enslaved on Mississippi plantations for generations. She, too, worked on one as a sharecropper, affording a living barely above the conditions of slavery. Yet Hamer believed she had fundamental rights, enshrined in the same U.S. Constitution that had once deliberately excluded her people, and she became a community activist to fight for those people.

Medgar Evers, the NAACP's first Mississippi field secretary—slain one year before the 1964 Democratic National Convention—had been leading the charge in insisting that those rights include being able to shop downtown, attend a movie, or eat in a restaurant without having to go through the back door; the right to work and earn a living outside of domestic jobs; and the right to vote and be part of the civic process. He called it "first-class citizenship."

Hamer had coined that phrase as she addressed the rules committee at the 1964 convention in Atlantic City. She'd come to New Jersey with 67 fellow delegates from the Mississippi Freedom Democratic Party (MFDP), which she cofounded with Bob Moses and members of the Student Nonviolent Coordinating Committee (SNCC). The delegation of "black, white, maids, ministers, farmers, painters, mechanics, schoolteachers, the young, [and] the old" had come to demand that they be seated instead of the all-white official Mississippi delegation.

Southern Democrats reacted to the defeat of the Confederacy and the Compromise of 1877, removing Union troops who had protected both Blacks and the Reconstruction, by finding creative ways to block and deny membership to and participation of the sons and grandsons of the formerly enslaved. These included impossible literacy tests and restrictive poll taxes.

The party refused to seat the Mississippi Freedom Democrats, offering them non-voting seats instead; and President Lyndon B. Johnson held a surprise press conference to interrupt Hamer's live testimony to the rules committee. But on the evening of August 22, 1964, her full remarks, vividly describing the brutality and terrorism she and other Black southerners faced in trying to register to vote and live as full citizens, aired across American television. Her impassioned words shook the nation to its core. Dr. Martin Luther King Jr. said her speech "educated a nation and brought the political powers to their knees in repentance," noting that never again would the Democratic Party seat an all-white delegation.

Hamer's activism paved the way for other women to step forward. She continued to seek coalitions, joining a who's who of women's rights activists, Black and white—including Gloria Steinem, Bella Abzug, Dorothy Height,

July 26, 2024: The White House is lit in red, white, and blue in support of Team USA at the Summer Olympics in Paris, France. (Abe McNatt)

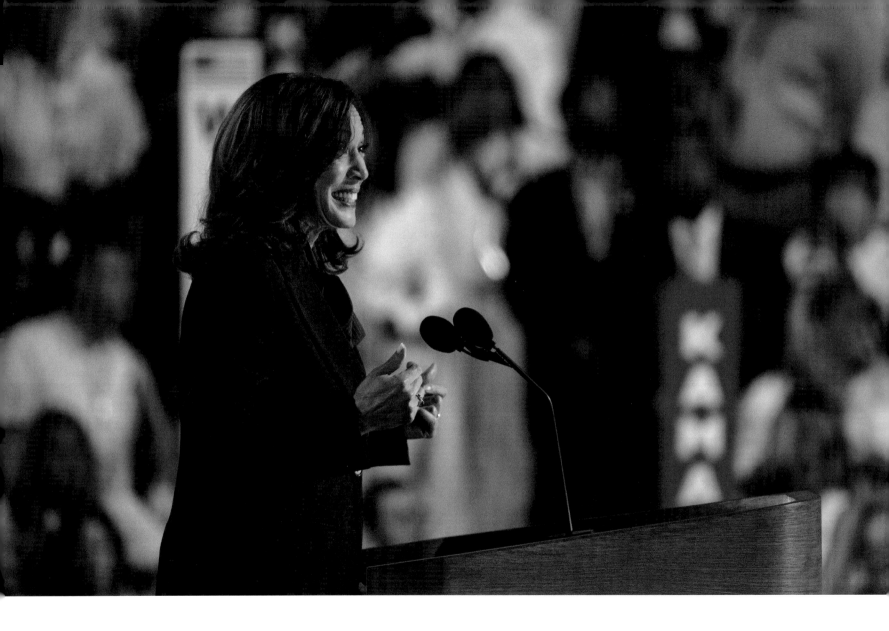

August 22, 2024: Harris speaking on the final day of the Democratic
National Convention in Chicago, Illinois. (MediaPunch Inc. / Alamy)

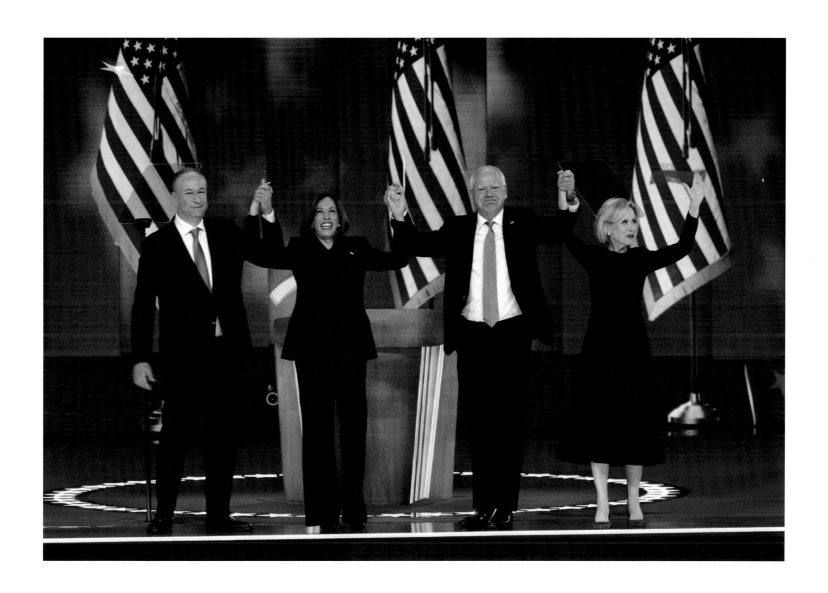

August 22, 2024: *From left to right*: Harris's husband, Doug Emhoff; Harris; her running mate, Minnesota Governor Tim Walz; and his wife, Gwen Walz, on stage at the Democratic National Convention in Chicago, Illinois. (dpa picture alliance / Alamy)

Eleanor Holmes Norton, and a Bahamian-Guyanese American educator from Brooklyn, New York, named Shirley Chisholm, who had become the first Black woman member of the U.S. House of Representatives—to form the National Women's Political Caucus in 1971. The organization was devoted to promoting racial, gender, and economic justice.

One year later, on January 25, 1972, Chisholm announced that she was running for her party's nomination for the presidency of the United States. In her announcement, she declared that 1972 must be the year that "women, Blacks, brown, the young, the old, activists for social change, and just people who are tired of reading the election results before the votes are counted—are going to prove that our candidates and our policies and our government are not the exclusive preserve of the financial community, the political establishment, and the opinion polls." The boldness of her candidacy set a benchmark for women, Black Americans, and the immigrant community to lay claim in full to the American dream, and to the prospect of wielding power in this country.

Chisholm's campaign was not successful, but in 1984, Democratic nominee Walter Mondale, in an attempt to draw attention during his run against incumbent President Ronald Reagan, chose congresswoman Geraldine Ferraro to be his running mate. Though the duo failed to defeat Reagan and his vice president, George H. W. Bush, Ferraro was the first woman nominated as vice president by a major party.

The nineties saw an increase in the number of women elected to the U.S. Senate, and America's First Lady during that time, Hillary Clinton, was an extraordinary woman in her own right. She was an outspoken feminist in the style of Steinem and Abzug, and she had long nurtured relationships with activists like Marian Wright Edelman, who had been a SNCC worker in Mississippi at the time of Hamer's fight for first-class citizenship. Not only was Mrs. Clinton outspoken in her views while in the White House for eight years, but she also made history in 2000 when she won a U.S. Senate seat in New York. Her victory forced the nation to confront a new way of thinking about the wives of American presidents and to accept that they could have ambitions of their own.

In 2008, Clinton ran to become the Democratic nominee for president, yet lost in a hard-fought primary against fellow senator Barack Obama. Clinton accepted another historic opportunity, though, becoming the new president's secretary of state.

Eight years later, Clinton ran again for the presidency and became the first woman to be the nominee of a major U.S. political party. After an ugly general election battle against Donald J. Trump—celebrity real estate developer, NBC's *The Apprentice* star, and notorious promoter of the "birther" lie that Obama was not a U.S. citizen—Clinton

won the popular vote by three million votes but narrowly lost the Electoral College.

The 2016 election was a setback for American women and Black Americans, setting the stage for a rightward shift in the Supreme Court and the reversal of hard-won abortion rights under *Roe v. Wade* and of affirmative action at America's elite schools. But that same year, Kamala Harris became the 46th woman and the second Black woman elected to the U.S. Senate. (There have been 60 to date.) Harris, the daughter of Jamaican and Indian immigrants, had risen from the San Francisco District Attorney's Office to be elected attorney general of California, and she had won Barbara Boxer's former seat in the Senate.

Harris's father, Donald Harris, had come to the United States from Jamaica in the early 1960s to pursue a graduate degree in economics at the University of California at Berkeley. He attended meetings of an off-campus Black studies group called the Afro-American Association, where Black studies majors and campus activists would gather to discuss historical and sociopolitical issues. It was there that he met Shyamala Gopalan, who had emigrated from India to the U.S. to earn her graduate degree in nutrition, with the goal of becoming a cancer researcher. Gopalan, in her sari and sandals, introduced herself to Harris after he gave a speech about colonialism—something common to both of their heritages. The two married in 1962, and Kamala was born two years later. A second daughter, Maya, followed in 1967.

When the couple later divorced, Shyamala became a single mother raising two Black girls in Berkeley and steeping them in their Black identity with frequent visits to neighboring Oakland and the Rainbow Sign, a Black cultural center where, Harris would later write in her 2019 memoir, *The Truths We Hold*, she was exposed to inspirational Black women—including Alice Walker, Nina Simone, Maya Angelou, and Shirley Chisholm, "extraordinary people . . . who showed us what we could become." At the same time, Shyamala assured that her girls maintained their connection to their mother's roots, too, with visits to spend time with their grandparents in India.

"My mother, Shyamala Gopalan, was a scientist who had two goals in life," Harris wrote in a March 2024 Instagram post, "to cure breast cancer and to raise her two daughters."

From an early age, Harris wanted to attend a Historically Black College. She chose Howard University, where she pledged Alpha Kappa Alpha Sorority, Inc.—the nation's oldest historically Black sorority. Law school at the University of California, Hastings College of Law, followed, where she was elected president of the Black Law Students Association. She graduated in 1989 and was admitted to the bar in 1990.

Harris's runs for office brought with them many firsts. When elected San Francisco's district attorney, she was the first woman, the first Black woman, and the first South Asian woman to hold the office. She was elected

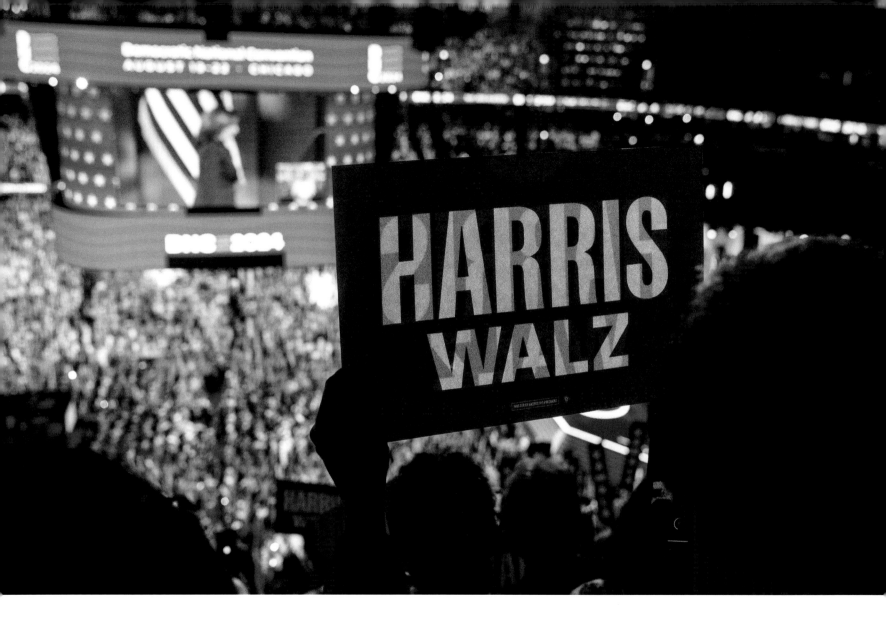

August 22, 2024: An audience member holds a Harris–Walz sign as Harris takes the stage at the Democratic National Convention in Chicago, Illinois. (Lorie Shaull)

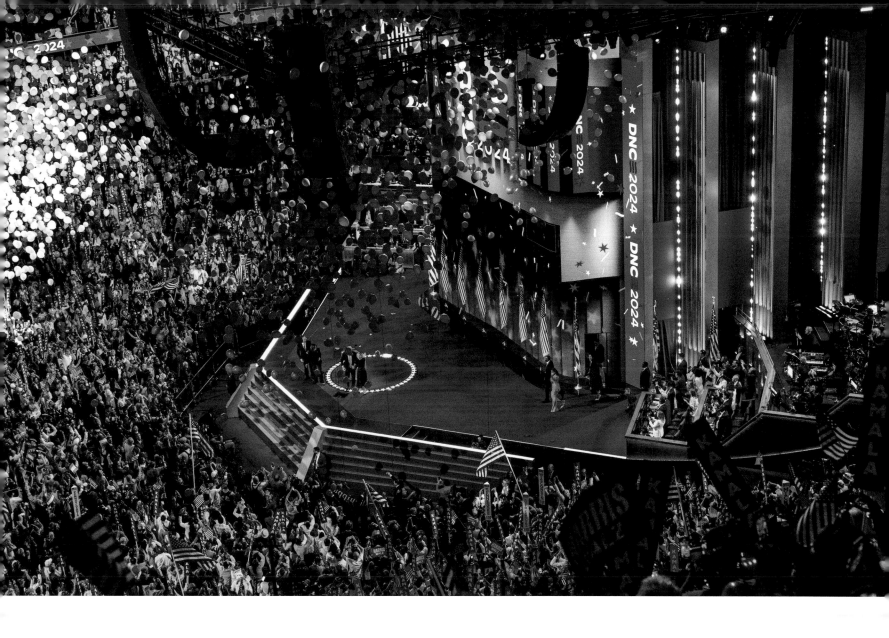

August 22, 2024: The balloon drop at the Democratic National Convention in Chicago, Illinois. (Lorie Schaull)

California's attorney general, succeeding Jerry Brown and becoming, again, the first woman, the first Black woman, and the first South Asian woman to hold the title. After serving in the U.S. Senate, Harris announced in 2019 that she was joining the large, diverse field of Democrats vying for the opportunity to face Trump in the 2020 presidential election. She made her announcement with odes to Chisholm and her slogan: "Unbought and unbossed." But Harris's candidacy failed to take off, and she ultimately dropped her bid.

It was Joe Biden, the former Delaware senator who had been vice president to President Obama, who secured the 2020 Democratic Party nomination. During his campaign, he promised Black voters, who had been key to his victory in the primaries, that he would name a Black woman as his vice presidential running mate. He chose Kamala Harris. Biden's victory against Trump a few months later made Harris the single most powerful woman in U.S. history.

Four years later, in the summer of 2024, when Biden made a historic decision to withdraw his candidacy for reelection, he immediately endorsed Harris as his successor, placing her at the cusp of the ultimate electoral power. Now, in *Kamala Harris: Selections from the Official White House Photography*, we see her tenure up close: in her history-making role as vice president, meeting heads of state and trusted emissaries, visiting college campuses, holding court from the head of the table and the podium, on the campaign trail, and, of course, joyously accepting the Democratic Party nomination for president.

We also see glimpses of the American story Harris carries with her—the story of immigrants coming to America to strive through education and hard work, rising through the middle class to achieve the American dream.

We see a self-made woman who did not shrink from her ambition and drive—the drive to participate in democracy, to vote and to run for office, and to fight to earn the right to lead.

We see an heir to the women who came before her.

We see the fruition of Fannie Lou Hamer's insistence that the Democratic Party include Black and white people together, as well as Hamer's activist's drive to fight the evils of racism, poverty, and women's subjugation.

We see the effect of Shirley Chisholm's bid for visibility, a fellow woman of Caribbean descent, whose audacious run for president forever altered the notion of what a presidential candidate should look and sound like.

And we see the power of Hillary Clinton's glass-ceiling-shattering ascendency, which crushed the myth that women should be the silent partners of men and take no interest in high achievement, let alone in politics.

Harris's rise embodies the historic journey of the Democratic Party and the United States, from the darkness of segregation, racism, and exclusion to the bright light of multiracial democracy, on the road to a more perfect union.

KAMALA HARRIS

When we fight, we win.

—Kamala Harris presidential campaign slogan

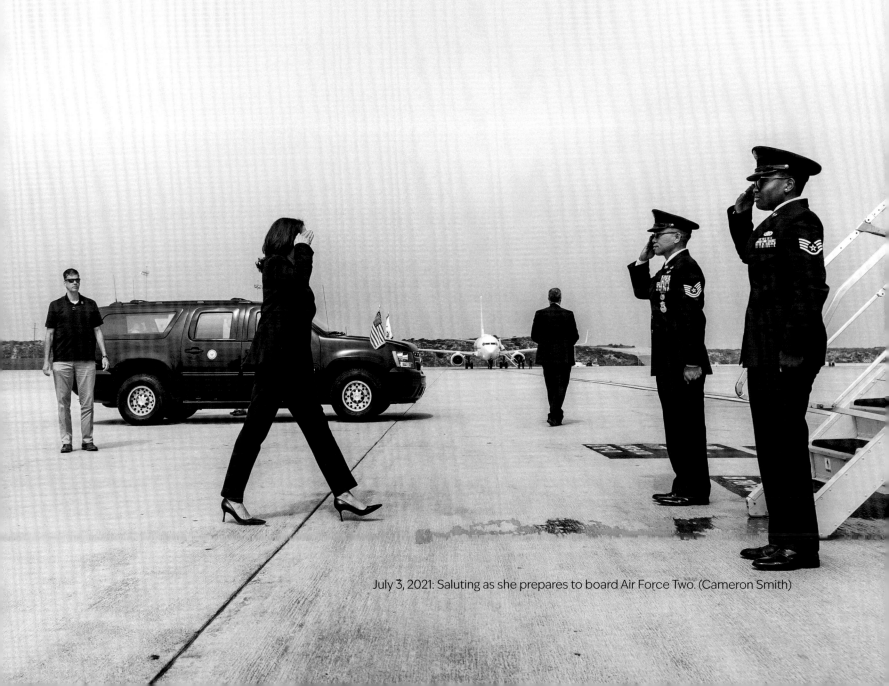

July 3, 2021: Saluting as she prepares to board Air Force Two. (Cameron Smith)

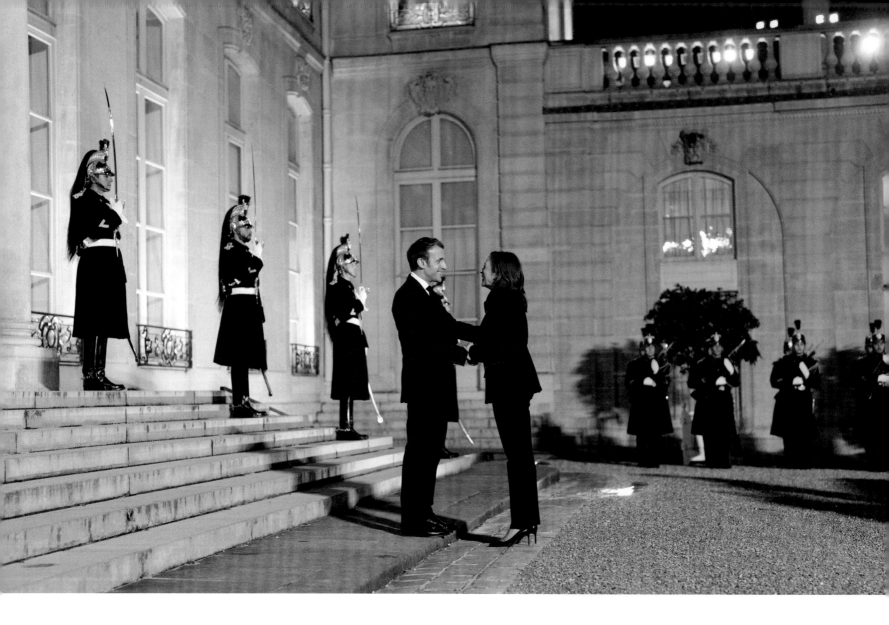

November 10, 2021: Arriving at the Élysée Palace in Paris, France, and being greeted by French President Emmanuel Macron. (Lawrence Jackson)

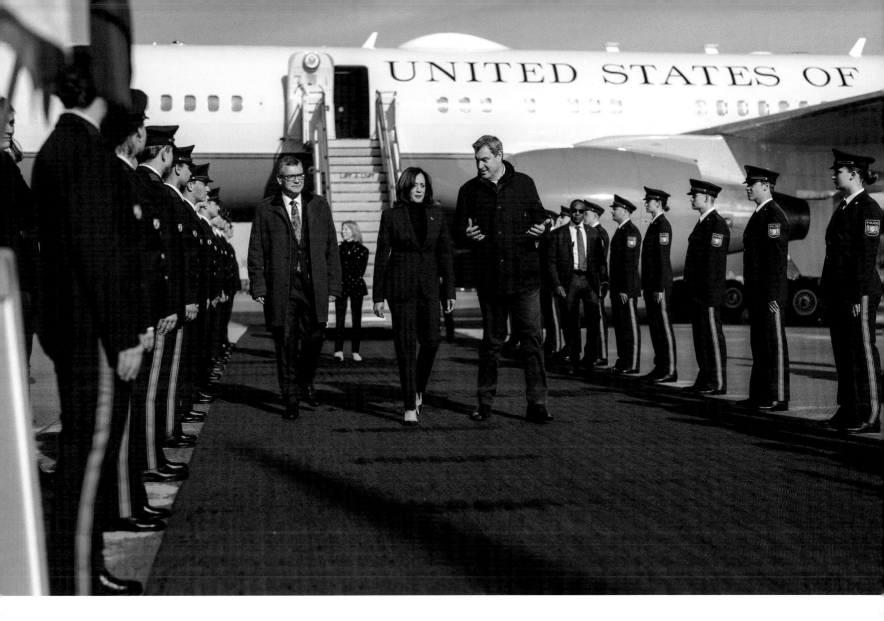

February 15, 2024: Greeting Minister-President of Bavaria, Markus Söder; State Minister Dr. Florian Herrmann; U.S. Ambassador to Germany Amy Gutmann; and U.S. Consul General Timothy Liston upon arriving at Munich International Airport in Munich, Germany. (Lawrence Jackson)

(Cameron Smith, 2021)

(Chandler West, 2021)

The American people deserve a leader who tells the truth, a leader who does not respond with hostility and anger when confronted with the facts.

—At the Sigma Gamma Rho Sorority, Inc., 60th International Biennial Boule in Houston, Texas, July 31, 2024

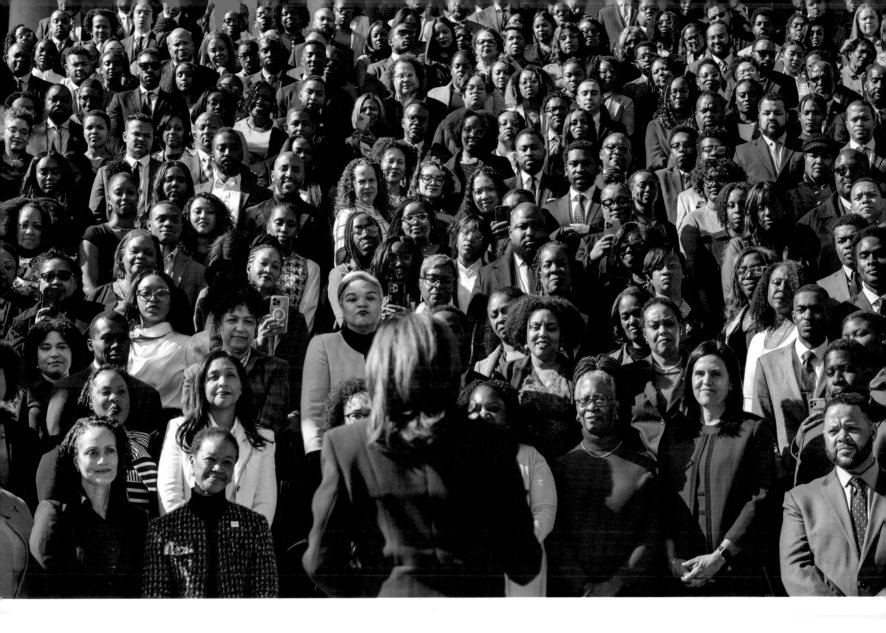

February 9, 2024: Speaking to White House and Administration staff before posing for a photo in honor of Black History Month. (Oliver Contreras Cruz)

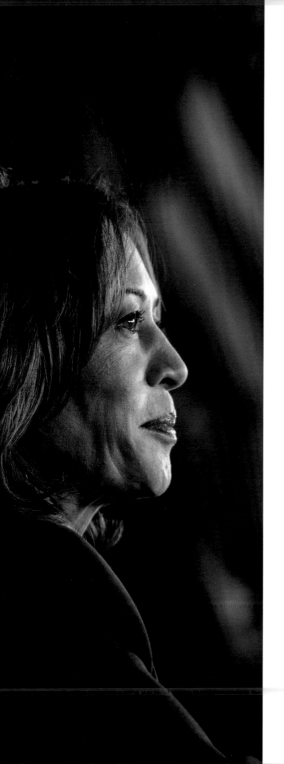

April 22, 2024: Participating in a roundtable discussion on nursing home care at the Hmong Cultural Center in La Crosse, Wisconsin. (Lawrence Jackson)

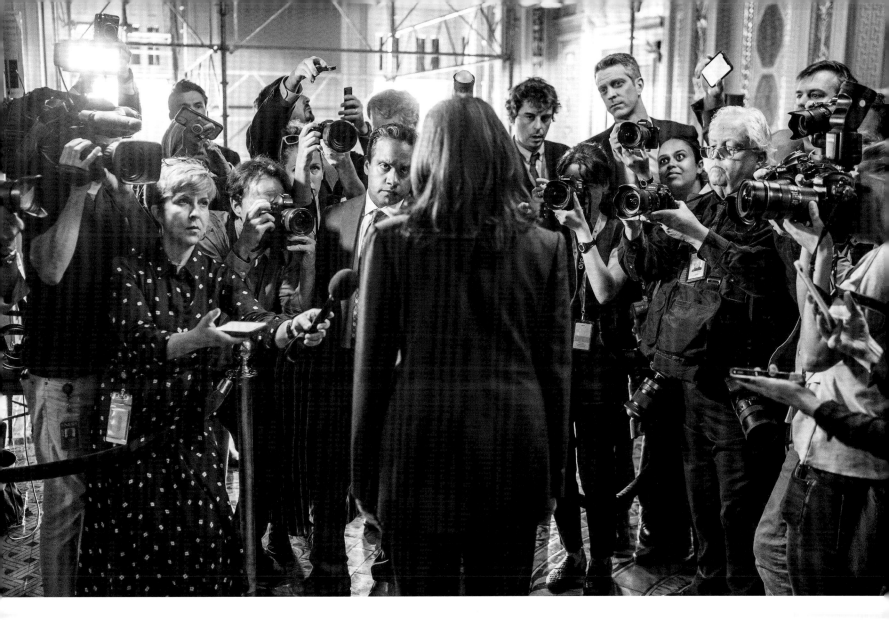

June 23, 2021: Addressing the media after presiding over a vote in the U.S. Senate at the U.S. Capitol in Washington, D.C. (Lawrence Jackson)

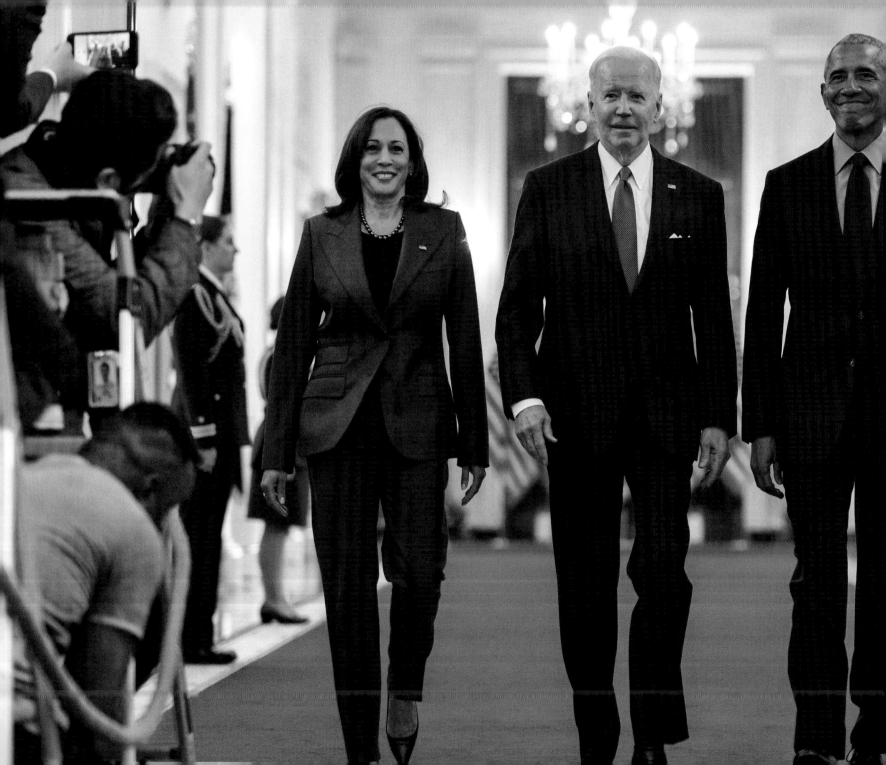

April 5, 2022: Arriving with former Presidents Joe Biden and Barack Obama at an Affordable Care Act event in the East Room of the White House. (Cameron Smith)

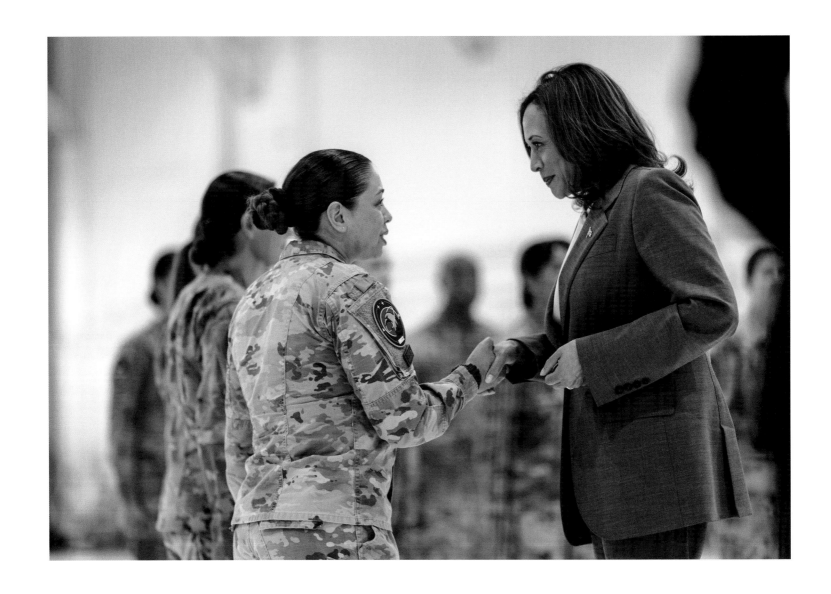

May 30, 2024: Greeting U.S. Space Force Guardians at Hangar 140 at
Peterson Space Force Base in Colorado Springs, Colorado. (Lawrence Jackson)

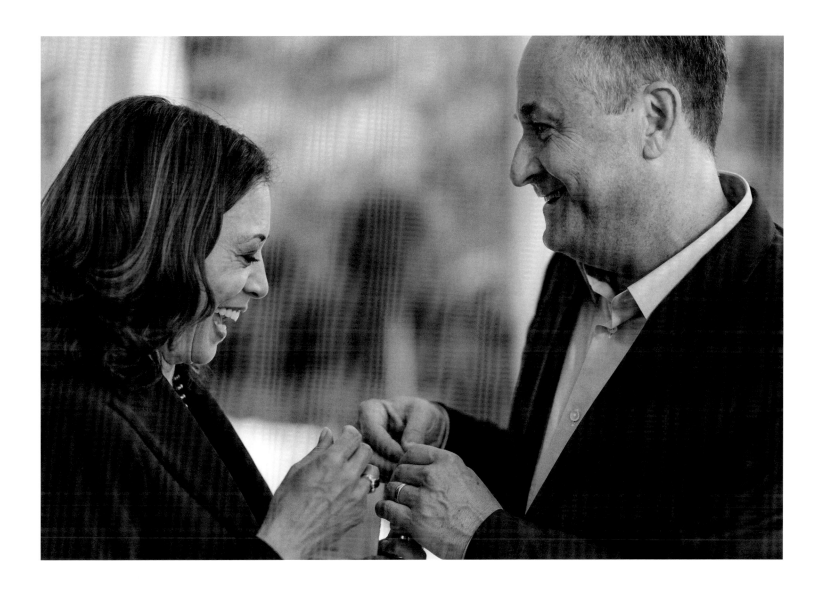

October 7, 2021: Participating in a blessing of the mezuzah at the Vice President's Residence with her husband, Doug Emhoff. (Cameron Smith)

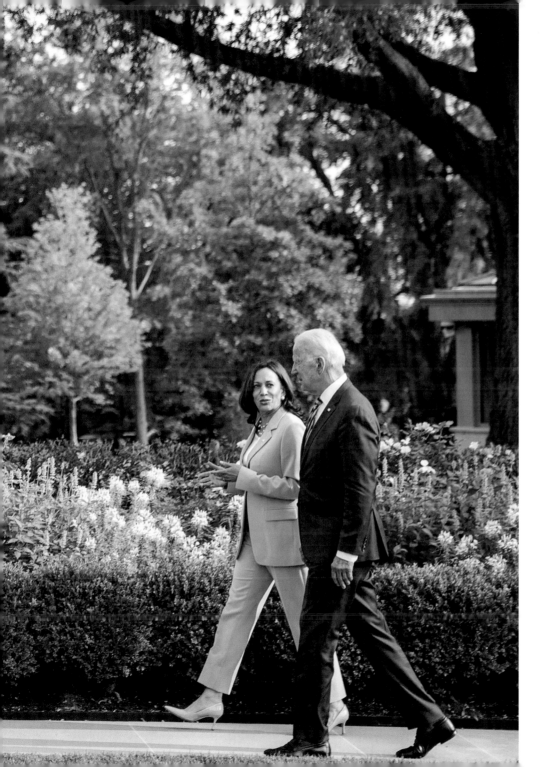

July 2, 2021: Walking through the
White House Rose Garden with former
President Joe Biden. (Lawrence Jackson)

CAUTION
LEAVE 3 INCH MAXIMUM GAP
BETWEEN FAIRINGS PRIOR TO
SLIDING AFT AND LATCHING

March 22, 2021: Disembarking Air Force Two at Jacksonville International Airport in Jacksonville, Florida. (Lawrence Jackson)

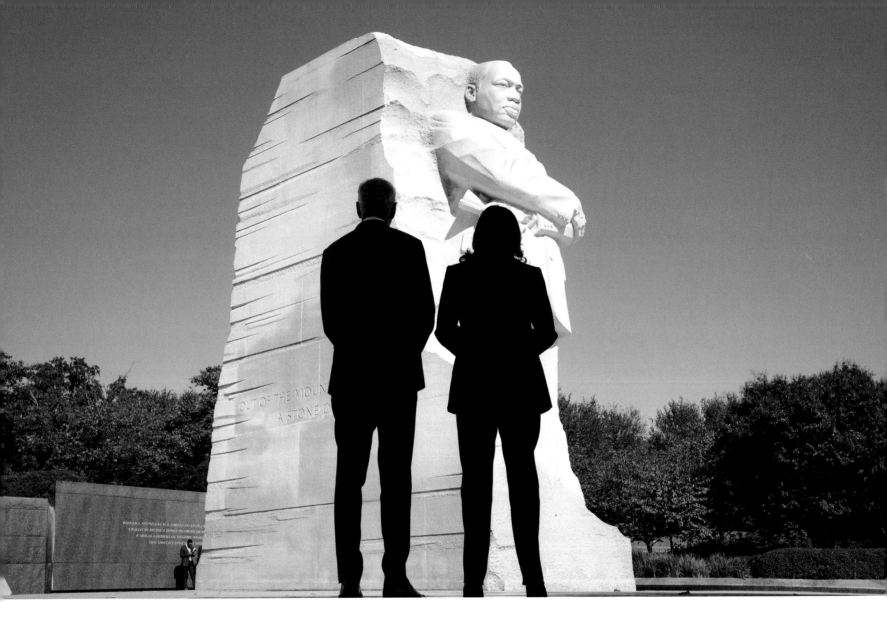

October 21, 2021: Observing a moment of reflection with former President Joe Biden at the Martin Luther King Jr. Memorial in Washington, D.C. (Erin Scott)

The vast majority of us have so much more in common than what separates us.

—To organizers of the 60th anniversary celebration of the March on Washington and to members of the King family, at the White House, August 28, 2023

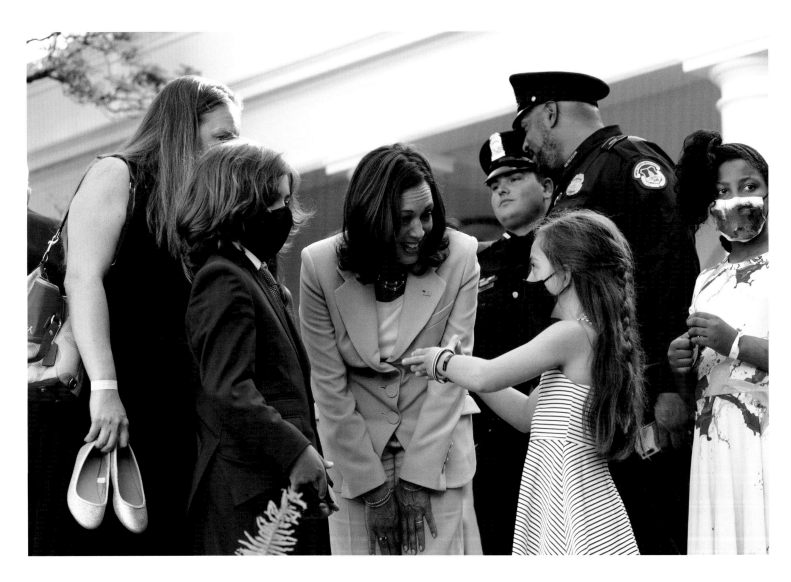

August 5, 2021: Greeting U.S. Capitol police officers and their family members at a Congressional Gold Medal bill-signing event to honor U.S. Capitol police in the White House Rose Garden. Harris speaks with the family of Officer William "Billy" Evans, who was killed in the line of duty on April 2, 2021. (Erin Scott)

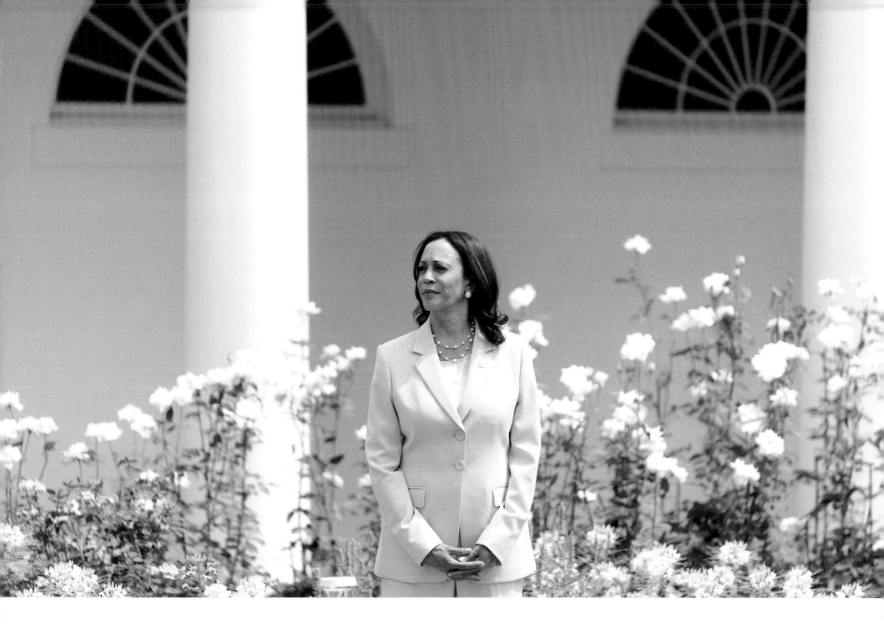

July 26, 2021: Attending an event celebrating the 31st anniversary of the Americans with Disabilities Act in the White House Rose Garden. (Lawrence Jackson)

The right to vote is fundamental. And so ensuring every eligible American can access that right is a top priority for our administration, and an effort that I am proud to lead.

—At the Summit for Democracy at the Eisenhower Executive Office Building at the White House, December 9, 2021

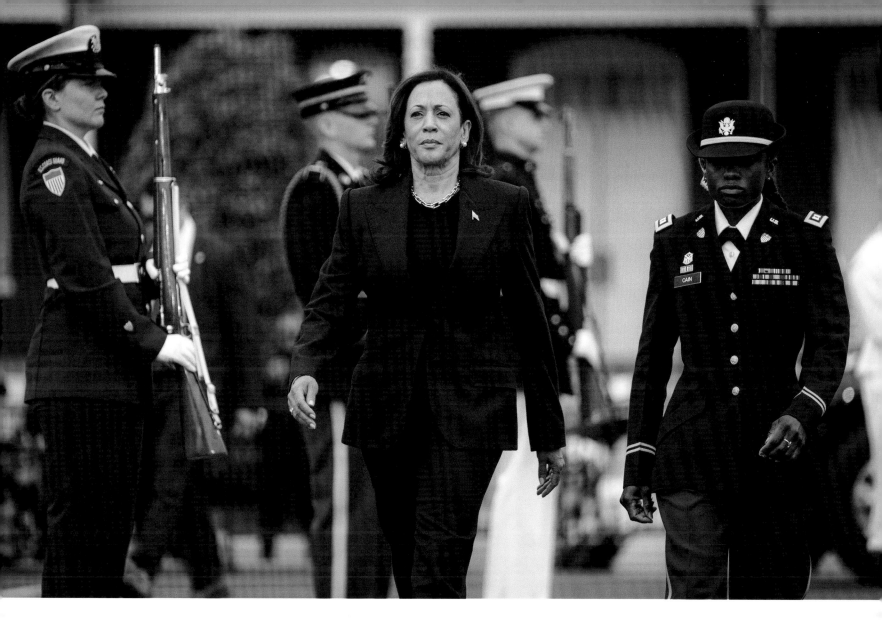

September 29, 2023: Attending the Armed Forces Hail ceremony at
Joint Base Myer–Henderson Hall, Virginia. (Benjamin Applebaum)

June 24, 2021: Delivering remarks during a virtual Vaccine
Month of Action partners call. (Lawrence Jackson)

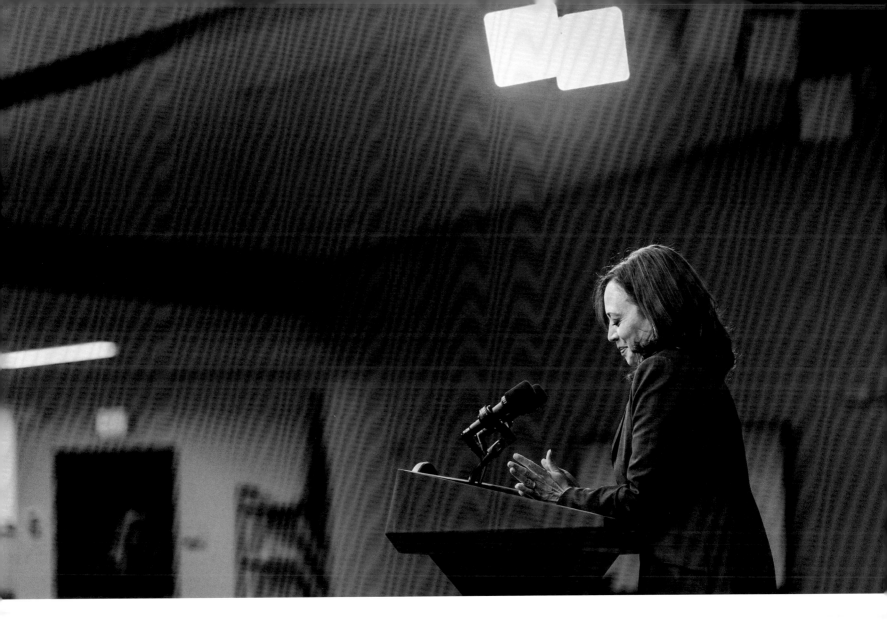

July 27, 2021: Delivering remarks virtually at the National Bar Association. (Cameron Smith)

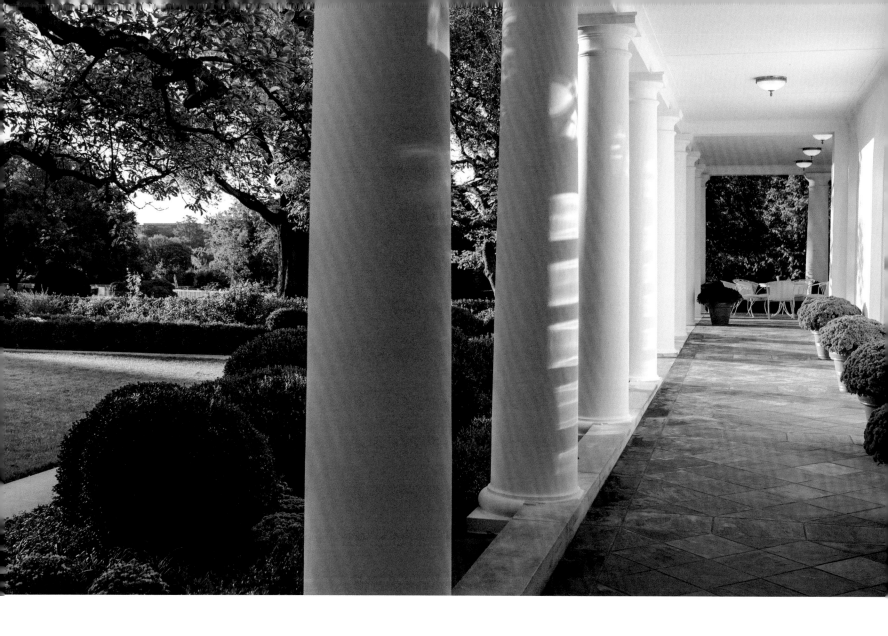

(Adam Schultz, 2021)

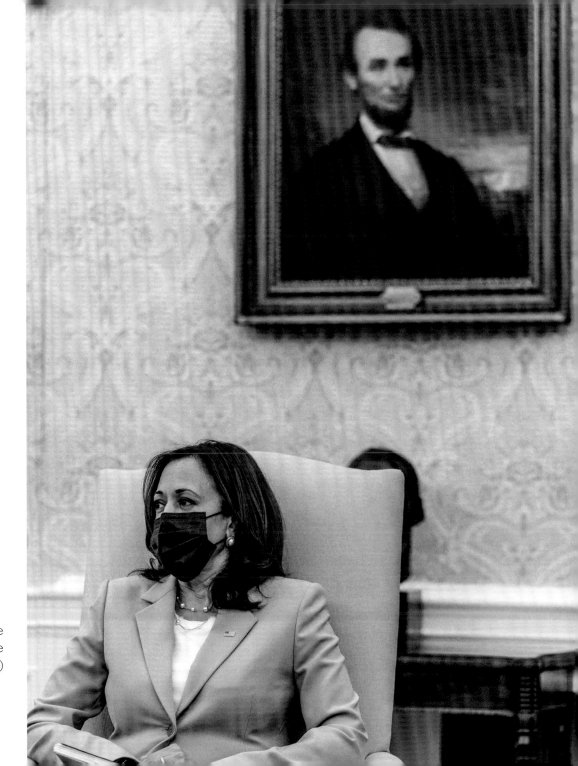

July 30, 2021: Meeting with White House staff in the Oval Office of the White House. (Adam Schultz)

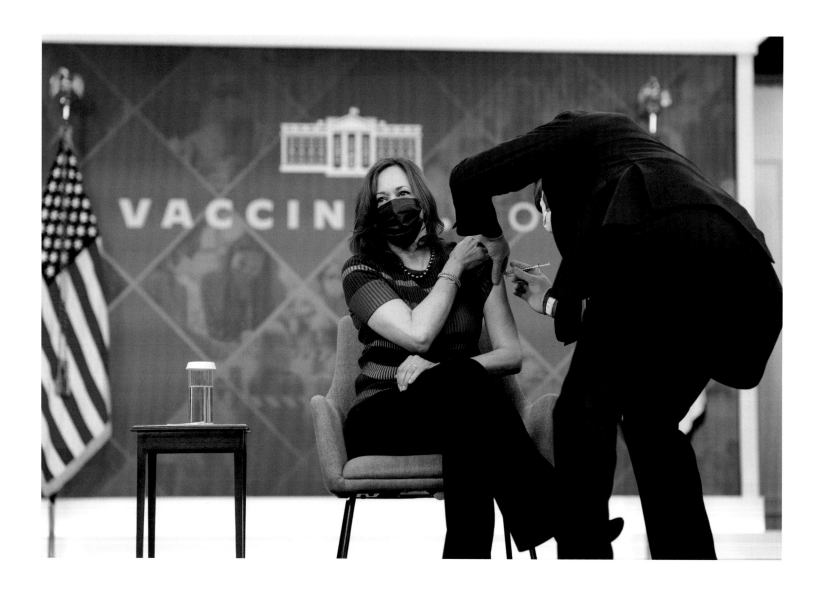

October 30, 2021: Receiving her Moderna COVID-19 vaccine booster shot at the White House. (Lawrence Jackson)

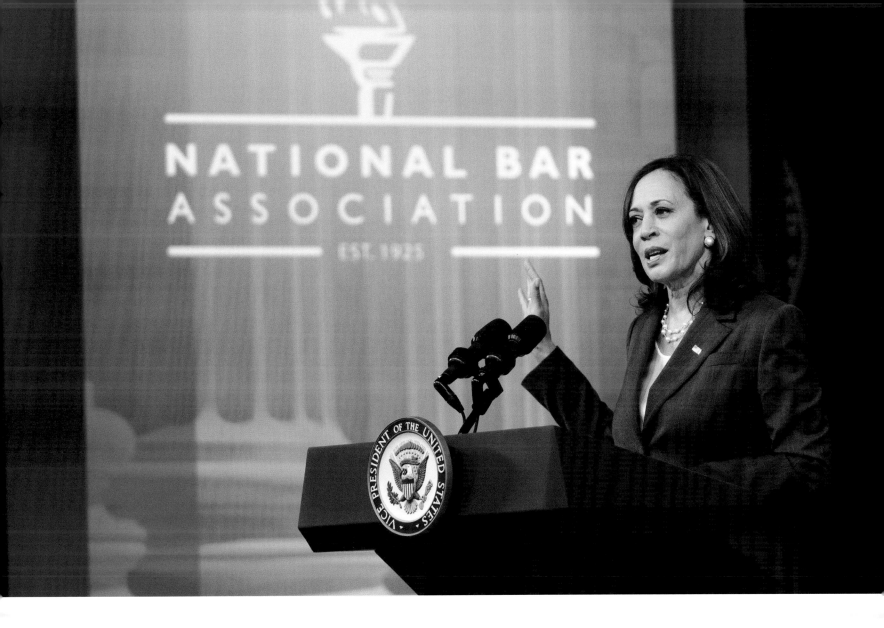

July 27, 2021: Delivering remarks virtually at the
National Bar Association. (Lawrence Jackson)

November 18, 2021: Talking with
Canadian Prime Minister Justin Trudeau
on the balcony of the Vice President's
Ceremonial Office. (Lawrence Jackson)

Opposite: August 4, 2021: Holding an
on-phone and in-person meeting in
preparation for her trip to Singapore
in her West Wing Office of the
White House. (Erin Scott)

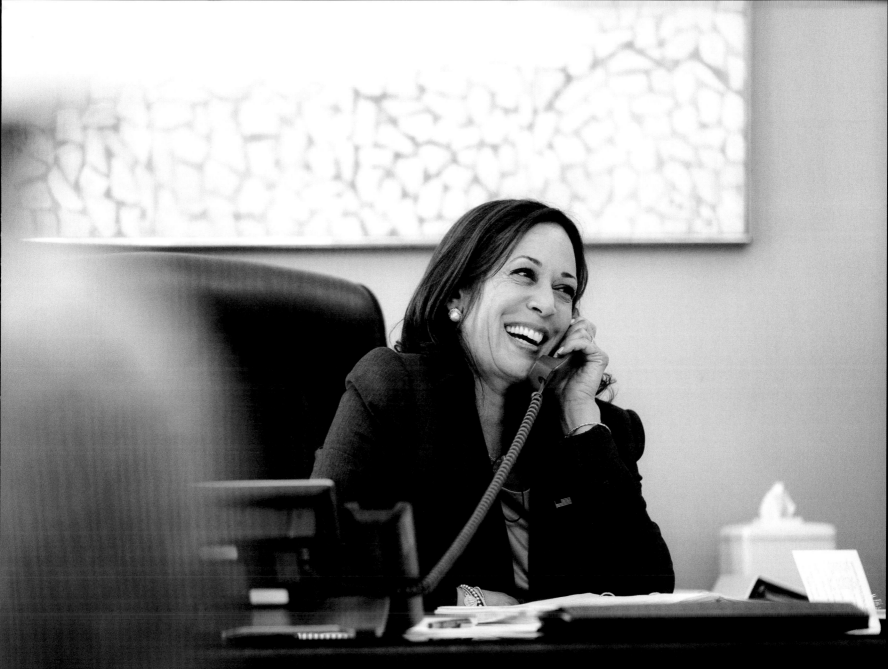

May 4, 2023: Holding a meeting with artificial intelligence (AI) CEOs in the Roosevelt Room of the White House. (Lawrence Jackson)

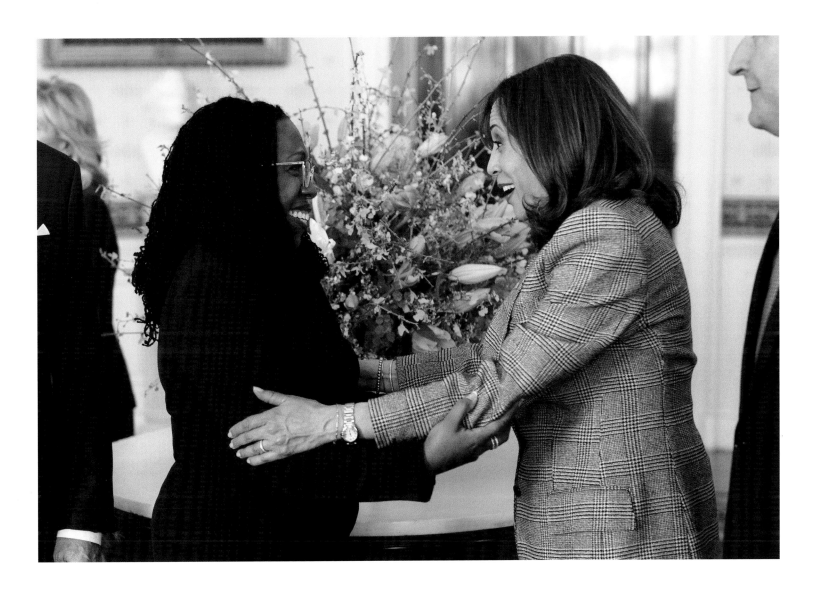

February 25, 2022: Greeting Judge Ketanji Brown Jackson in the Blue Room of the White House after Jackson's official nomination to the Supreme Court. (Lawrence Jackson)

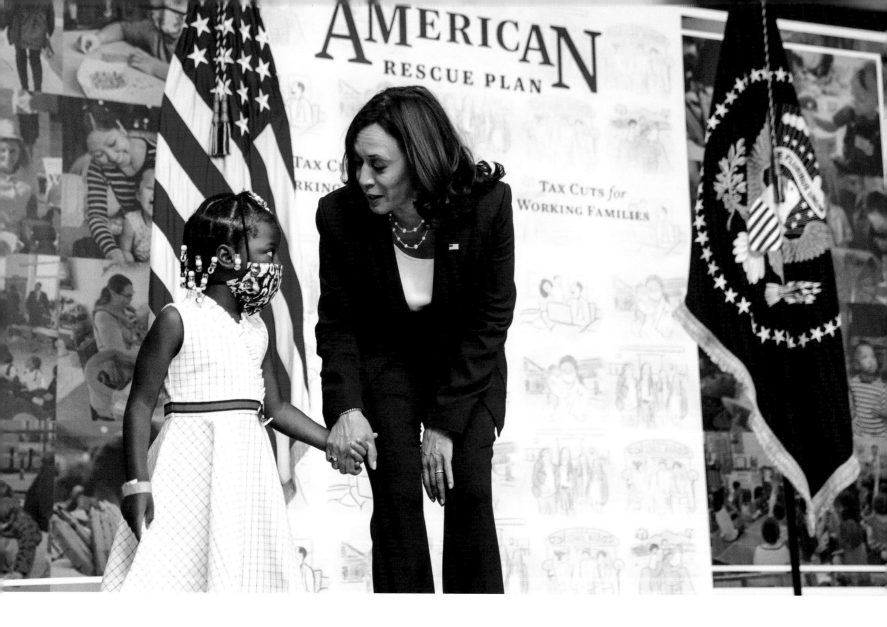

July 15, 2021: Speaking with a young girl following former President Biden's remarks on the Child Tax Credit in the South Court Auditorium in the Eisenhower Executive Office Building at the White House. (Lawrence Jackson)

It is in the fundamental interest of the American people for the United States to fulfill our long-standing role of global leadership.

—At the Munich Security Conference in Munich, Germany, February 16, 2024

March 12, 2021: Taking notes during a virtual Quad Summit
with Australia, India, and Japan. (Adam Schultz)

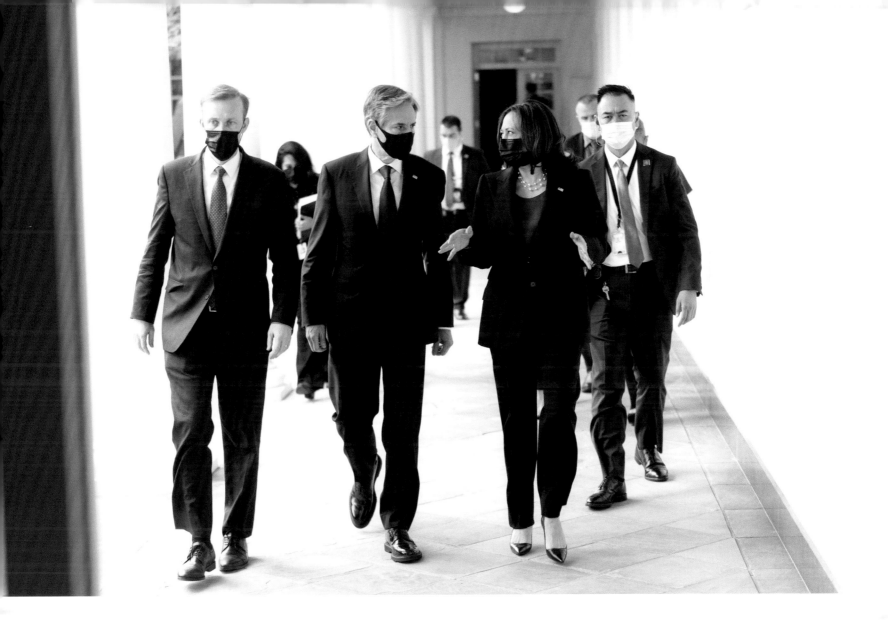

August 20, 2021: Walking along the West Colonnade of the White House with Secretary of State Antony Blinken (*center*) and National Security Advisor Jake Sullivan (*left*). (Lawrence Jackson)

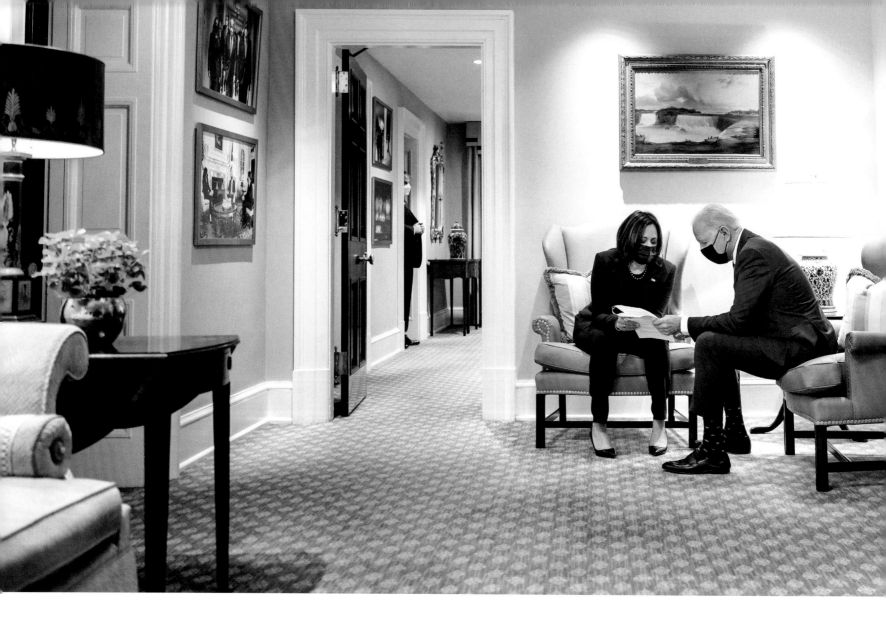

March 29, 2021: Discussing notes from a meeting on the White House COVID-19 response with former President Joe Biden in the Outer Oval Office of the West Wing of the White House. (Adam Schultz)

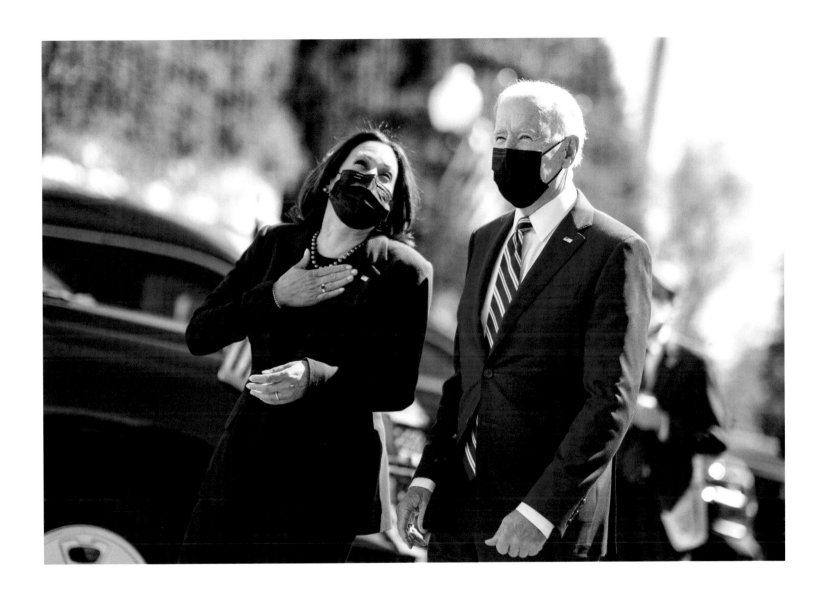

March 29, 2021: Walking with former President Joe Biden, following his remarks in the South Court Auditorium in the Eisenhower Executive Office Building at the White House. (Lawrence Jackson)

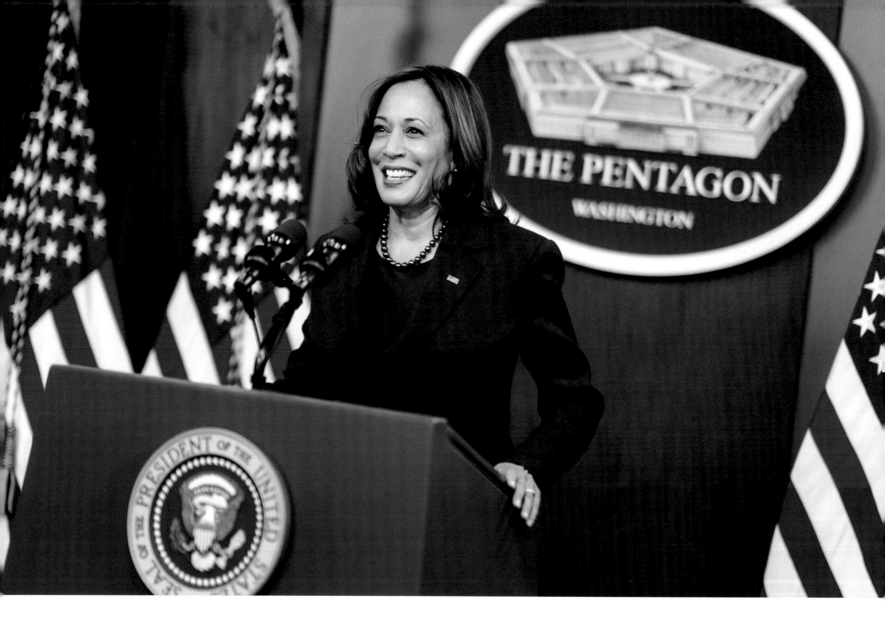

February 10, 2021: Delivering remarks during a press conference
at the Pentagon in Arlington, Virginia. (Adam Schultz)

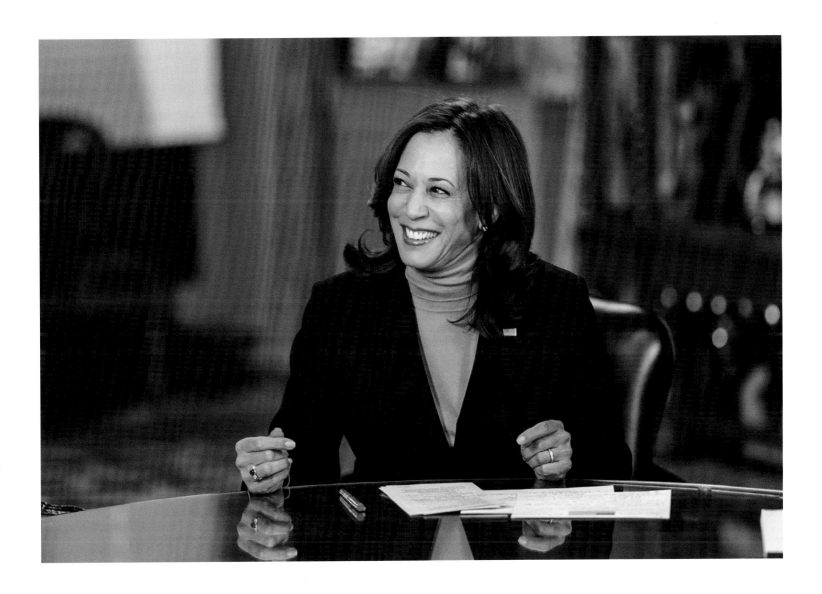

February 17, 2021: Participating in an interview on the NBC *Today* show with anchor Savannah Guthrie. (Lawrence Jackson)

(Adam Schultz, 2022)

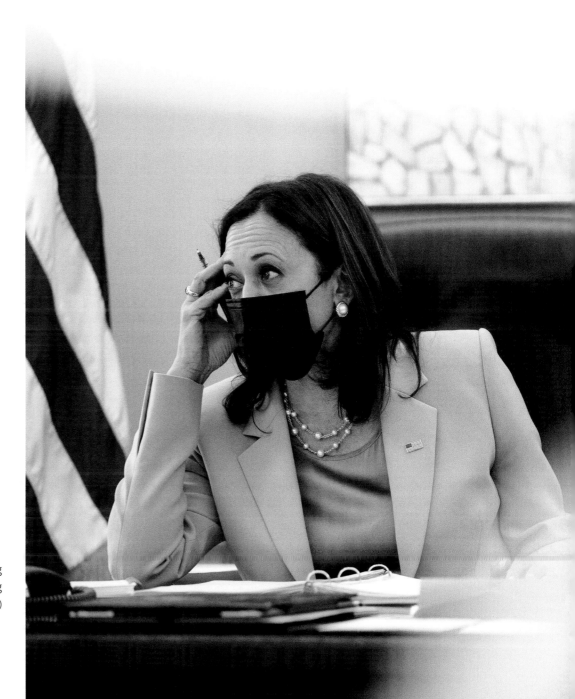

August 6, 2021: Making calls and holding meetings in preparation for her upcoming trip to Singapore. (Erin Scott)

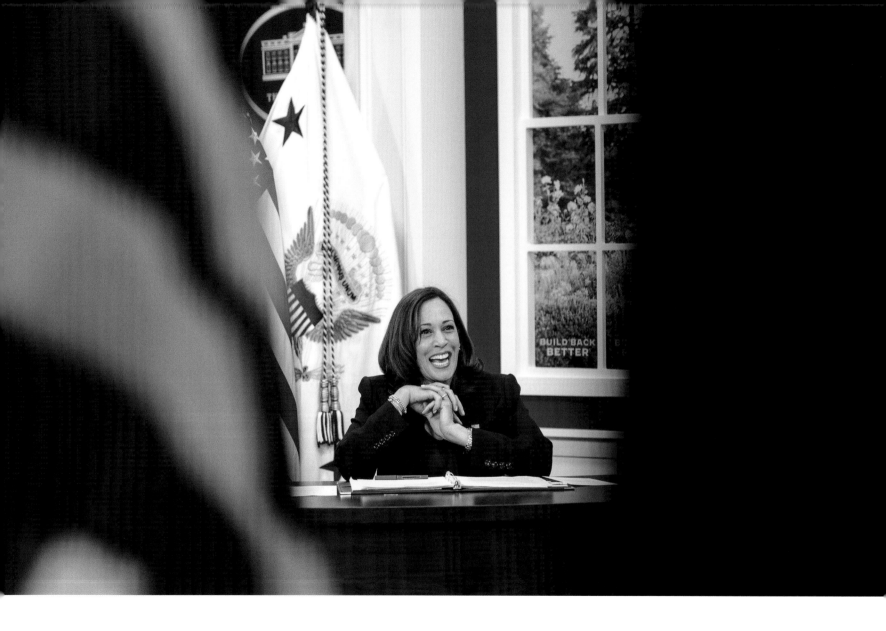

October 28, 2021: Participating in a Build Back Better virtual event with mayors from across the country. (Lawrence Jackson)

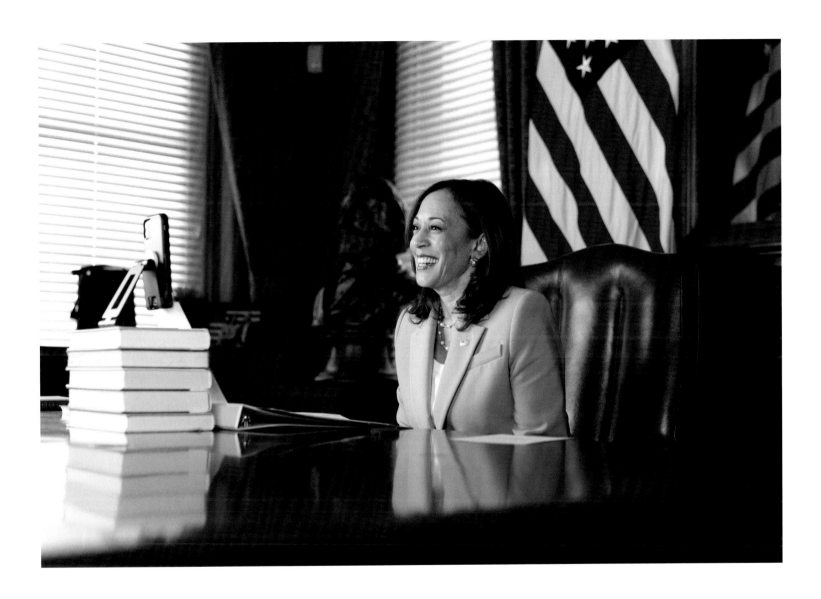

August 4, 2021: Participating in an Instagram Live
event on voting. (Lawrence Jackson)

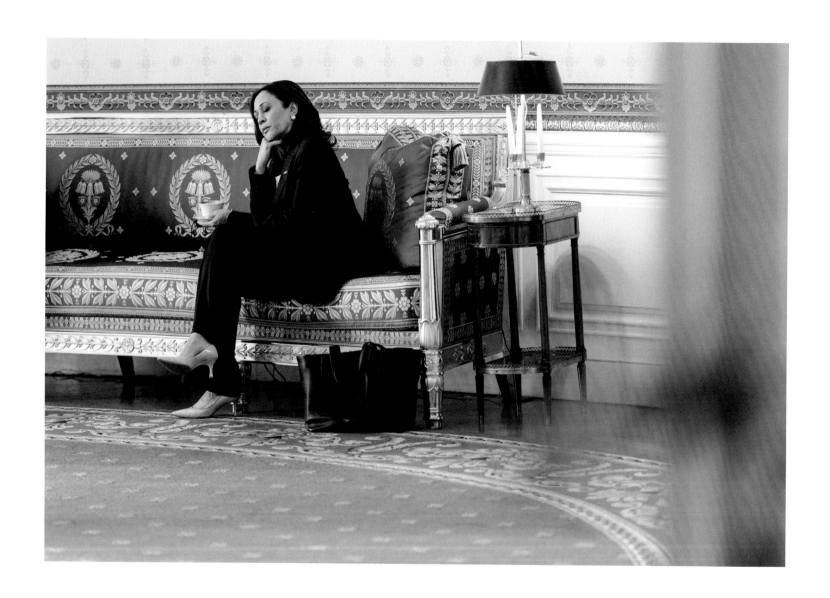

August 10, 2021: Waiting in the Blue Room for an event with former President Joe Biden. (Lawrence Jackson)

(Adam Schultz, 2022)

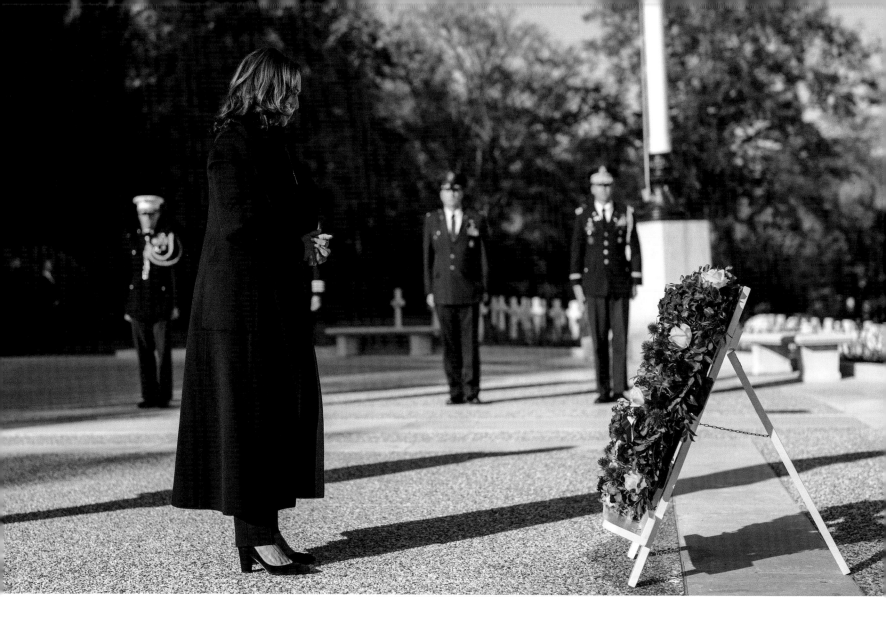

November 10, 2021: Paying her respects in a wreath-laying ceremony at the Suresnes American Cemetery in Paris, France. (Lawrence Jackson)

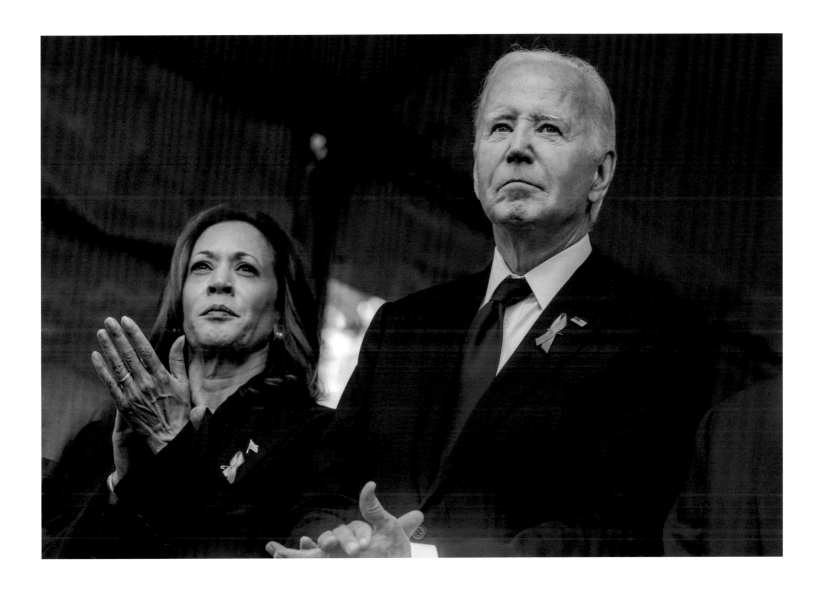

September 11, 2024: With former President Joe Biden at a ceremony marking the 23rd anniversary of the 9/11 terrorist attacks, at the 9/11 Memorial plaza, the previous site of the World Trade Center, in New York, New York. (Adam Schultz)

Our history as a nation is born out of tragedy and triumphs. That's who we are.

—*At the signing of the Emmett Till and Mamie Till-Mobley National Monument Proclamation at the Eisenhower Executive Office Building at the White House, July 25, 2023*

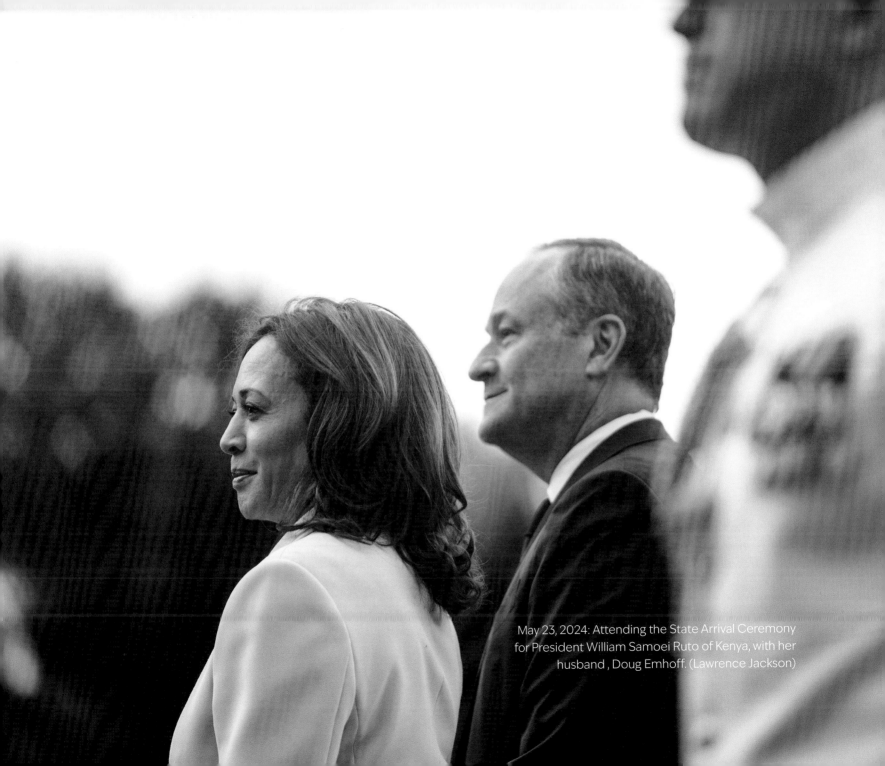

May 23, 2024: Attending the State Arrival Ceremony for President William Samoei Ruto of Kenya, with her husband , Doug Emhoff. (Lawrence Jackson)

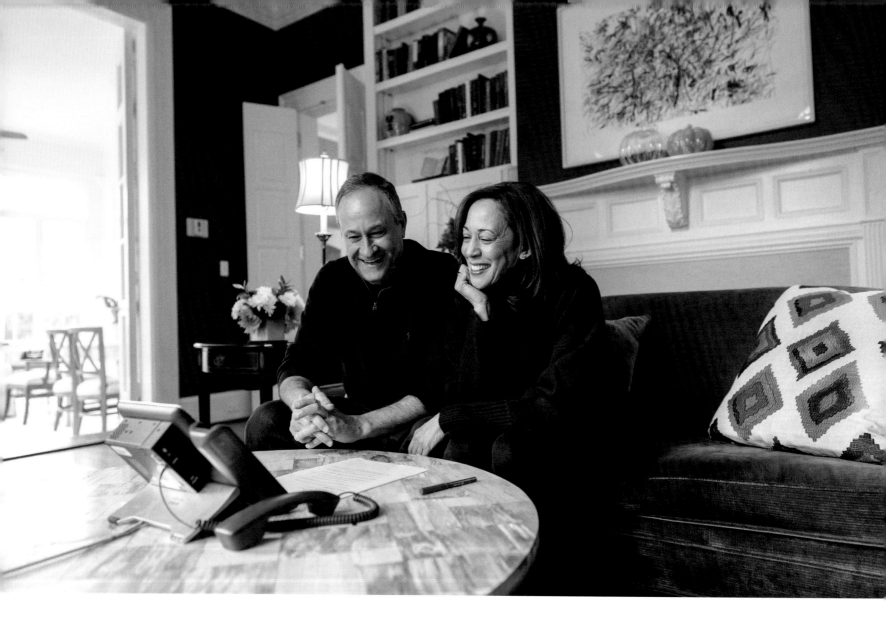

November 25, 2021: Making phone calls to military troops in Kuwait and San Diego with her husband, Doug Emhoff, to wish them a happy Thanksgiving, from the Vice President's Residence in Washington, D.C. (Lawrence Jackson)

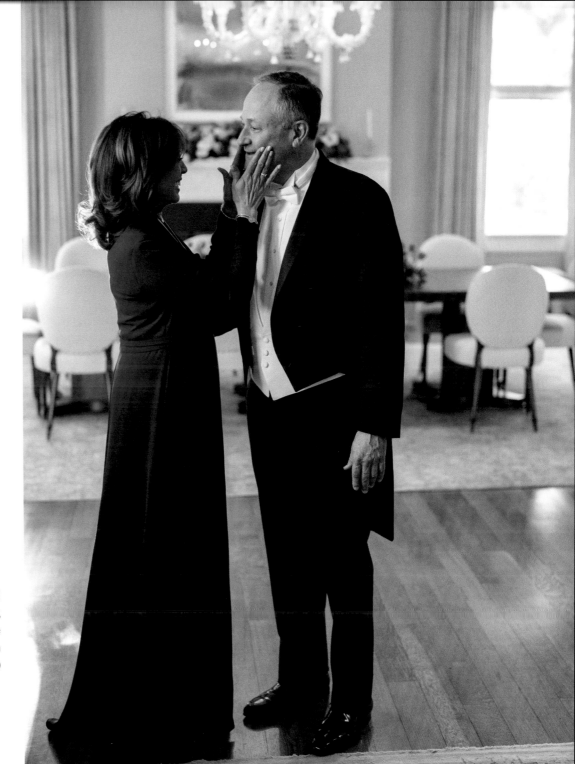

March 16, 2024: Preparing to pose for official portraits with her husband, Doug Emhoff, at the Vice President's Residence before attending the Gridiron Club and Foundation Dinner in Washington, D.C. (Lawrence Jackson)

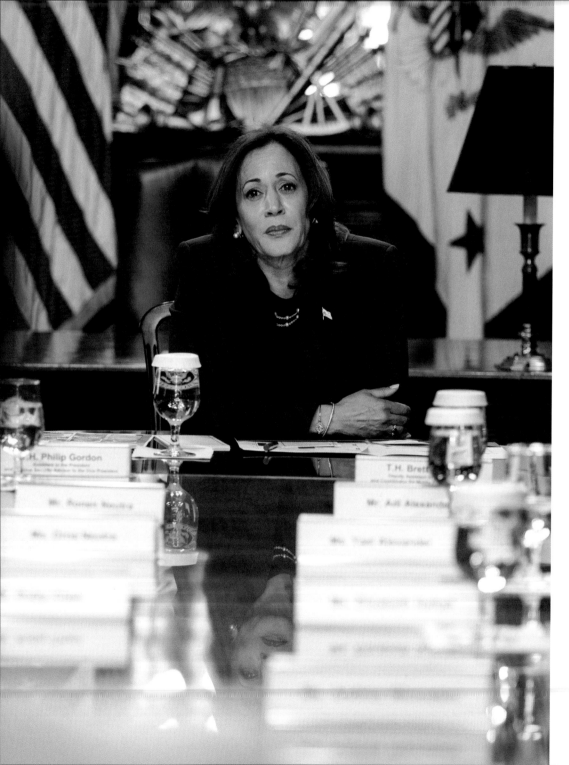

April 9, 2024: Meeting with families of hostages from the October 7 attack on Israel, in the Vice President's Ceremonial Office. (Polly Irungu)

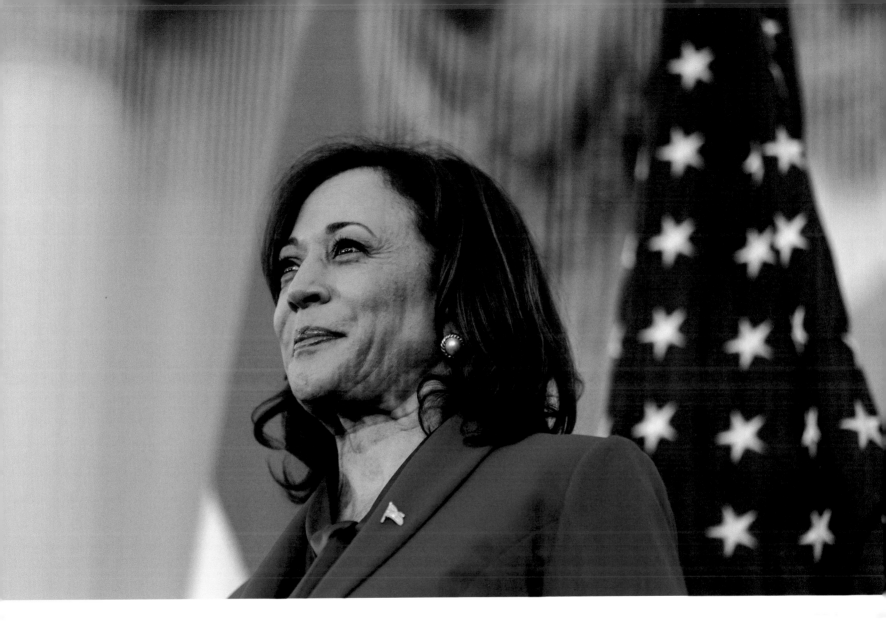

June 23, 2023: Attending a state luncheon for Prime Minister Narendra Modi of India at the U.S. Department of State in Washington, D.C. (Lawrence Jackson)

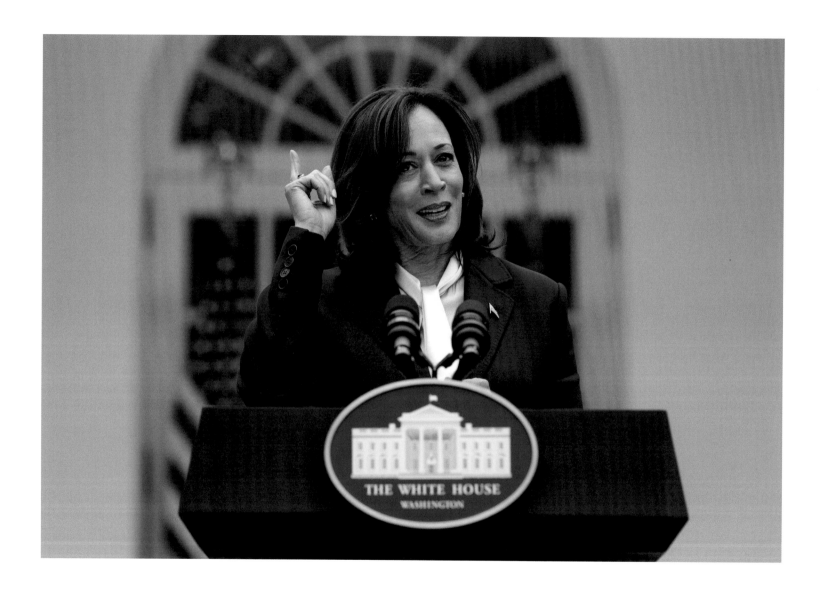

October 18, 2023: Delivering remarks at a Hispanic Heritage Month reception in the White House Rose Garden. (Oliver Contreras)

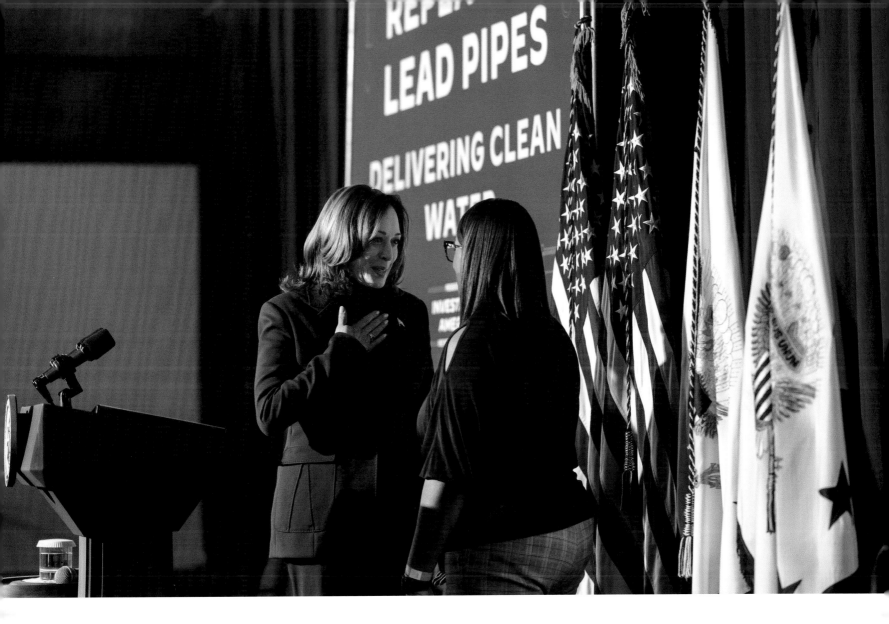

February 20, 2024: Speaking with community member Kim Clark-Baskin after being introduced at an event announcing clean water investments in Pittsburgh, Pennsylvania. (Lawrence Jackson)

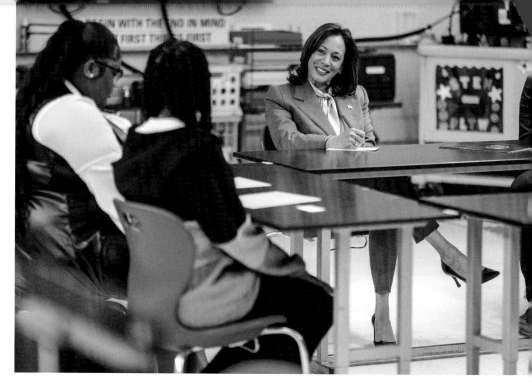

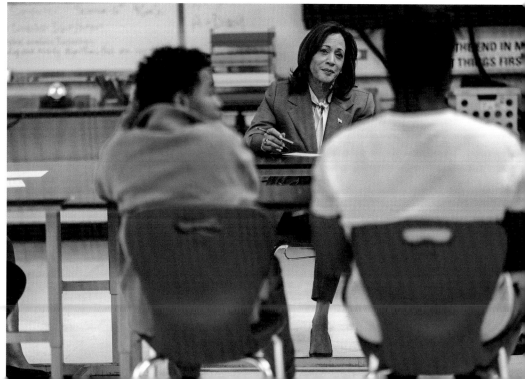

January 11, 2024: Participating in a roundtable conversation on gun violence prevention and mental health with students at Eastway Middle School, in Charlotte, North Carolina, with Greg Jackson, deputy director of the White House Office of Gun Violence Prevention. (Lawrence Jackson)

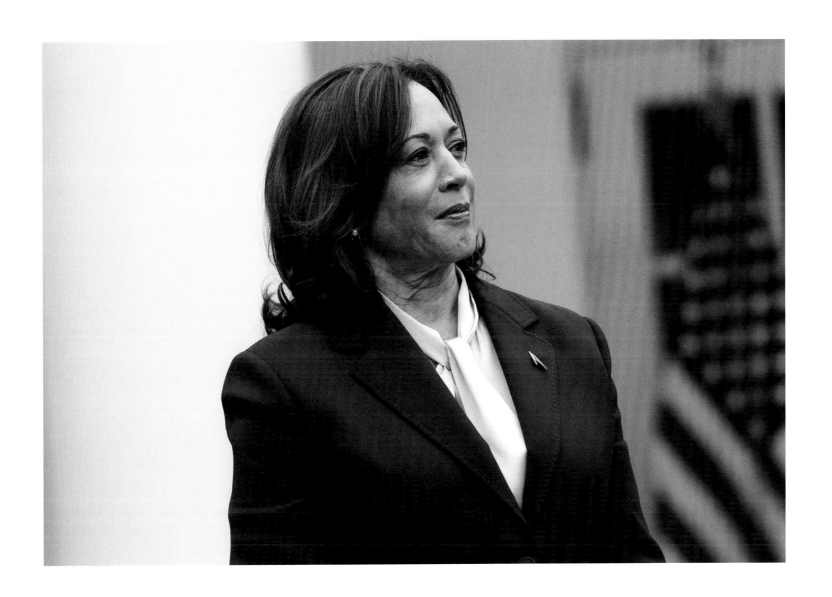

October 18, 2023: Attending a Hispanic Heritage Month reception in the White House Rose Garden. (Oliver Contreras)

(Adam Schultz, 2022)

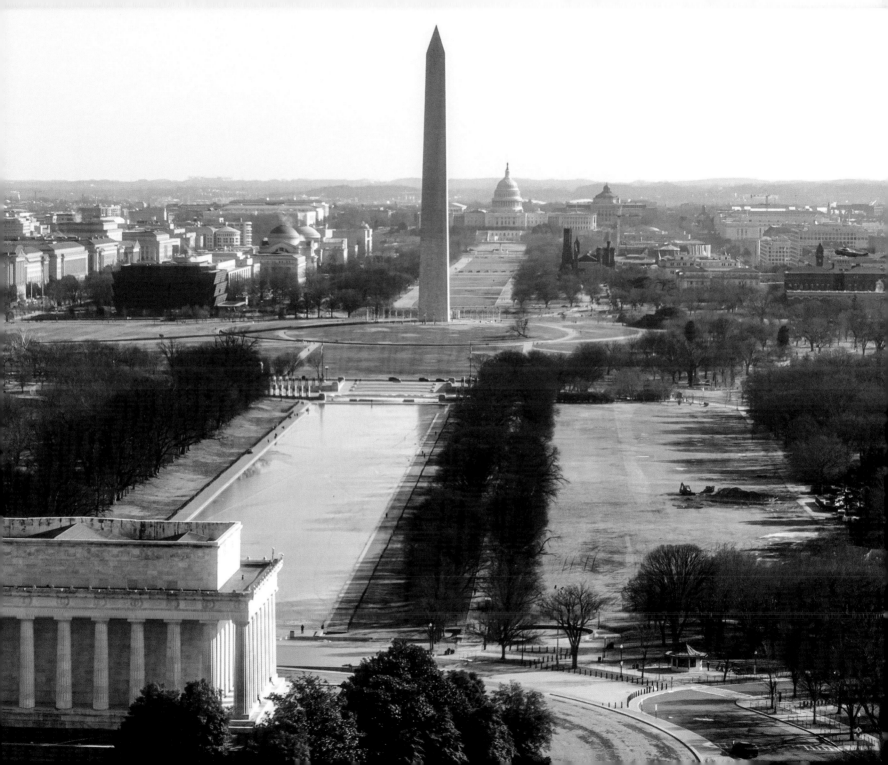

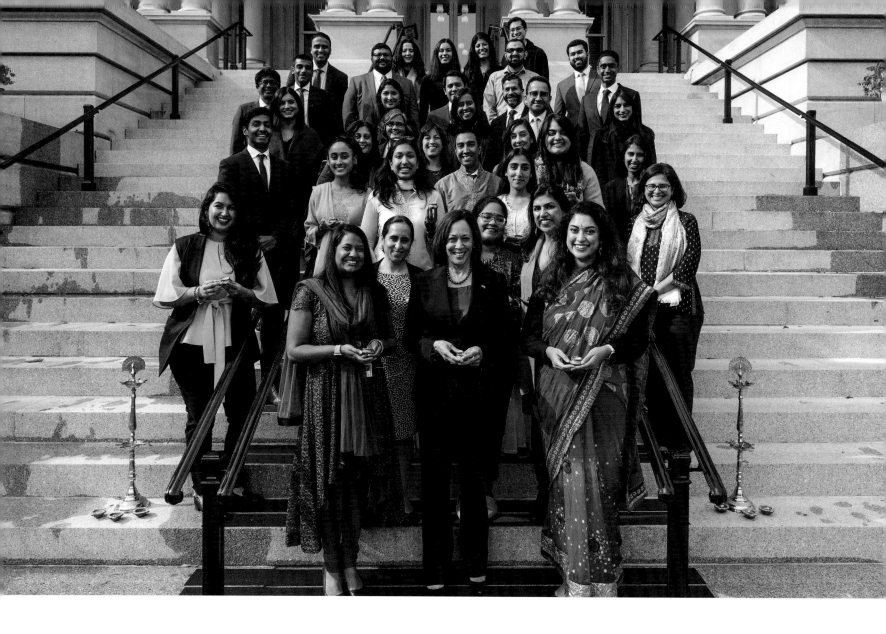

November 4, 2021: Posing with White House staff for a group photo in celebration of Diwali on the Navy Steps of the Eisenhower Executive Office Building at the White House. (Cameron Smith)

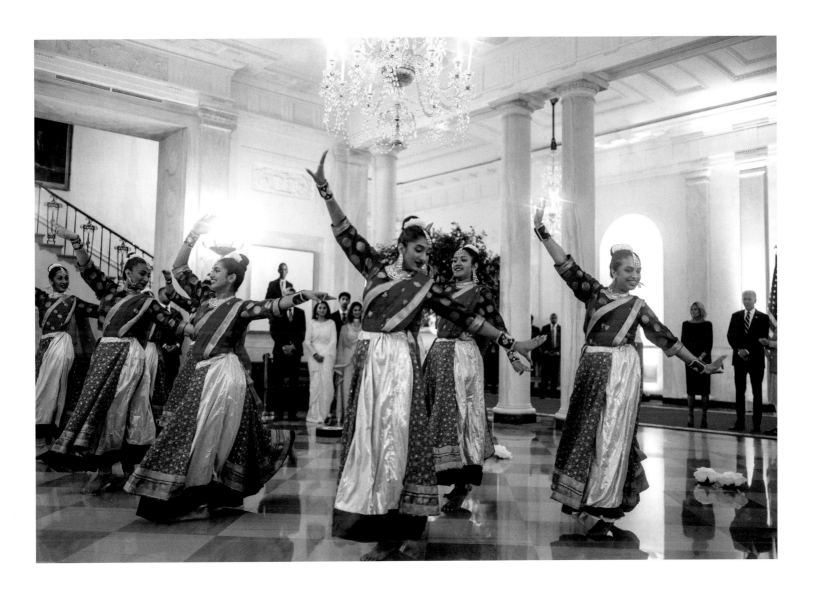

June 21, 2023: A traditional dance performance by high school students from Studio Dhoom, in the Grand Foyer of the White House. (Adam Schultz)

October 27, 2021: A diya in celebration of Diwali on display in the Blue Room of the White House. (Adam Schultz)

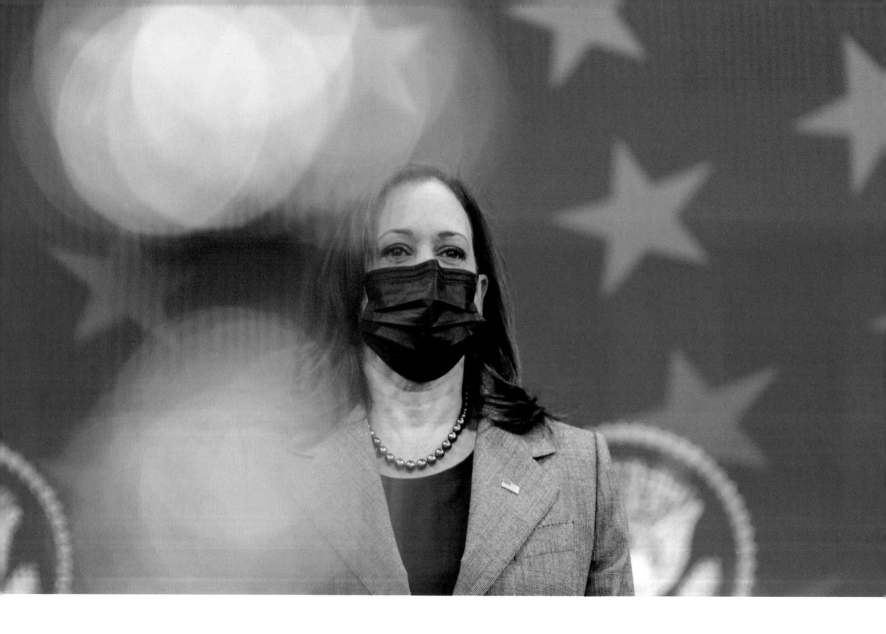

November 30, 2021: Looking on as former President Joe Biden delivers remarks prior to signing a bipartisan veterans' bill. (Lawrence Jackson)

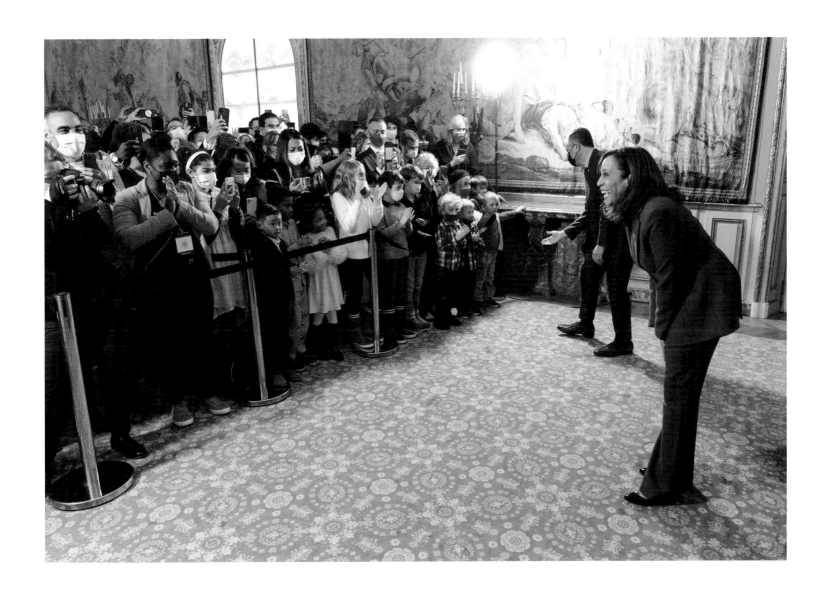

November 13, 2021: Greeting staff at the embassy meet and greet at the Chief of Mission Residence in Paris, France. (Lawrence Jackson)

(Adam Schultz, 2021)

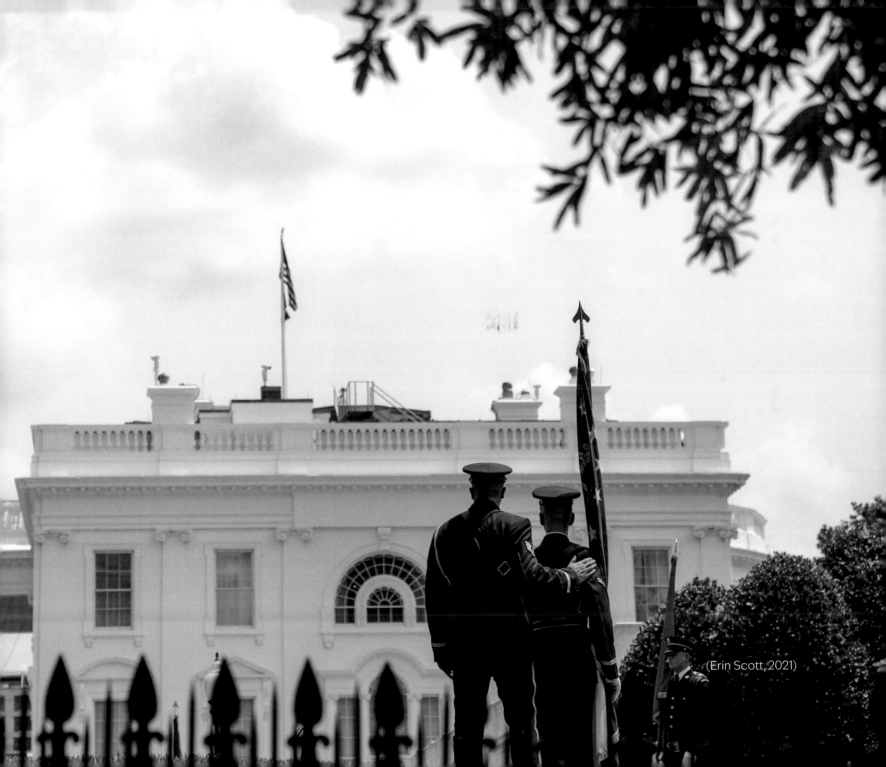

(Erin Scott, 2021)

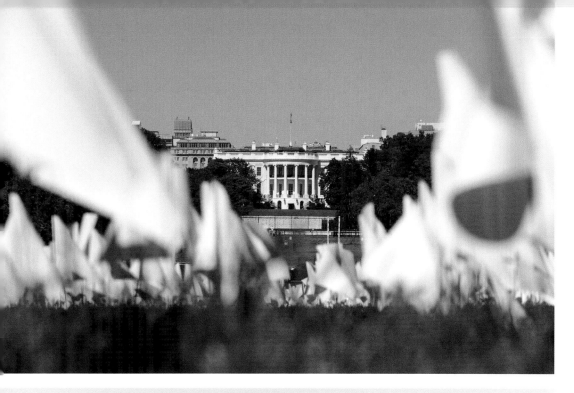

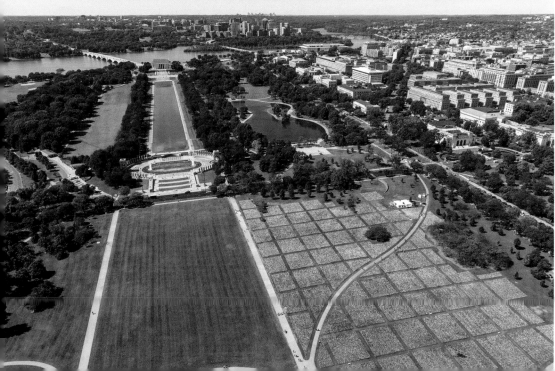

September 29, 2021: Approximately 690,000 flags are seen on the National Mall as part of an art installation to honor American lives lost to COVID-19. (Yash Mori)

(Adam Schultz, 2021)

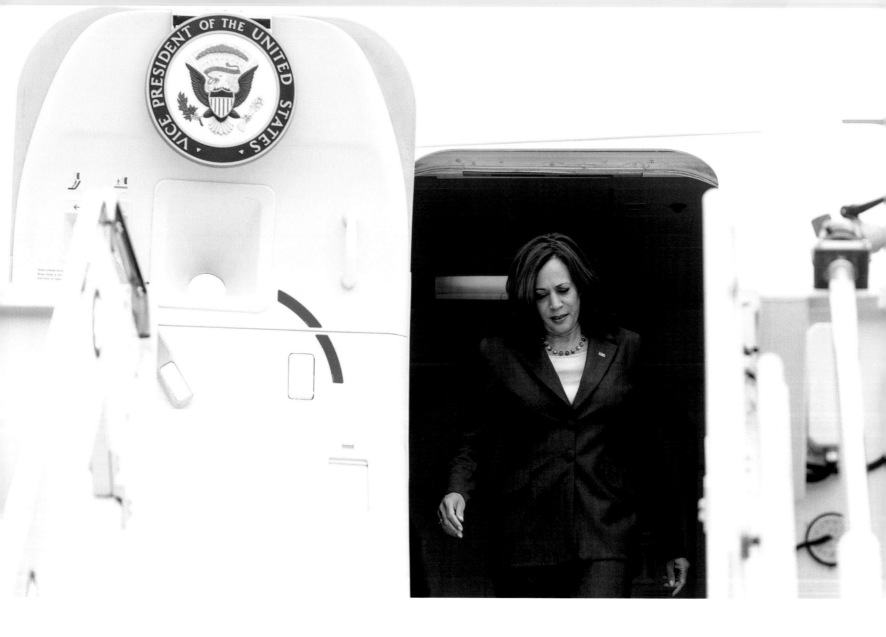

July 12, 2021: Disembarking Air Force Two at Detroit Metro Airport in Detroit, Michigan. (Lawrence Jackson)

November 8, 2021: Signing two bills in her West Wing Office of the White House. (Lawrence Jackson)

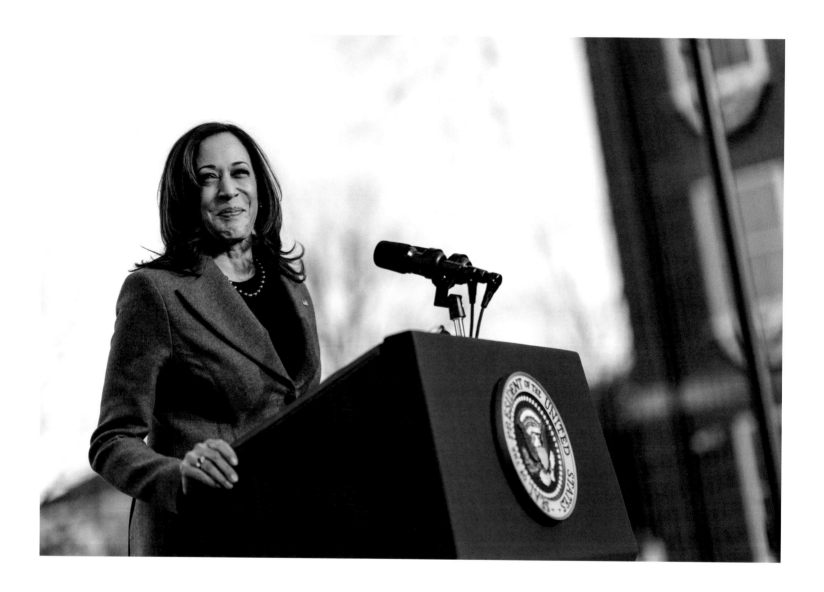

January 11, 2022: Delivering remarks on voting rights at Morehouse
College in Atlanta, Georgia. (Adam Schultz)

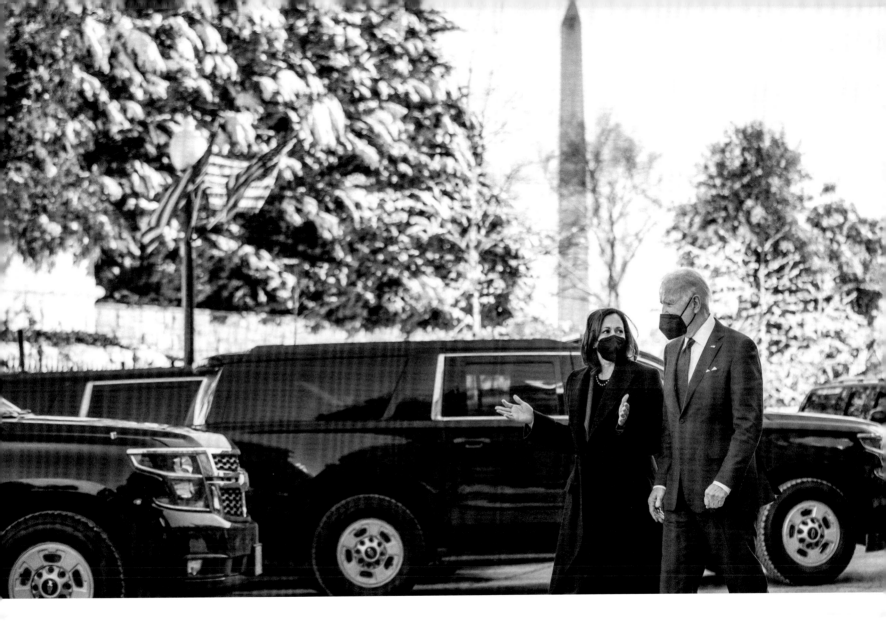

January 4, 2022: Walking across West Executive Avenue with former President Joe Biden on their way to the West Wing. (Adam Schultz)

January 31, 2022: Walking through the Red Room with former President Joe Biden after attending the National Governors Association Business Meeting at the White House. (Adam Schultz)

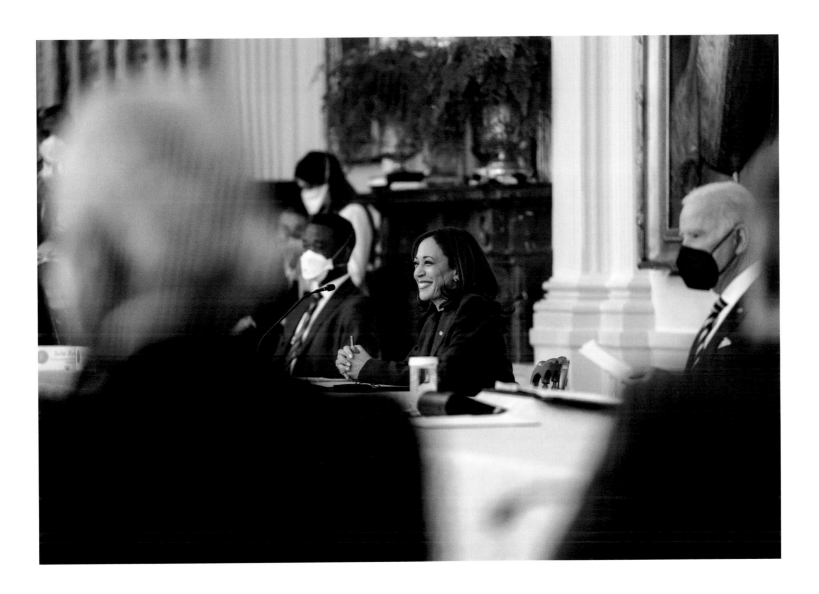

January 31, 2022: Attending the National Governors Association Business Meeting. (Adam Schultz)

Let us continue to fight with faith, with optimism, and with hope.

—At the Sigma Gamma Rho Sorority, Inc., 60th International Biennial Boule in Houston, Texas, July 31, 2024

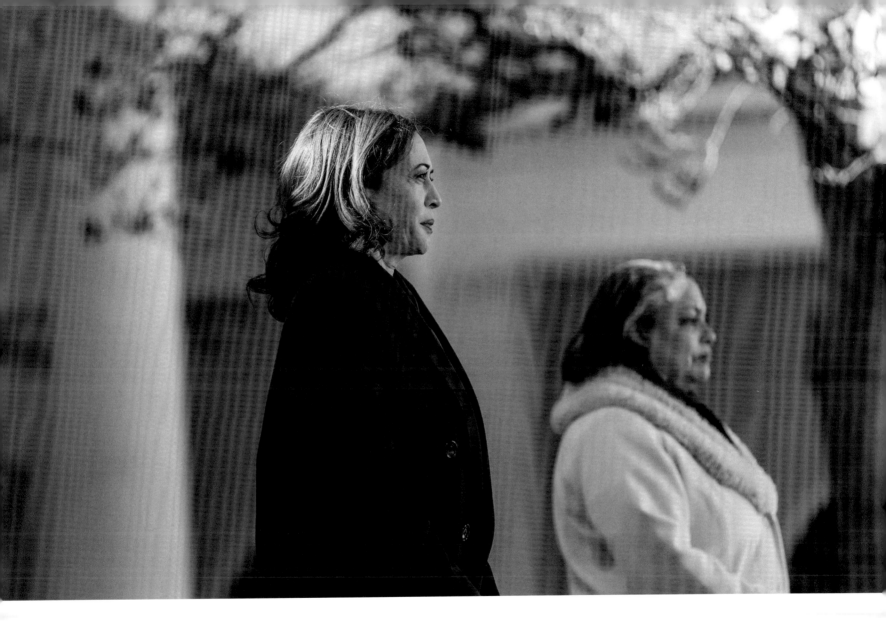

March 29, 2022: Standing alongside Michelle Duster, great-granddaughter of civil rights pioneer Ida B. Wells, and looking on as former President Joe Biden speaks after signing H.R. 55, the Emmett Till Antilynching Act, in the White House Rose Garden. (Cameron Smith)

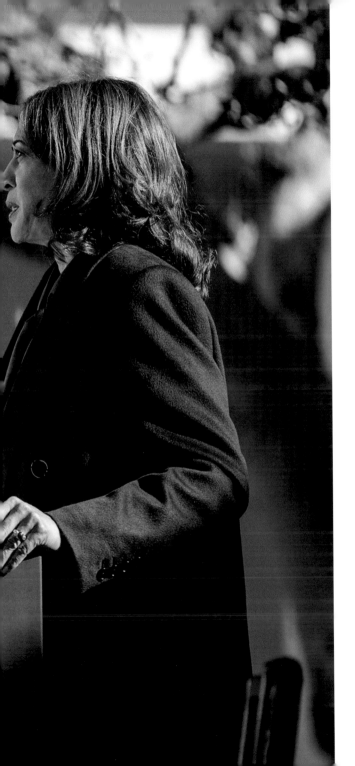

March 29, 2022: Speaking after former President Joe Biden signed the Emmett Till Antilynching Act, in the White House Rose Garden. (Carlos Fyfe)

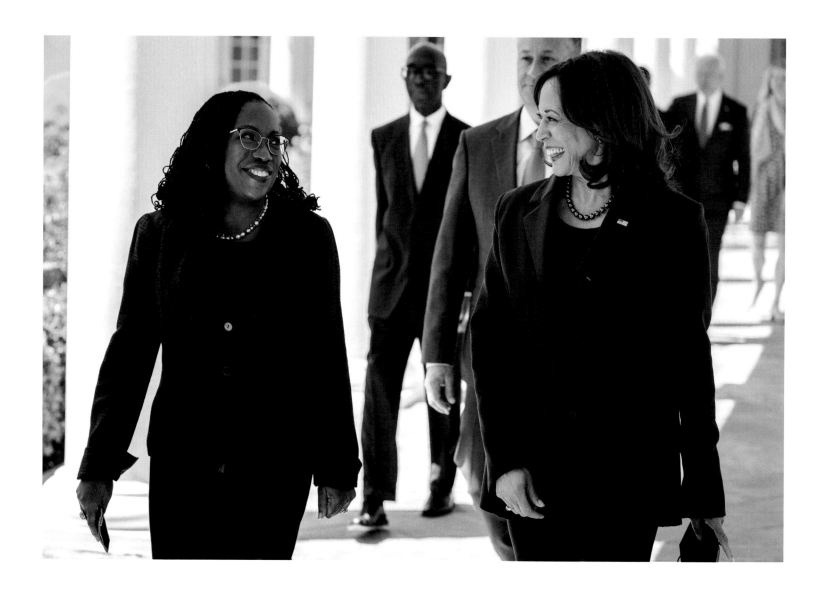

April 8, 2022: Walking along the West Colonnade of the White House with Justice Ketanji Brown Jackson on their way to an event to celebrate Jackson's confirmation to the Supreme Court. (Adam Schultz)

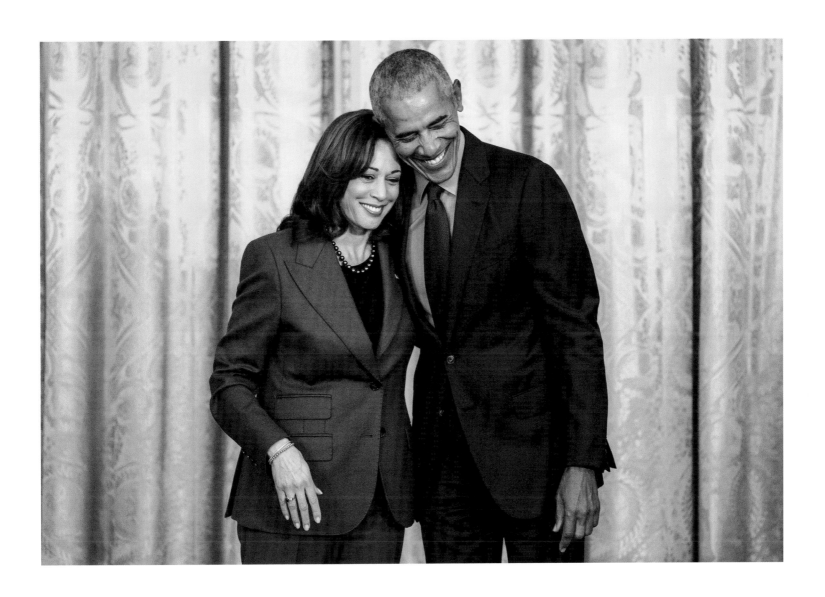

April 5, 2022: Hugging former President Barack Obama during an Affordable Care Act event. (Adam Schultz)

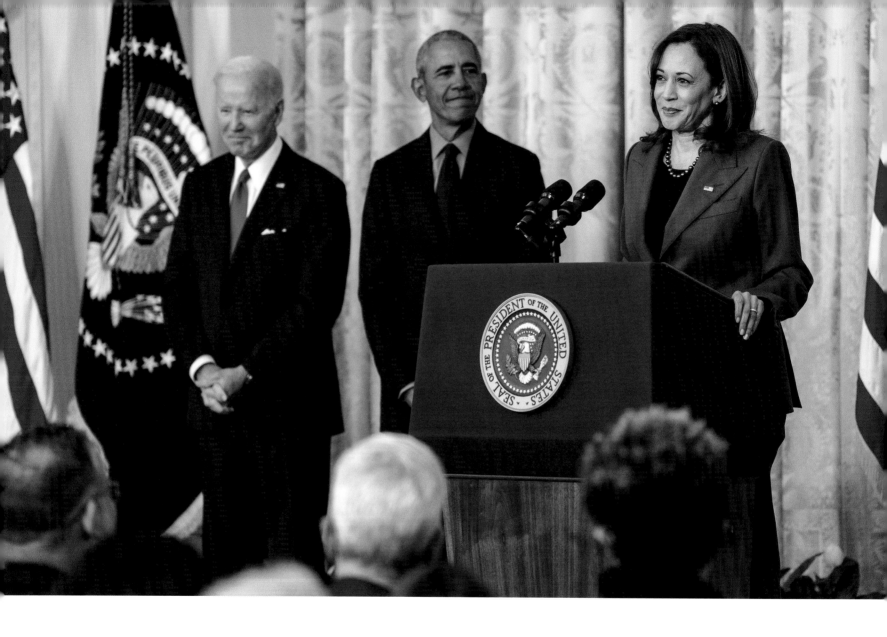

April 5, 2022: Delivering remarks on the Affordable Care Act as former Presidents Joe Biden and Barack Obama look on. (Adam Schultz)

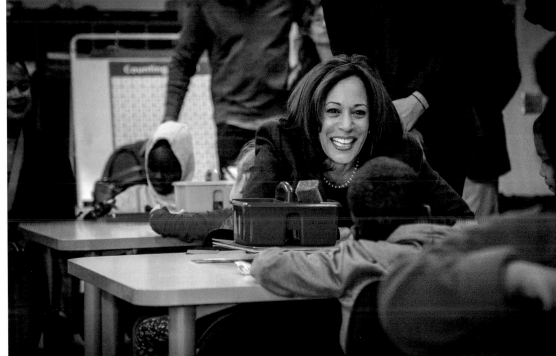

October 7, 2019: Paying a visit to King Elementary School in Des Moines, Iowa, during the first Biden–Harris campaign, where she spent time with a kindergarten class as they were learning the sounds and shapes of letters and met with teachers and staff. (Phil Roeder)

Years from now, our children and our grandchildren, they will ask us about this moment. They will look back on this time and they will ask us not about how we felt. They will ask us, what did we do?

—At Atlanta University Center Consortium in Atlanta, Georgia, January 11, 2022

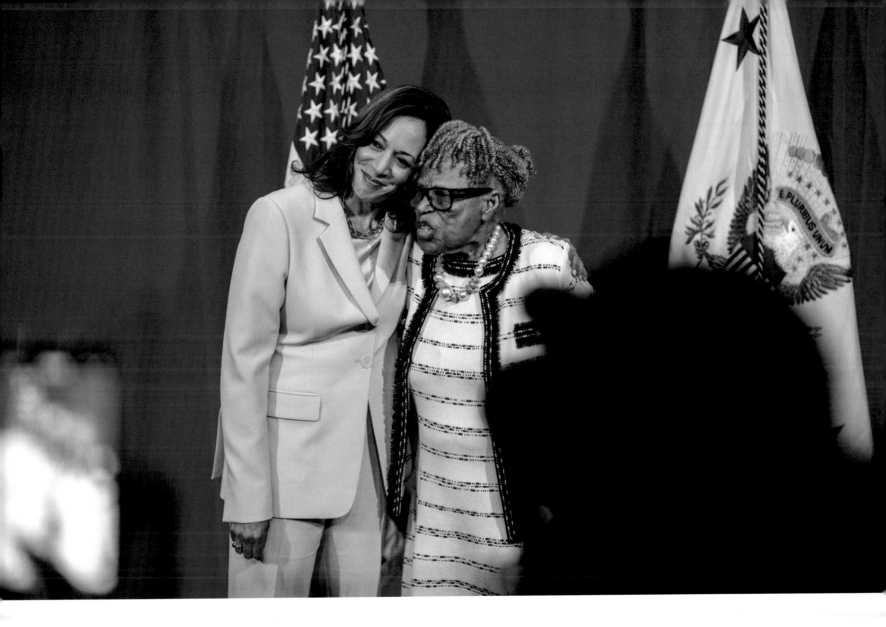

July 24, 2024: Greeting Opal Lee, "Grandmother of Juneteenth," during a photo line at the Zeta Phi Beta Sorority, Inc., Grand Boule at the Indiana Convention Center in Indianapolis, Indiana. (Lawrence Jackson)

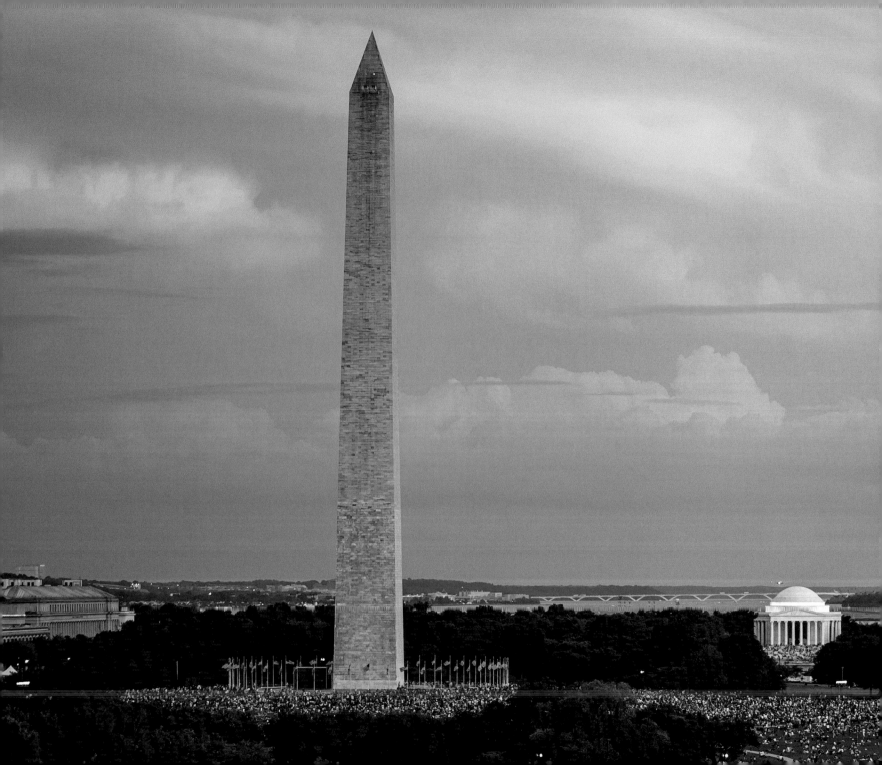

(Carlos M. Vazquez II, 2023)

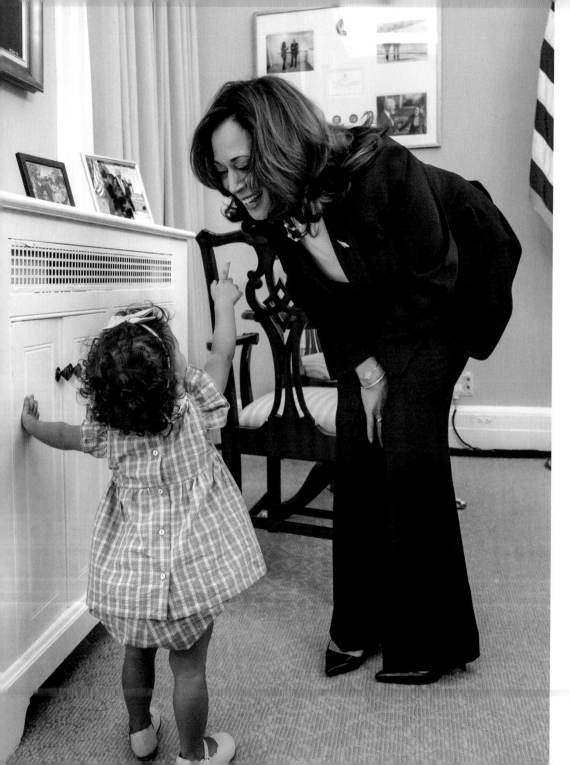

June 20, 2024: Greeting the young daughter of model and TV personality Chrissy Teigen and musician John Legend during their visit with Harris, in her West Wing Office of the White House. (Carlos Fyfe)

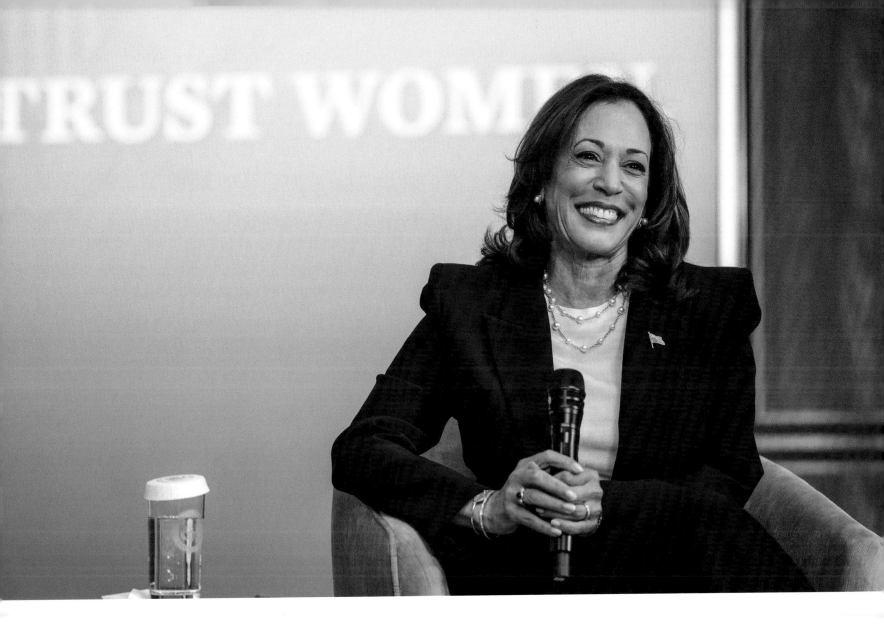

June 20, 2024: Participating in a moderated conversation on reproductive rights with Chrissy Teigen in the South Court Auditorium of the Eisenhower Executive Office Building at the White House. (Carlos Fyfe)

(Carlos Fyfe, 2024)

I strongly believe the status of women is the status of democracy, the exclusion of women in decision-making is a marker of a flawed democracy, and the full participation of women strengthens democracy.

—At the Summit for Democracy at the Eisenhower Executive Office Building at the White House, December 9, 2021

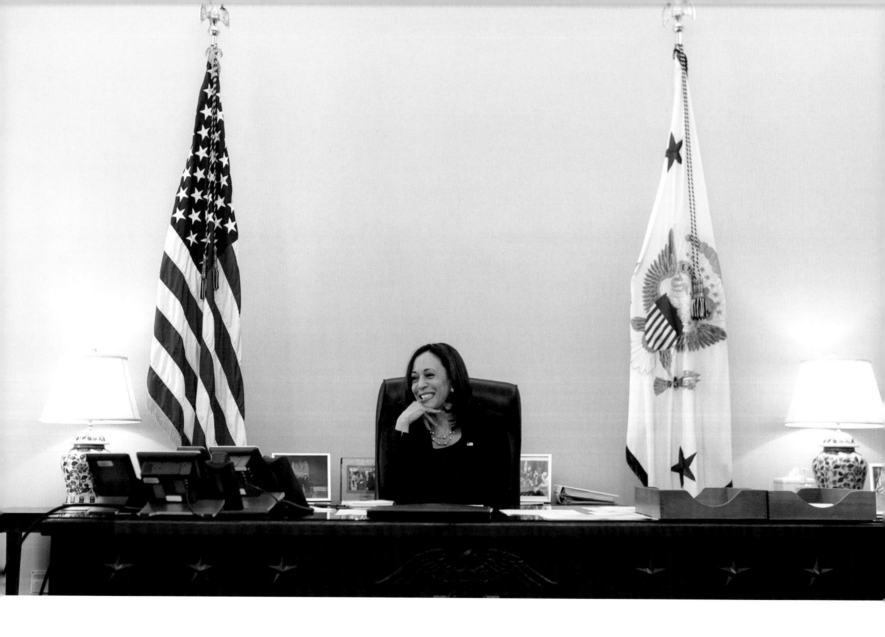

May 20, 2021: Participating in a head-of-state call with King Abdullah II of Jordan, in her West Wing Office of the White House. (Lawrence Jackson)

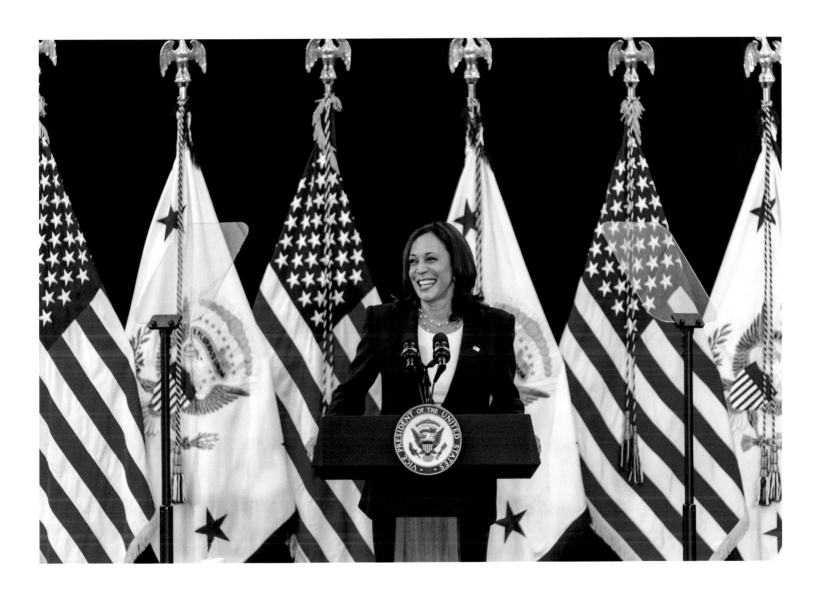

July 3, 2021: Delivering remarks at the Carpenters International Training Center in Las Vegas, Nevada. (Cameron Smith)

We are clear: We cannot be strong abroad if we are not strong at home.

—At the Munich Security Conference in Munich, Germany, February 16, 2024

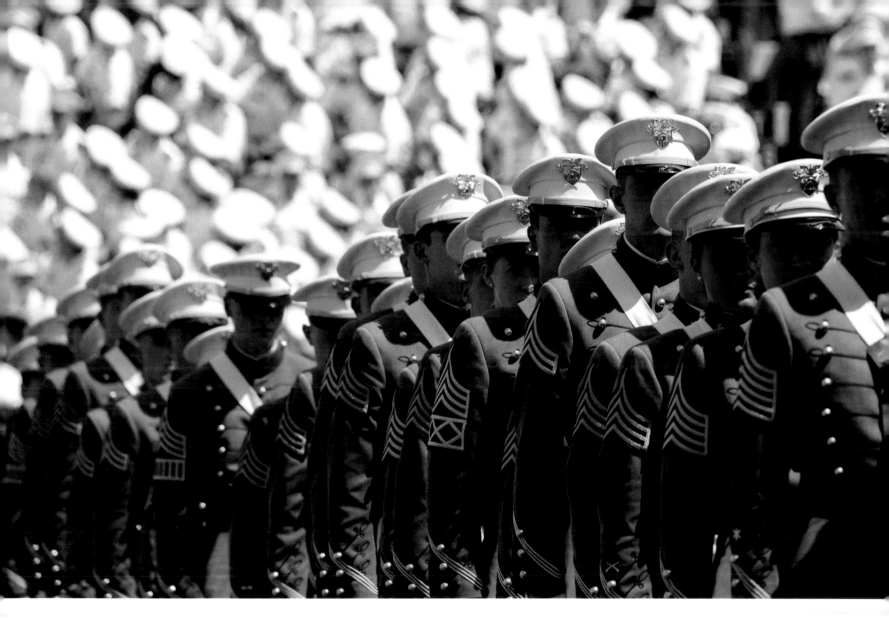

May 25, 2024: Cadets stand during a commencement ceremony for the U.S. Military Academy class of 2024 in West Point, New York. (Erin Scott)

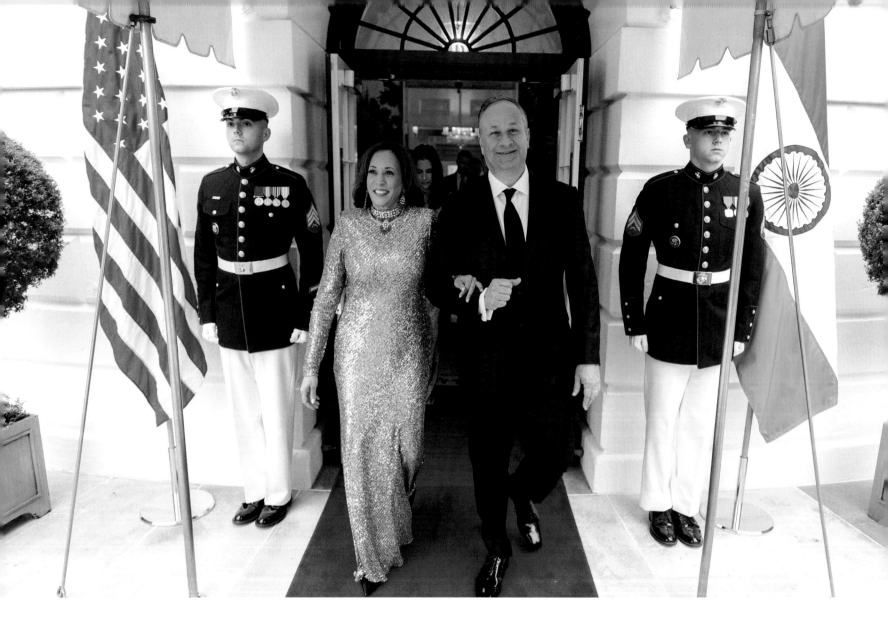

June 22, 2023: Harris and her husband, Doug Emhoff, on their way to the
State Dinner for Prime Minister Narendra Modi of India. (Lawrence Jackson)

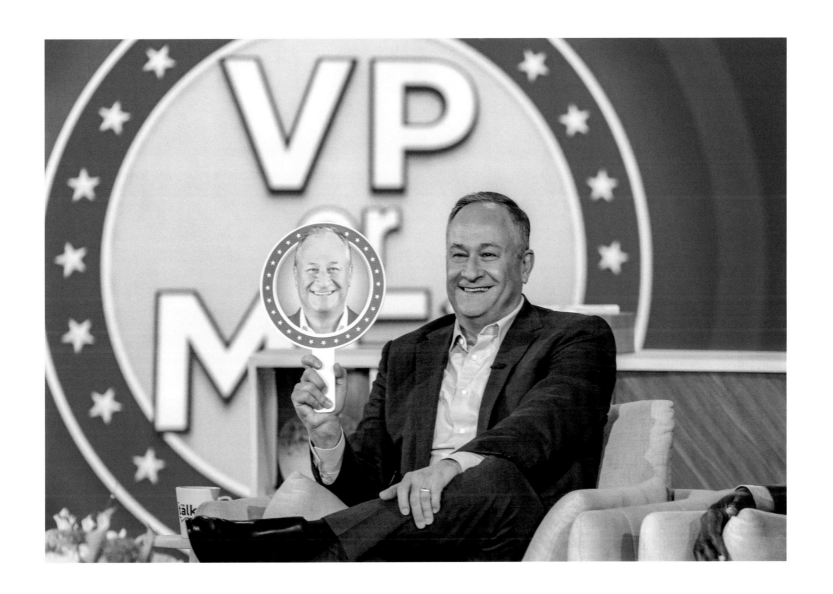

March 12, 2024: Harris's husband, Doug Emhoff, participating in a live interview on *The Talk*. (Katie Ricks)

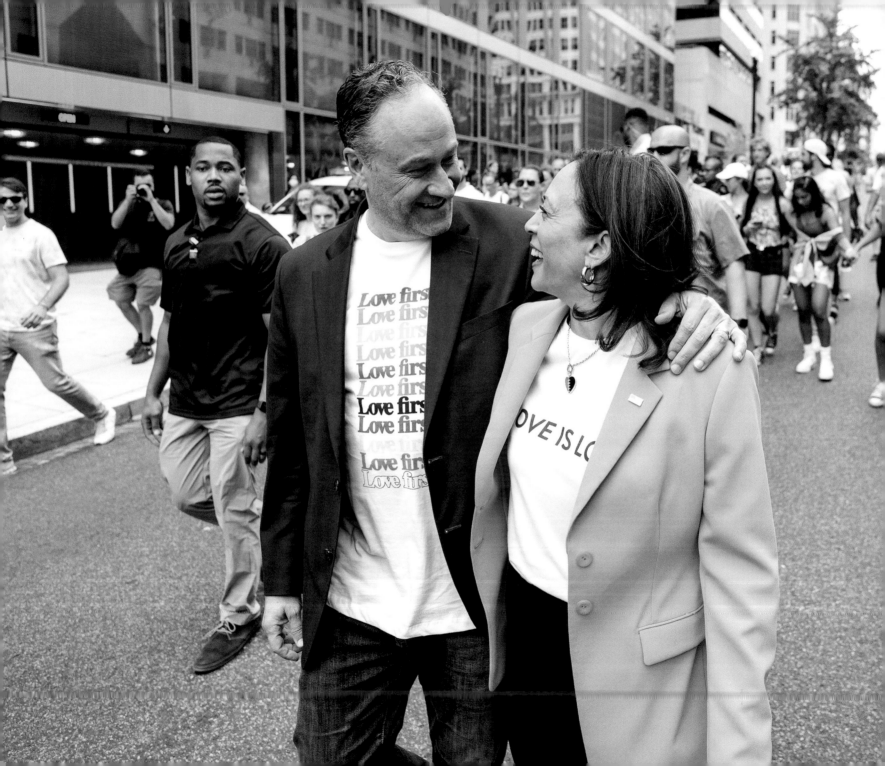

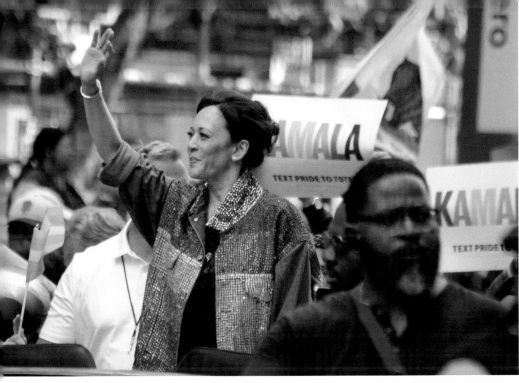

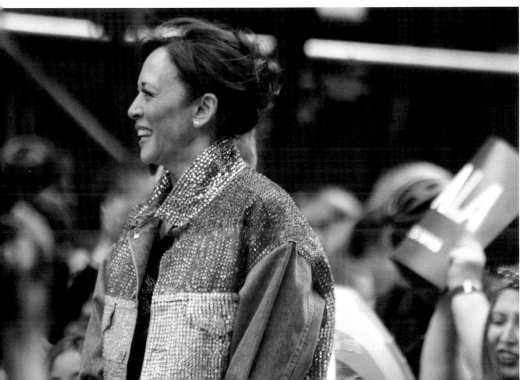

June 30, 2019: At San Francisco Pride, six weeks before former President Joe Biden selected her as his vice presidential pick. (Quinn Dombrowski)

Opposite: June 12, 2021: Participating with her husband, Doug Emhoff, in the Capital Pride Walk and Rally in Washington, D.C. (Lawrence Jackson)

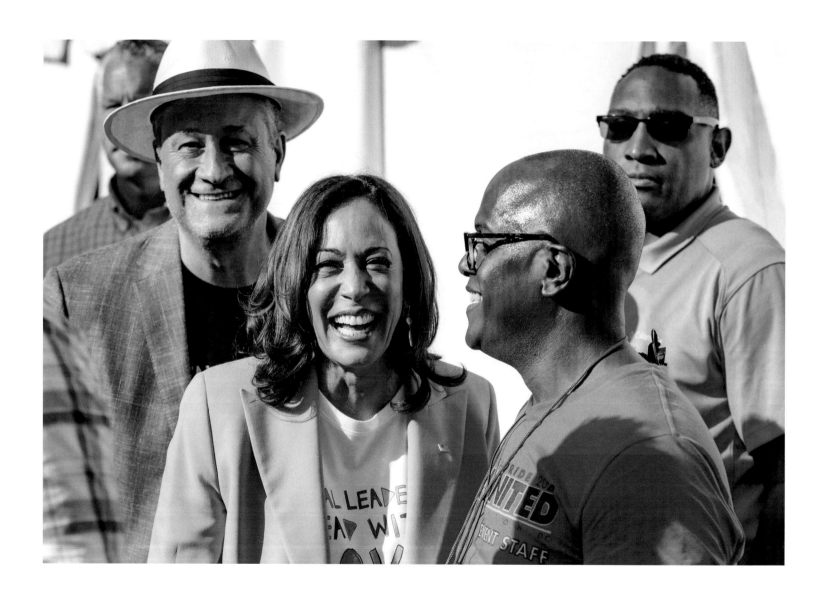

June 12, 2022: At the Capital Pride Festival and
Concert in Washington, D.C. (Ted Eytan)

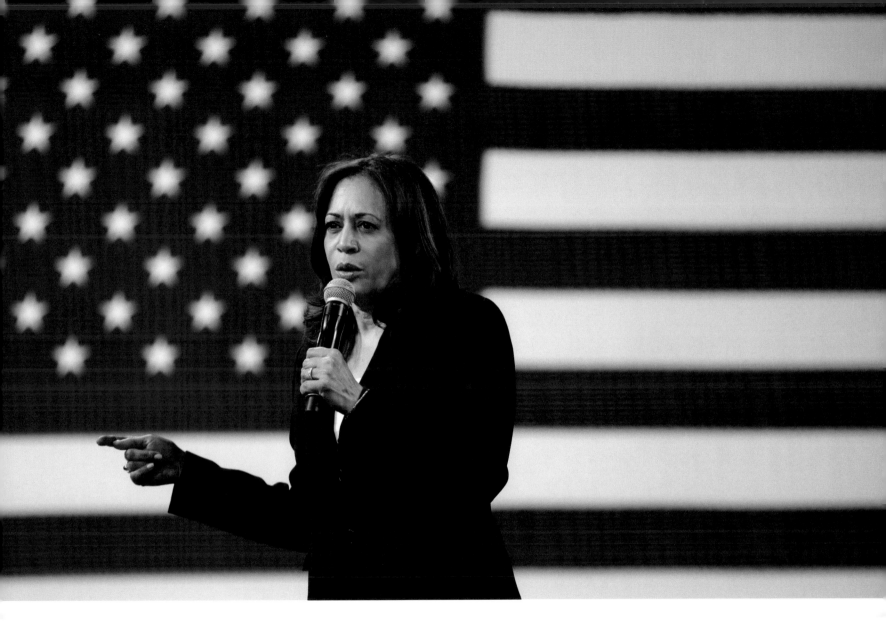

April 27, 2019: Speaking at the 2019 National Forum on Wages and Working People, hosted by the Center for American Progress Action Fund and the Service Employees International Union (SEIU), in Las Vegas, Nevada, during the first Biden–Harris campaign. (Gage Skidmore)

We will fight to safeguard our democracy.
We will fight to secure our most fundamental
freedom: the freedom to vote.

—At Atlanta University Center Consortium in
Atlanta, Georgia, January 11, 2022

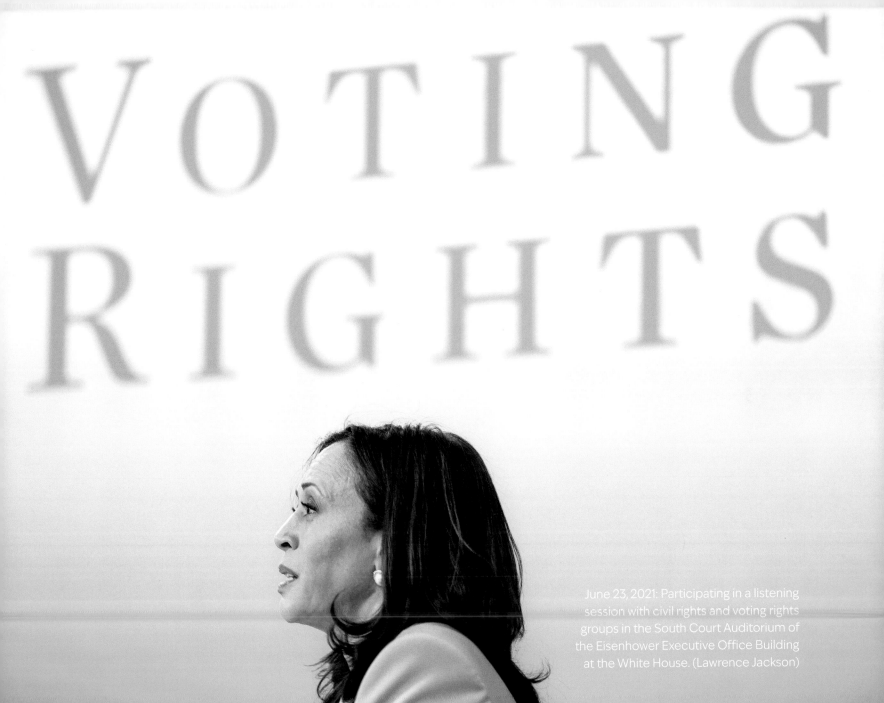

VOTING
RIGHTS

June 23, 2021: Participating in a listening session with civil rights and voting rights groups in the South Court Auditorium of the Eisenhower Executive Office Building at the White House. (Lawrence Jackson)

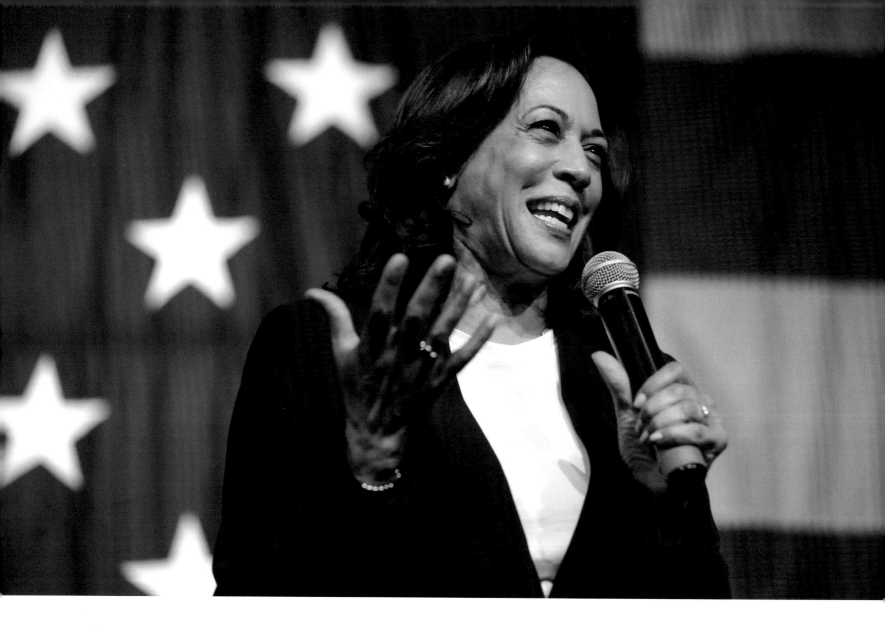

August 9, 2019: Speaking at the 2019 Iowa Democratic Wing Ding in Clear Lake, Iowa, during the first Biden–Harris campaign. (Gage Skidmore)

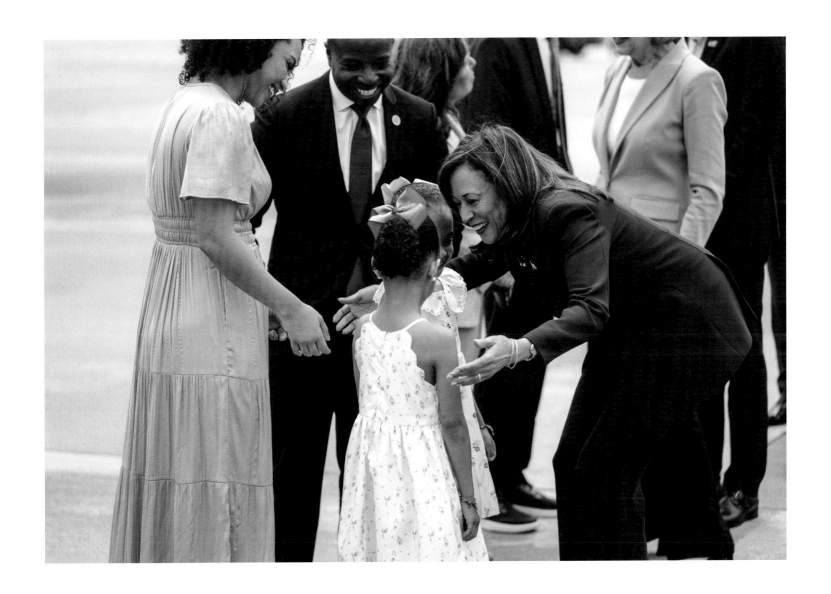

July 23, 2024: Greeting Milwaukee County Executive David Crowley (D-Wis.) and Mrs. Ericka Crowley, along with their daughters, at Milwaukee Mitchell International Airport in Milwaukee, Wisconsin. (Lawrence Jackson)

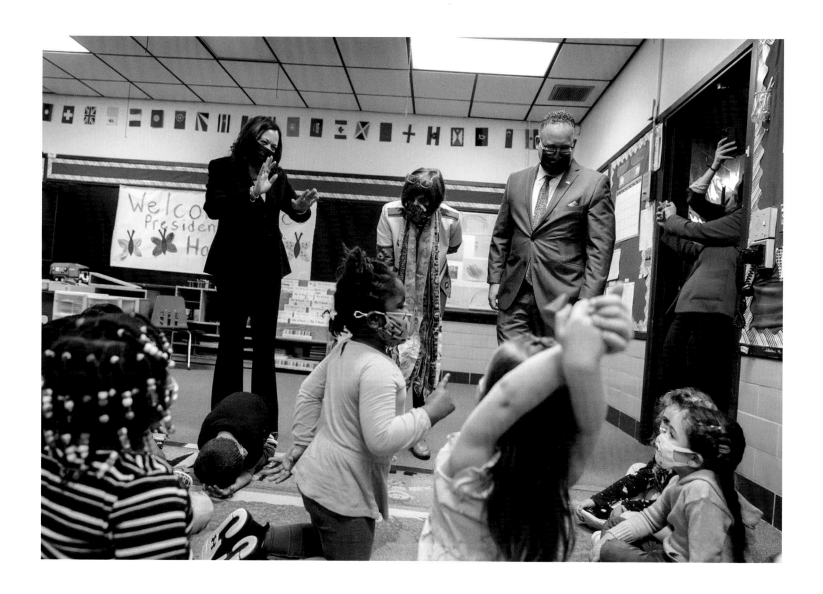

March 26, 2021: Visiting a classroom at the West Haven Child Development Center in West Haven, Connecticut. (Lawrence Jackson)

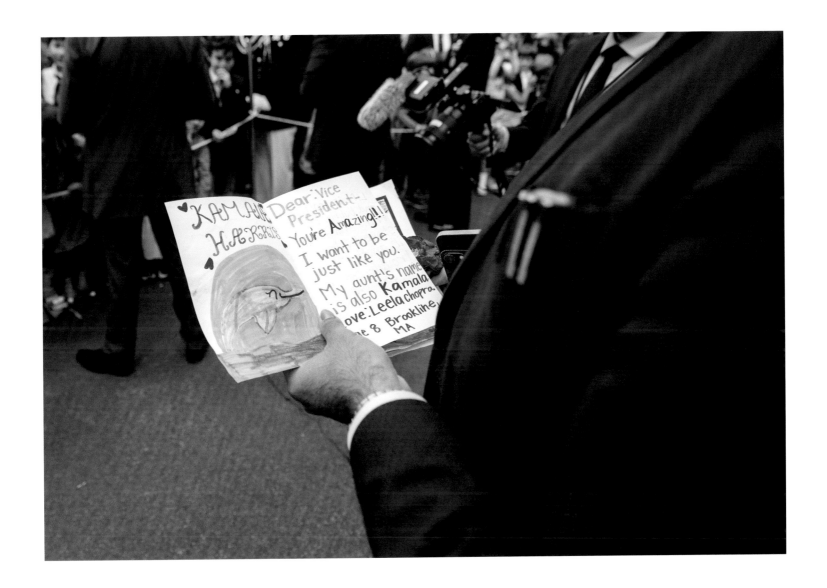

April 25, 2024: A member of the White House staff holds a note that a child gave to Harris at a Take Your Child to Work Day event on the South Lawn of the White House. (Lawrence Jackson)

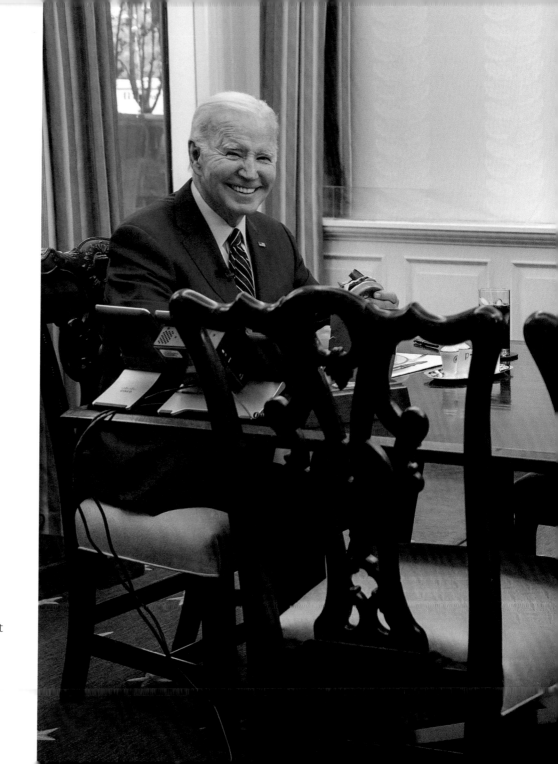

January 17, 2023: Harris and former President Joe Biden eat takeout for lunch in the Oval Office Dining Room. (Adam Schultz)

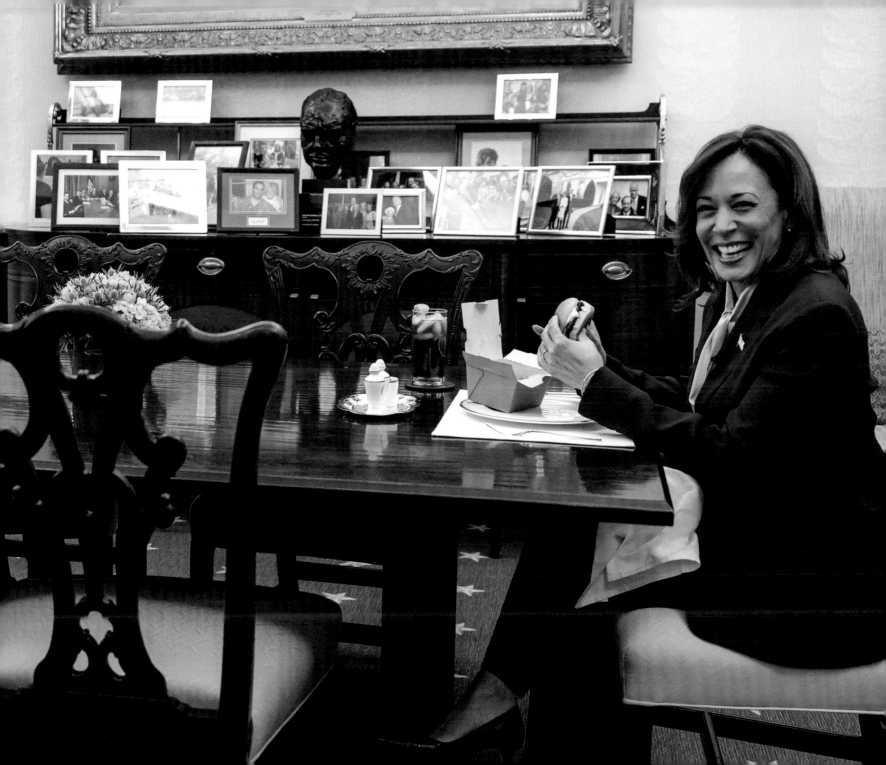

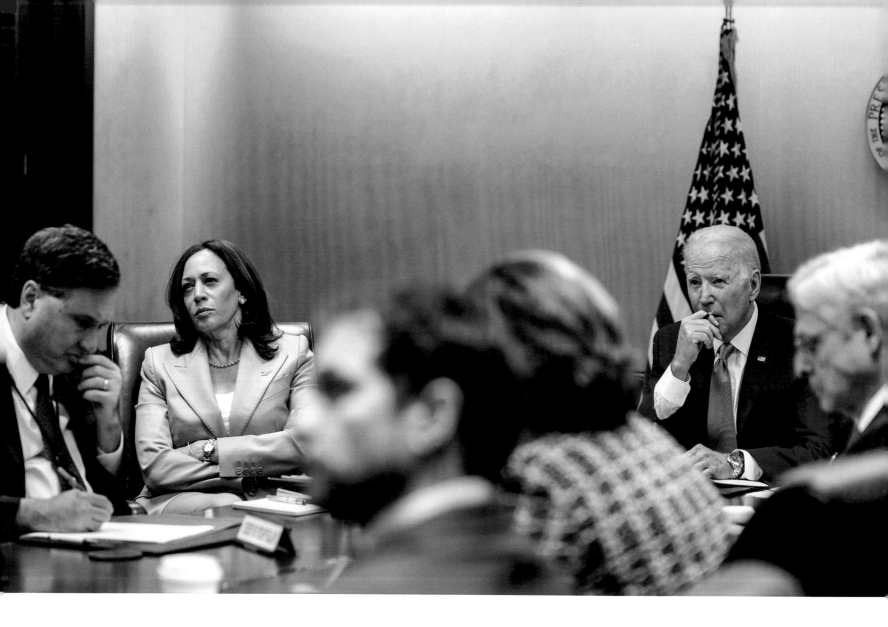

July 7, 2021: At a national security cyber briefing to discuss efforts to counter ransomware, in the White House Situation Room. (Cameron Smith)

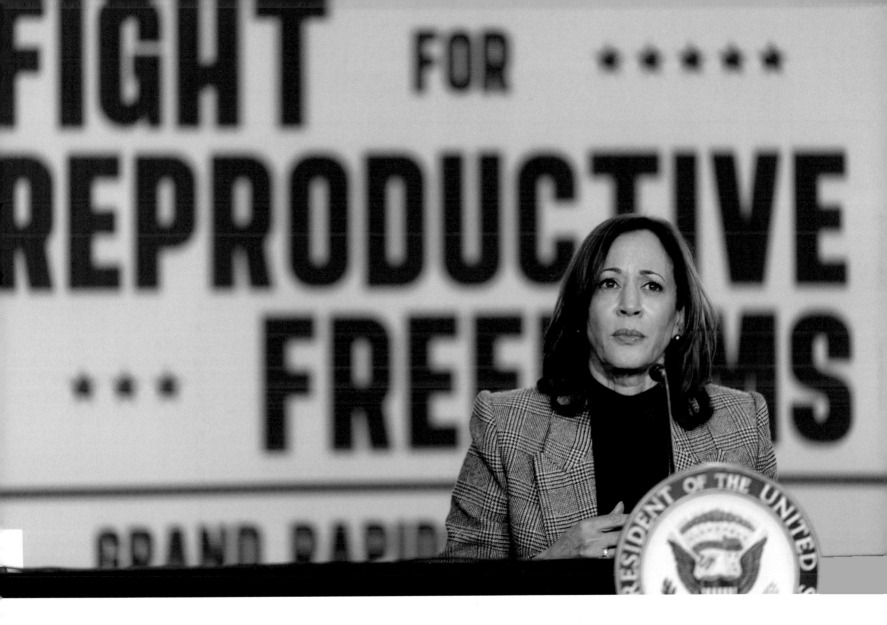

February 22, 2024: Participating in a roundtable conversation at a Fight for Reproductive Freedoms Tour stop at Fountain Street Church in Grand Rapids, Michigan. (Lawrence Jackson)

(Adam Schultz, 2022)

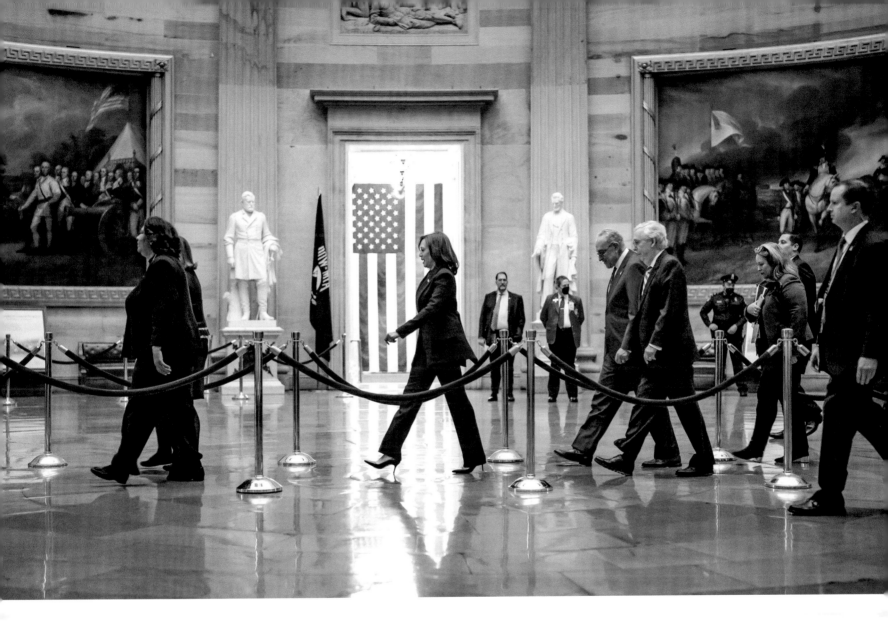

February 7, 2023: Participating in the Senate procession to the House Chamber for former President Joe Biden's State of the Union Address at the U.S. Capitol in Washington, D.C. (Lawrence Jackson)

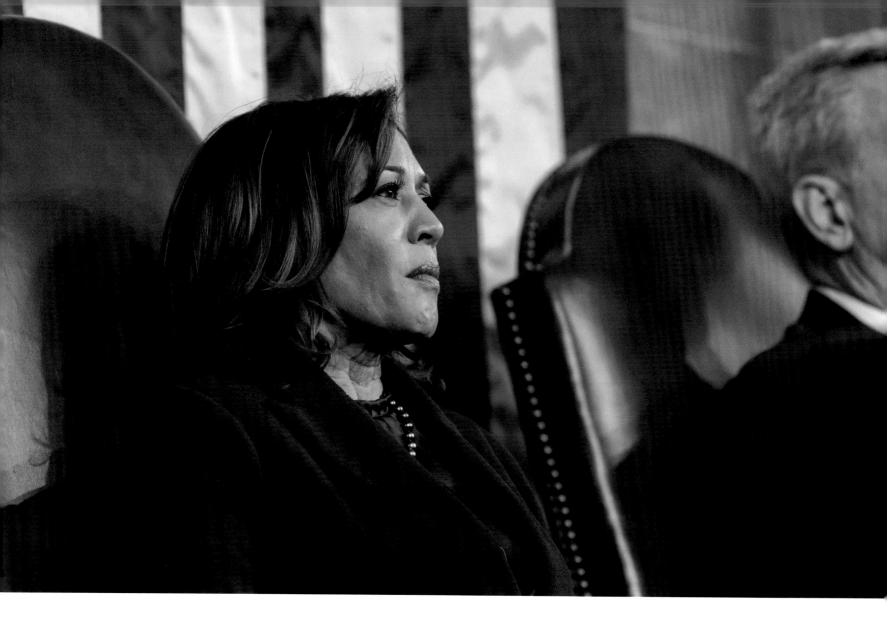

February 7, 2023: Listening as former President Joe Biden delivers his State of the Union Address on the House floor of the U.S. Capitol in Washington, D.C. (Adam Schultz)

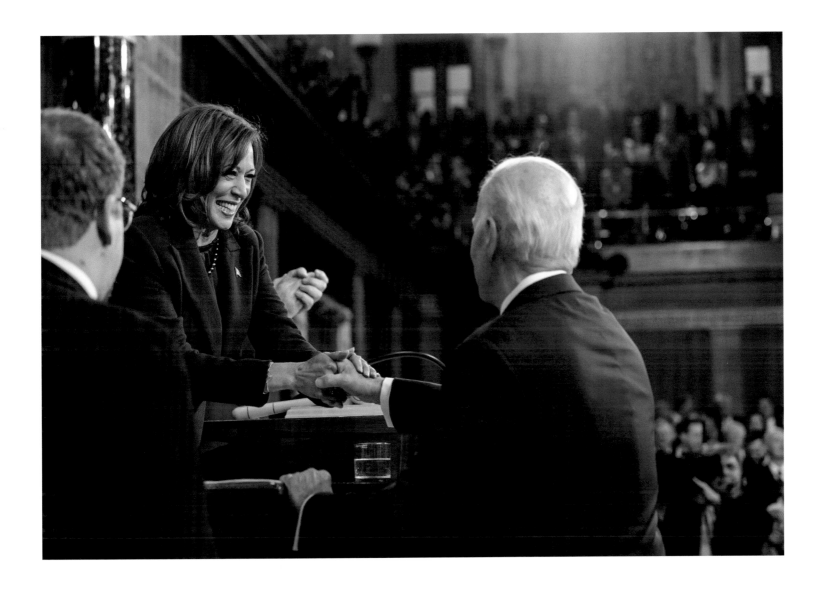

February 7, 2023: Greeting former President Joe Biden as he arrives to deliver his State of the Union Address on the House floor of the U.S. Capitol in Washington, D.C. (Adam Schultz)

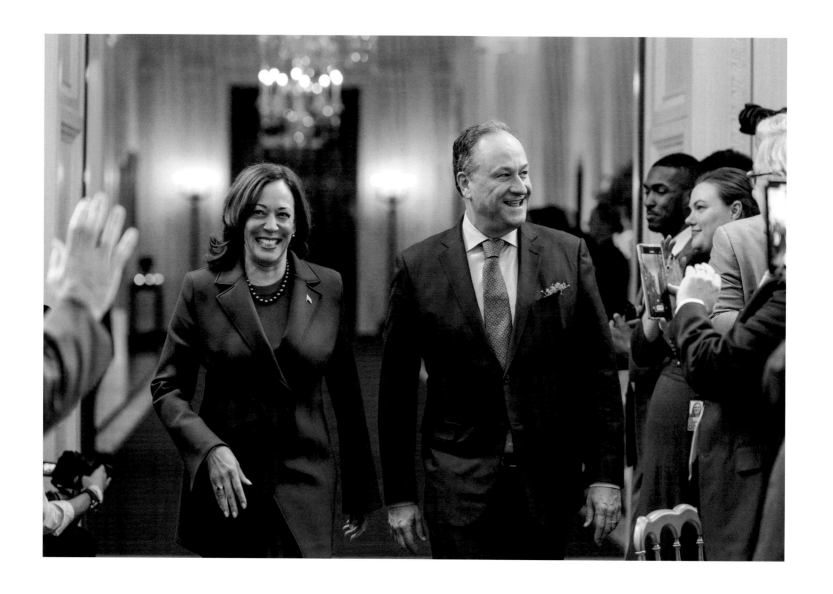

March 17, 2023: Arriving at a St. Patrick's Day reception with her husband, Doug Emhoff. (Cameron Smith)

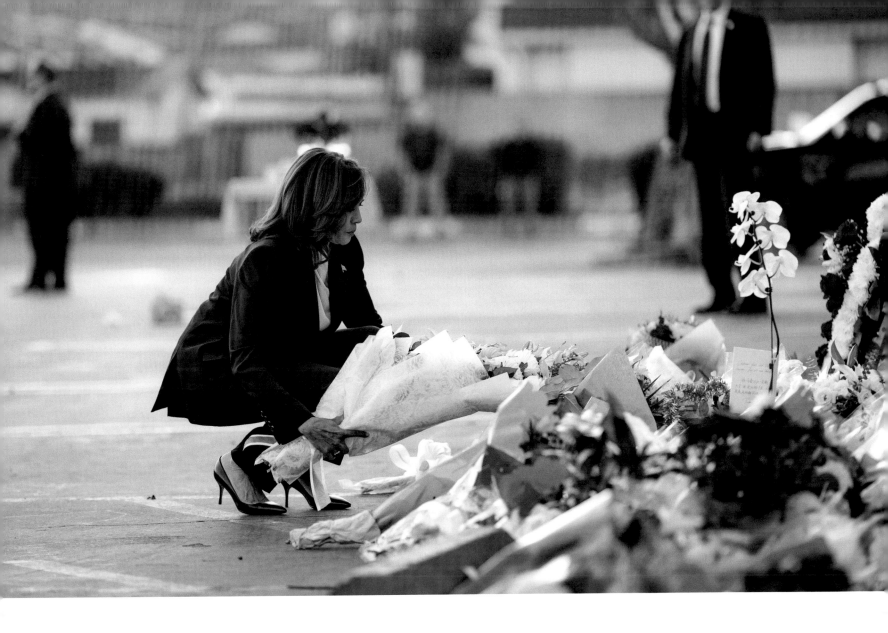

January 25, 2023: Visiting the memorial outside a dance studio in Monterey Park, California, where a mass shooting took place on Lunar New Year's Eve. (Lawrence Jackson)

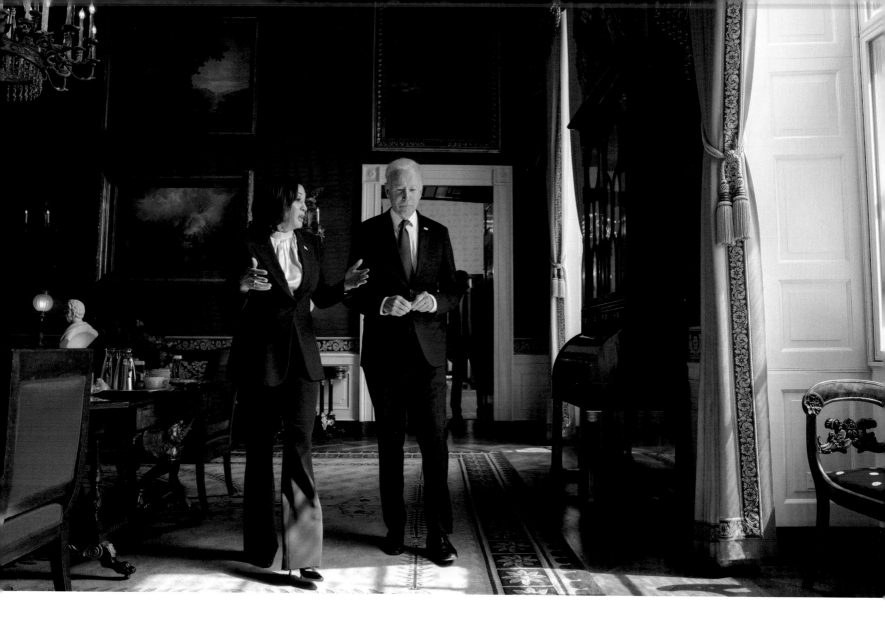

March 23, 2023: Talking with former President Joe Biden in the Red Room of the White House after an event celebrating the 13th anniversary of the Affordable Care Act. (Adam Schultz)

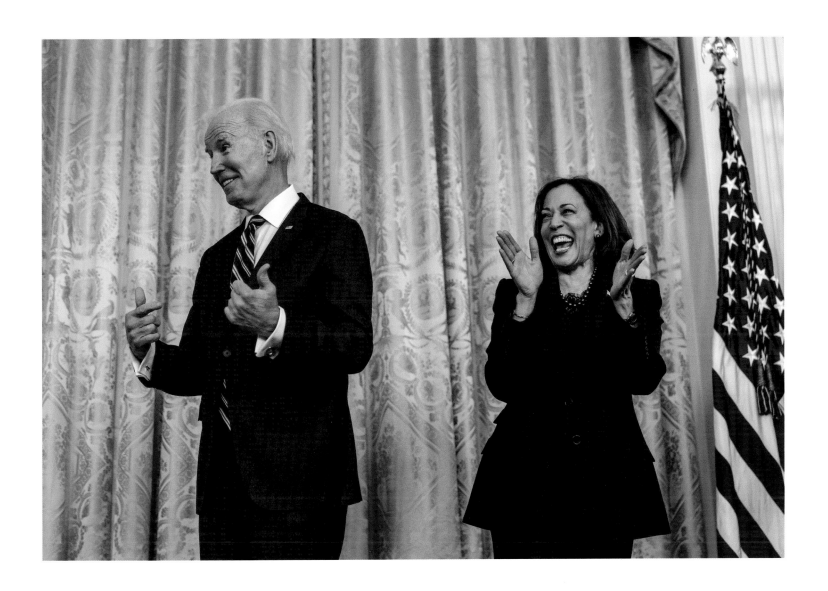

February 27, 2023: Cheering with former President Joe Biden while high school senior and youth leader DuWayne Portis Jr. delivers remarks at a Black History Month reception in the East Room of the White House. (Adam Schultz)

Part of true patriotism means fighting for a nation that will be better for each generation to come.

—To the Florida State Board of Education in Jacksonville, Florida, July 21, 2023

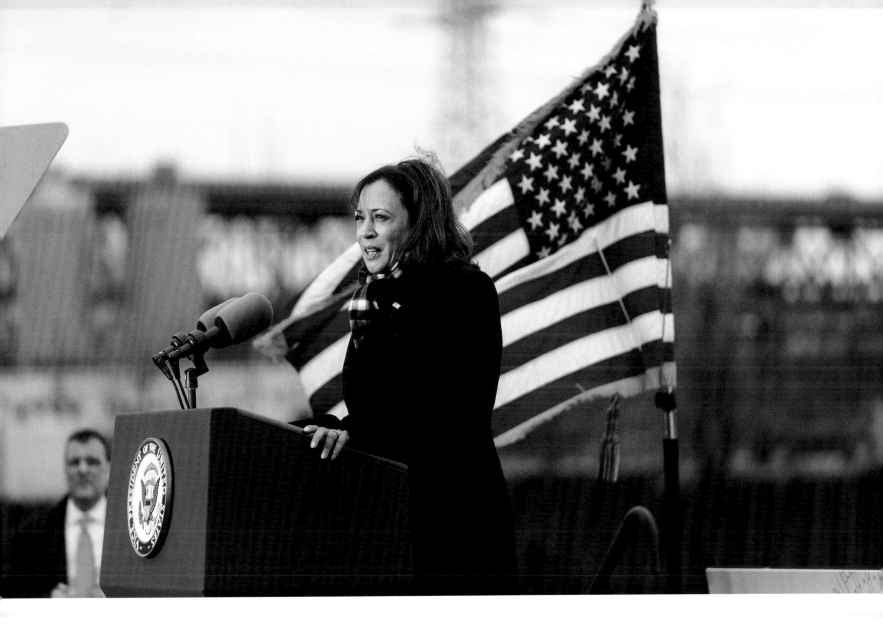

January 4, 2023: Delivering remarks on the Bipartisan Infrastructure Law and giving an announcement on bridge funding at Crowley's Yacht Yard in Chicago, Illinois. (Lawrence Jackson)

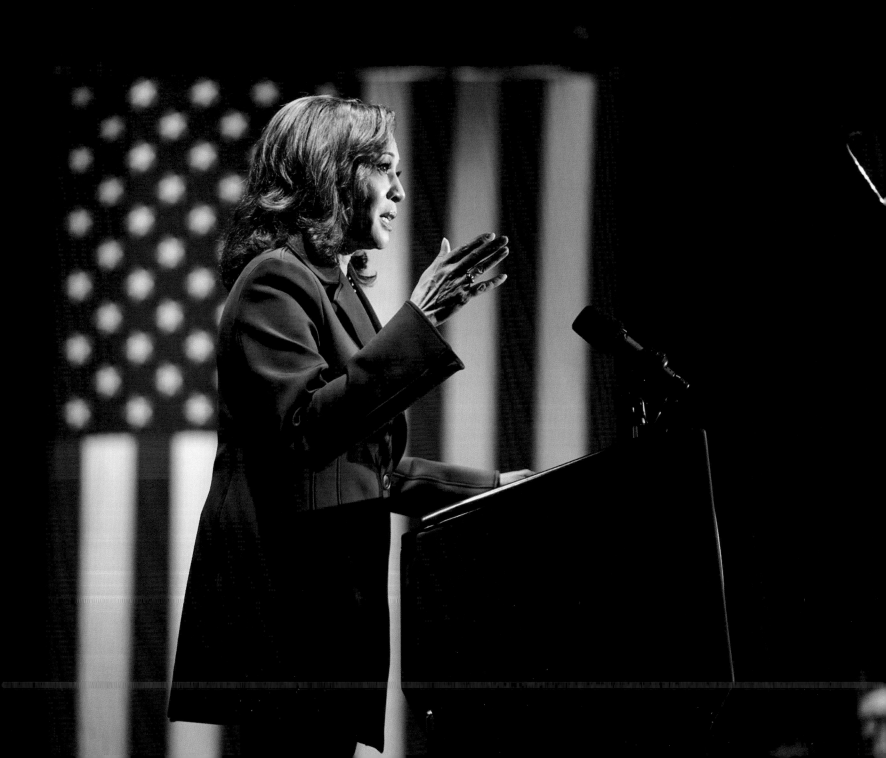

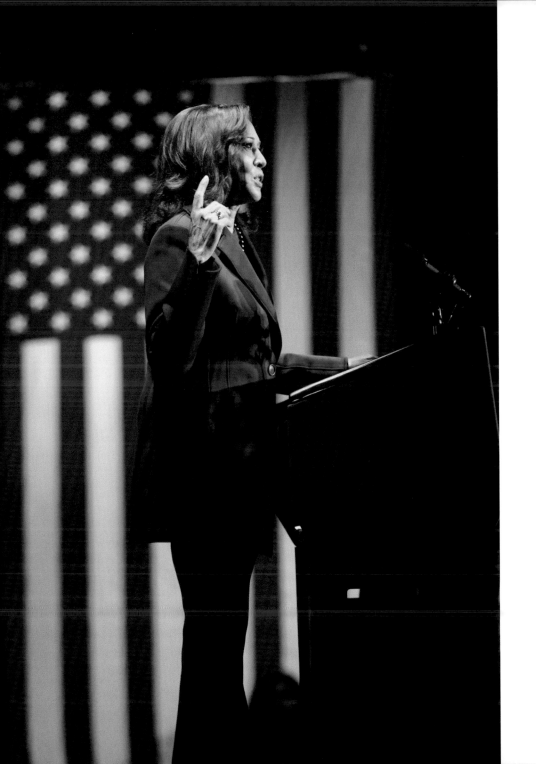

January 22, 2023: Delivering remarks at an event in honor of the 50th anniversary of *Roe v. Wade*, at the Moon, an event space in Tallahassee, Florida. (Lawrence Jackson)

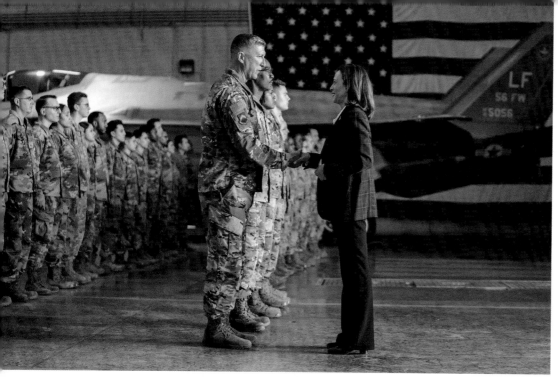

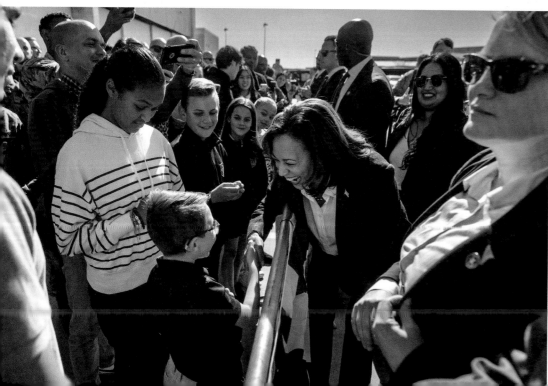

January 19, 2023: Greeting Luke Air Force Base personnel (*top and opposite*) and their families (*bottom*) in Maricopa County, Arizona. (Lawrence Jackson)

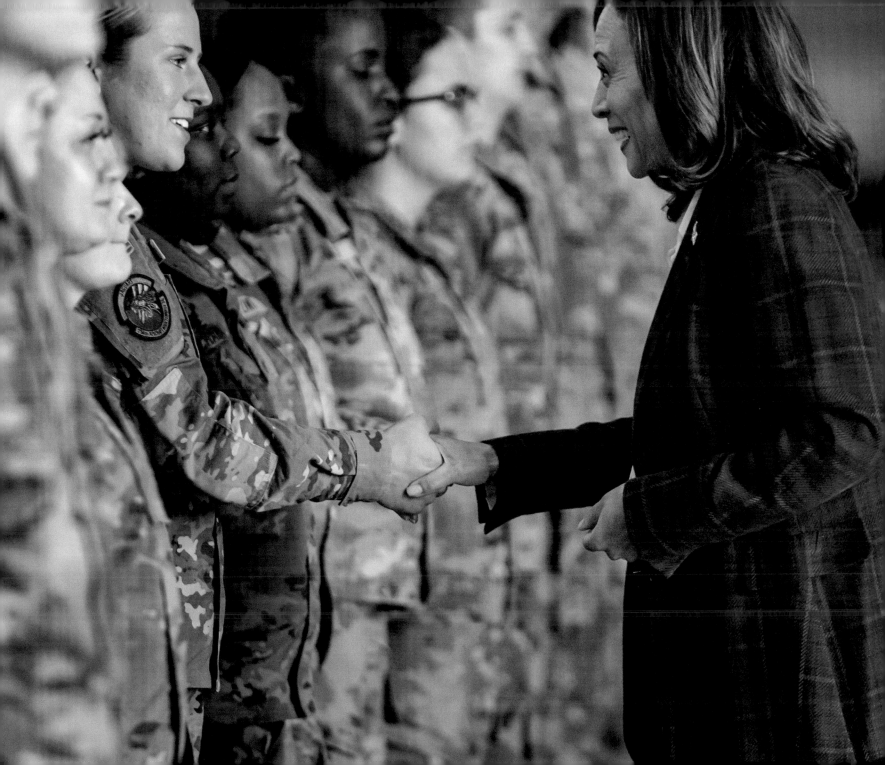

January 31, 2023: Reflecting for a moment before calling the family of Tyre Nichols, a man killed by Memphis police officers. (Lawrence Jackson)

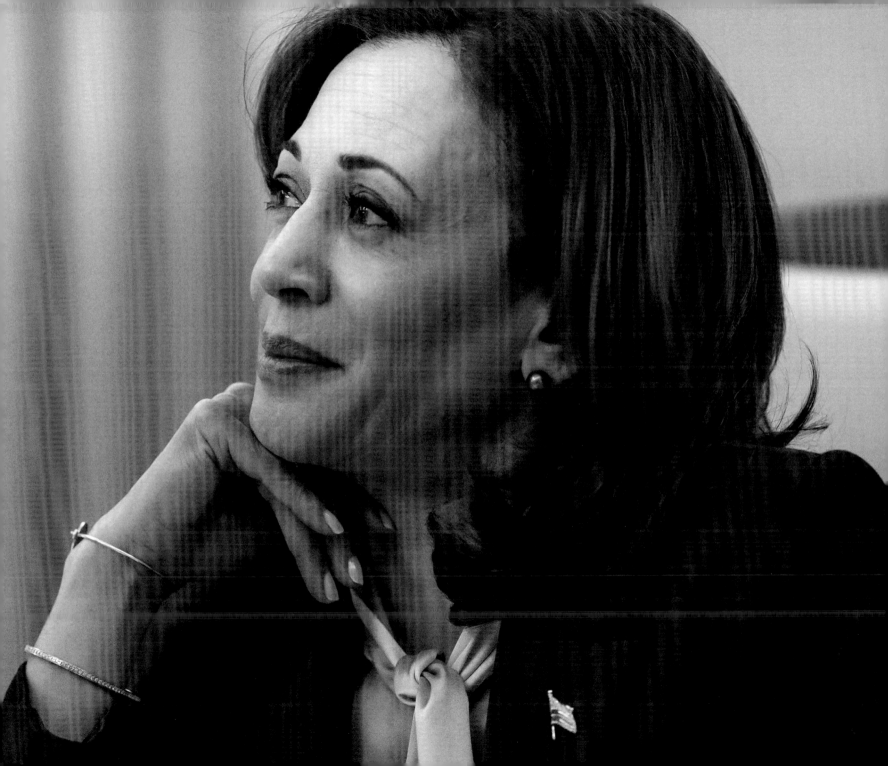

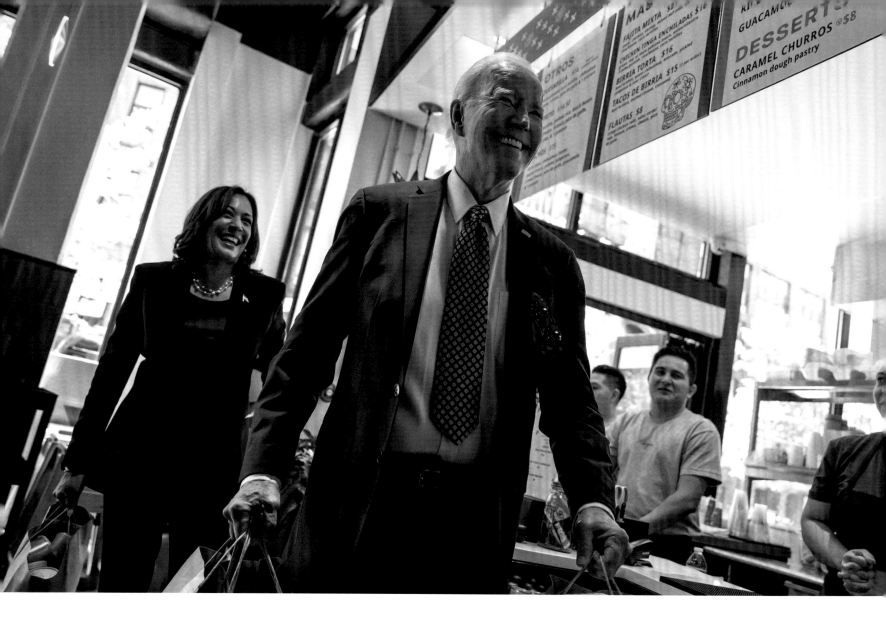

May 5, 2023: Picking up lunch from Taqueria Habanero with former
President Joe Biden in Washington, D.C. (Adam Schultz)

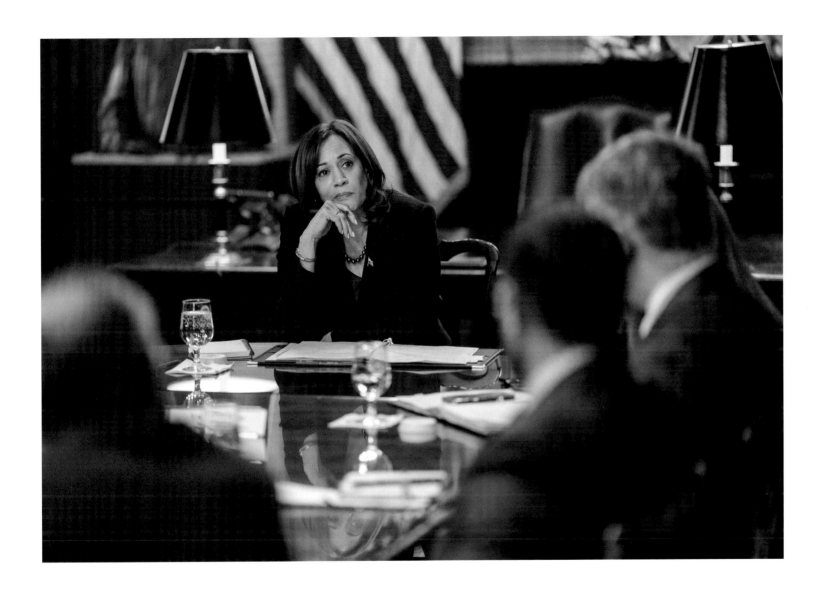

February 7, 2023: Holding a roundtable meeting with experts in the Eisenhower Executive Office Building at the White House. (Lawrence Jackson)

(Adam Schultz, 2022)

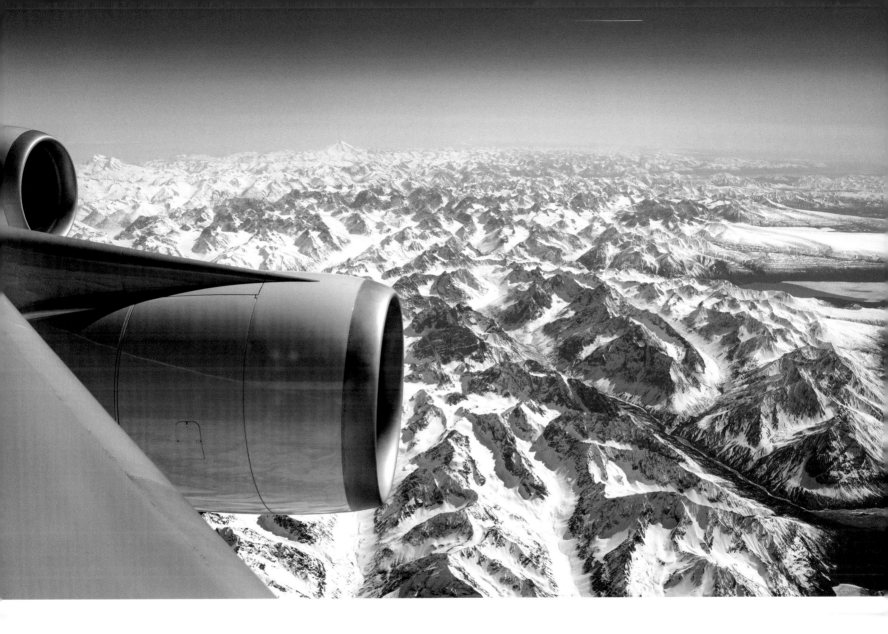

May 19, 2022: Mountains in Alaska are seen from on board Air Force One, en route to Osan Air Base in South Korea. (Adam Schultz)

(Cameron Smith, 2022)

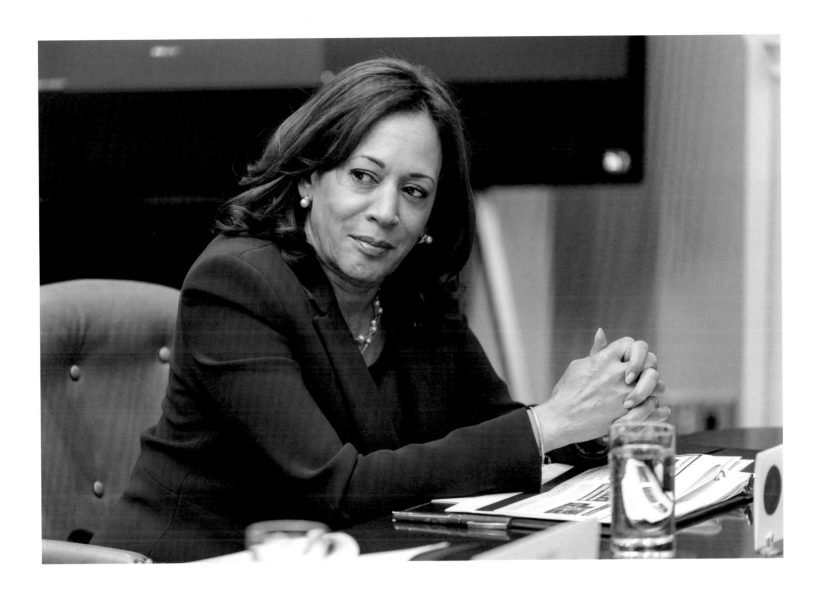

May 5, 2023: Attending a meeting with former President Joe Biden and the Investing in America Cabinet to discuss the Administration's economic agenda. (Adam Schultz)

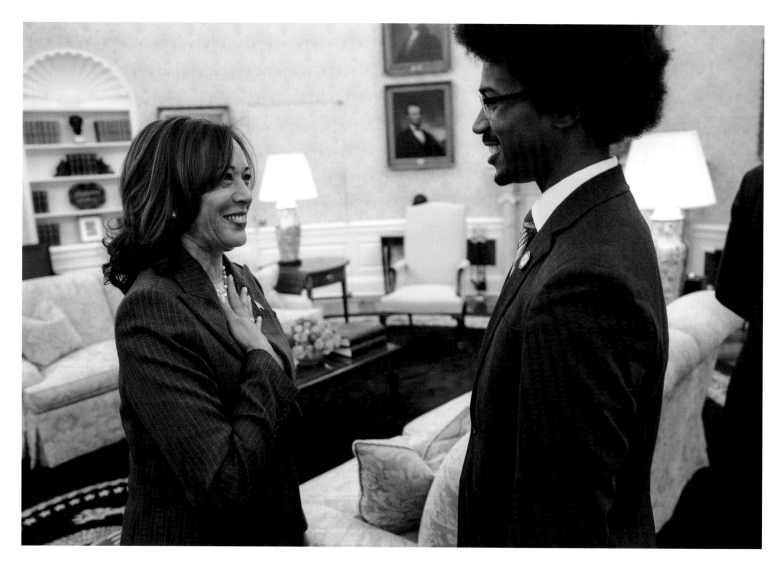

April 24, 2023: Meeting with Justin Pearson of the "Tennessee Three" in the Oval Office of the White House. Pearson and his fellow state legislator Justin Jones were expelled from Tennessee's House of Representatives after they, alongside another Tennessee state legislator, Gloria Johnson, participated in gun control demonstrations on the House floor. Pearson and Jones were later reinstated. (Adam Schultz)

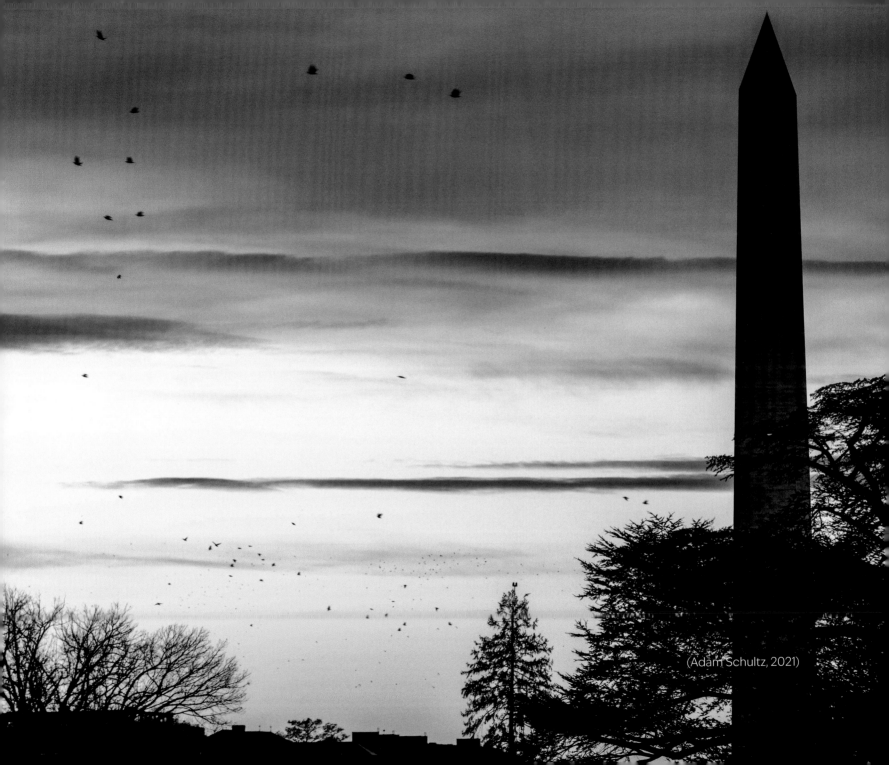

(Adam Schultz, 2021)

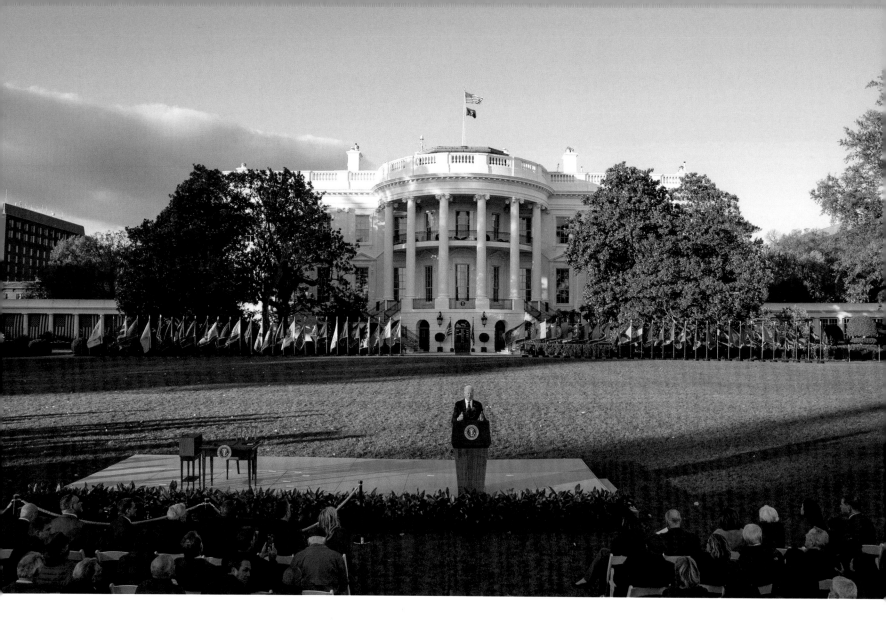

(Erin Scott, 2021)

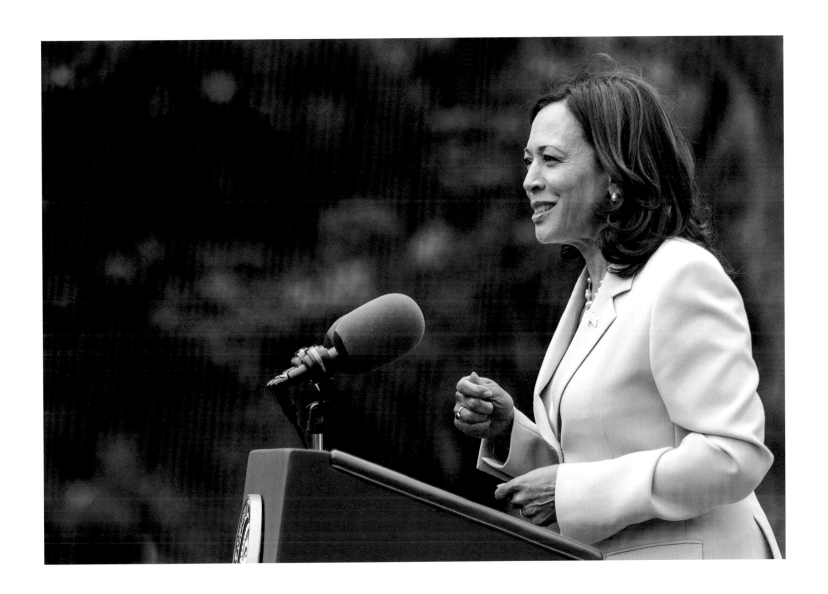

May 1, 2023: Delivering remarks at a Rose Garden event celebrating National Small Business Week. (Lawrence Jackson)

(Adam Schultz, 2024)

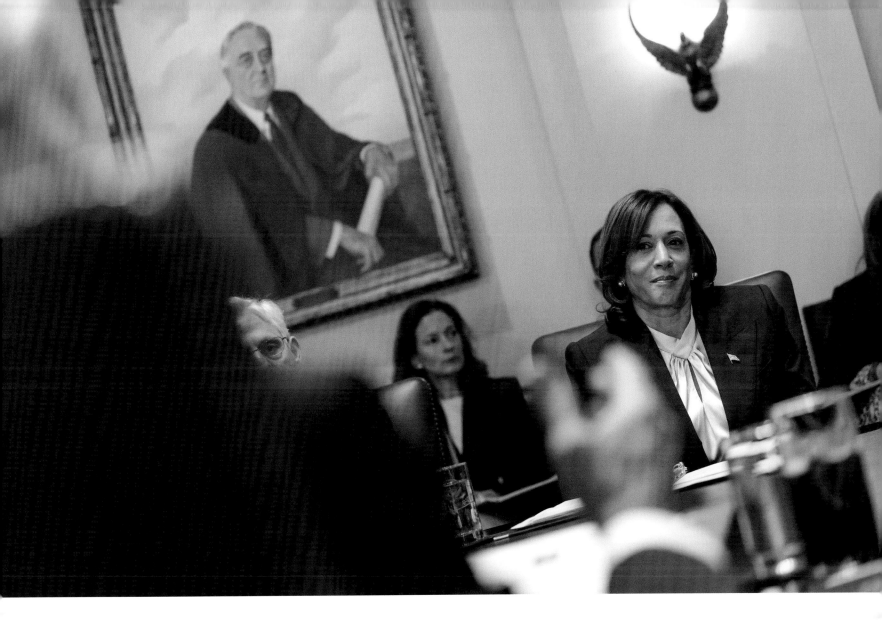

June 6, 2023: Holding a Cabinet meeting. (Adam Schultz)

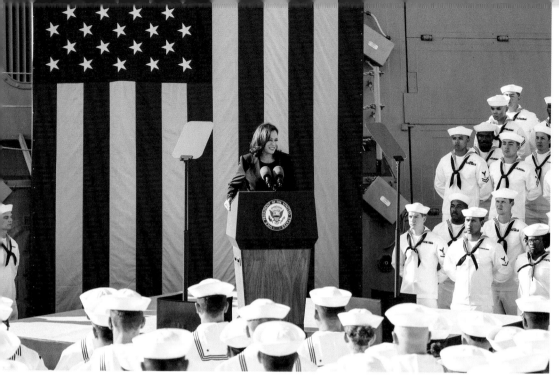
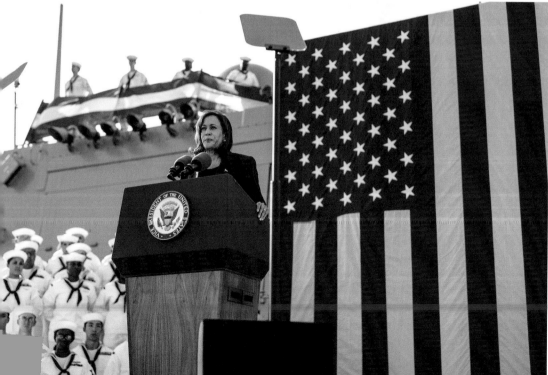

September 28, 2022: Delivering remarks aboard the USS *Howard* at Yokosuka Naval Base in Tokyo, Japan. (Lawrence Jackson)

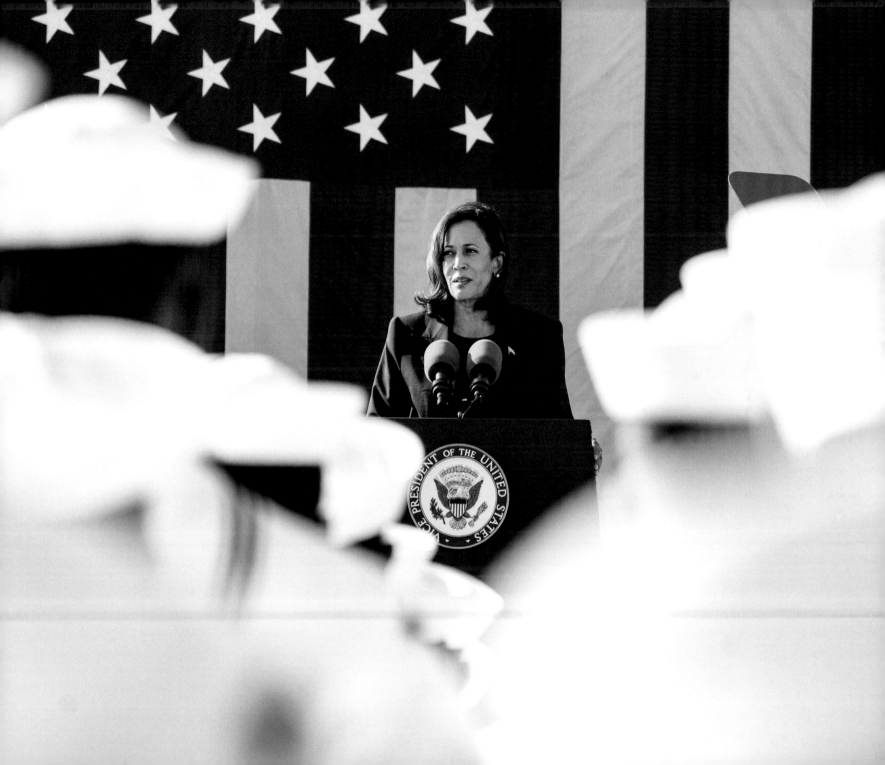

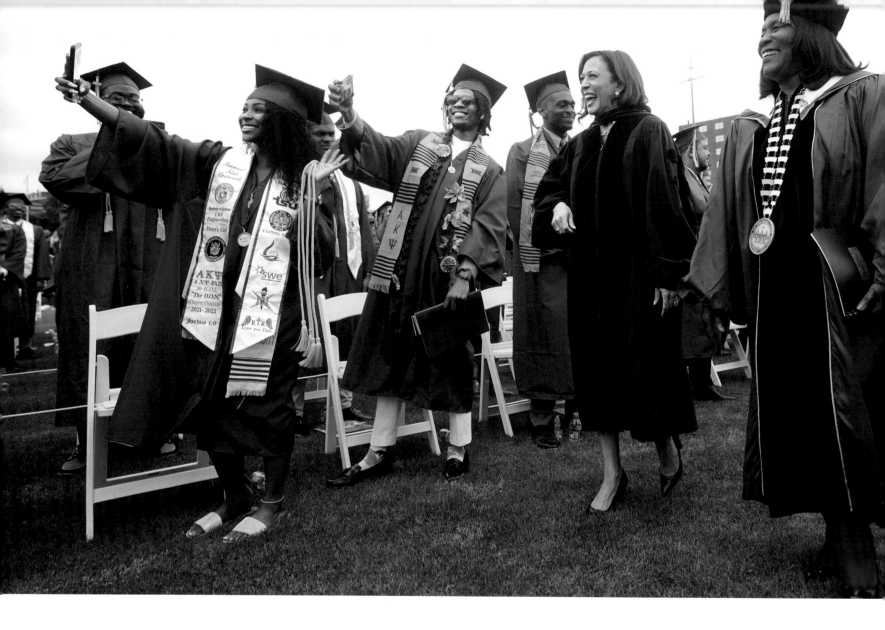

May 7, 2022: Arriving at Tennessee State University's commencement ceremony in Nashville, Tennessee. (Lawrence Jackson)

August 10, 2023: Participating in an interview with Reverend Al Sharpton. (Polly Irungu)

August 10, 2019: Speaking with attendees at the Presidential Gun Sense Forum, hosted by Everytown for Gun Safety and Moms Demand Action, in Des Moines, Iowa, during the first Biden–Harris campaign. (Gage Skidmore)

Opposite: August 10, 2019: Speaking with supporters at a campaign rally in West Des Moines, Iowa, during the first Biden–Harris campaign. (Gage Skidmore)

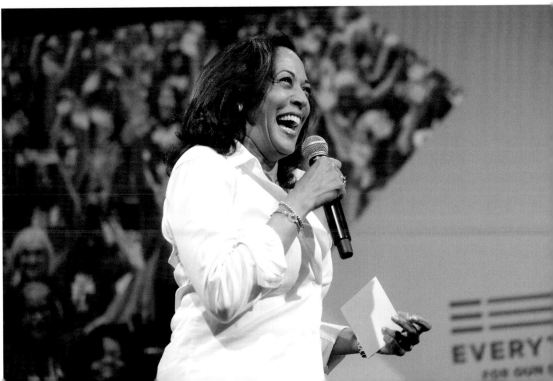

August 25, 2021: Harris's husband, Doug Emhoff, attending a table tennis
match during the Tokyo Paralympics. (Cameron Smith)

August 24, 2021: Emhoff receiving a briefing at the Chief of Mission Residence in Tokyo, Japan. (Cameron Smith)

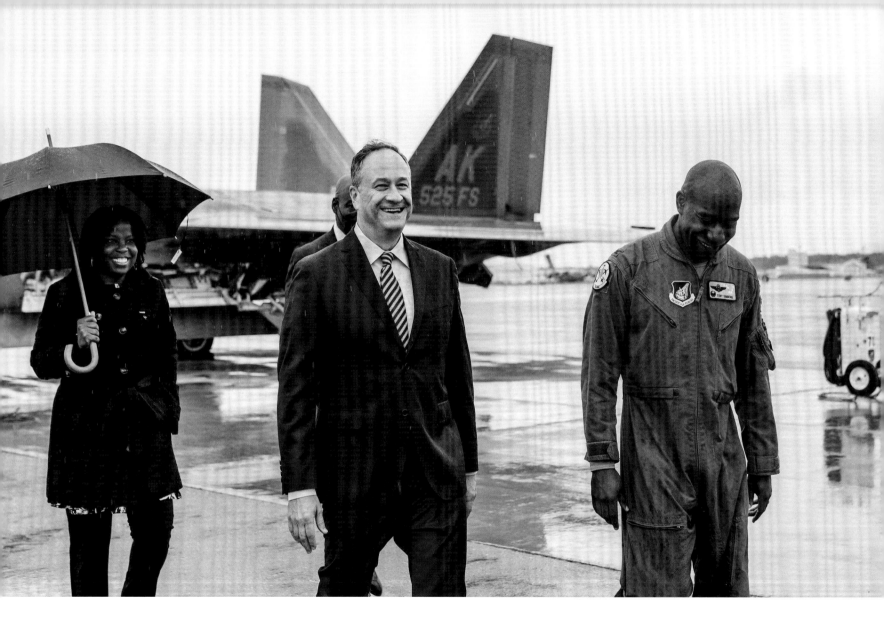

August 22, 2021: Emhoff arriving at Elmendorf Air Force Base
in Anchorage, Alaska. (Cameron Smith)

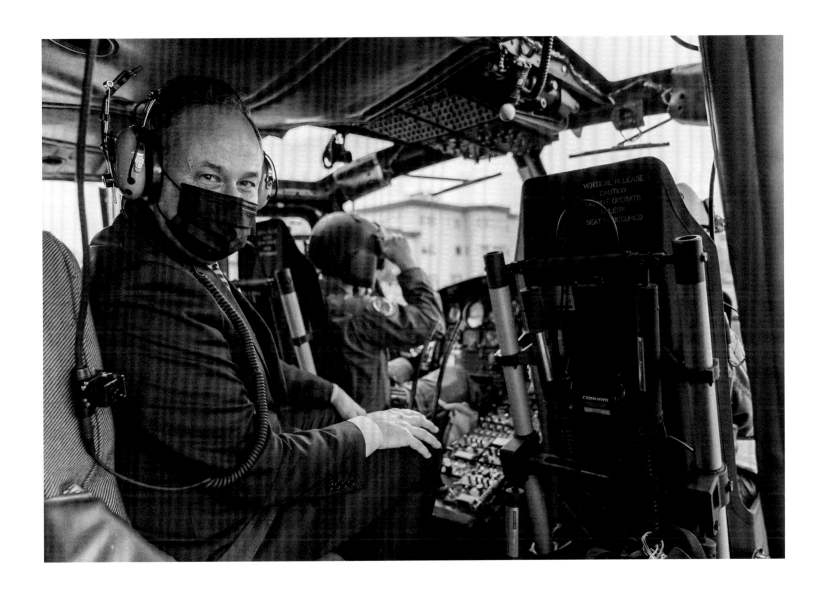

August 22, 2021: Emhoff departing Yokota Air Base in Tokyo, Japan, en route to the Chief of Mission Residence. (Cameron Smith)

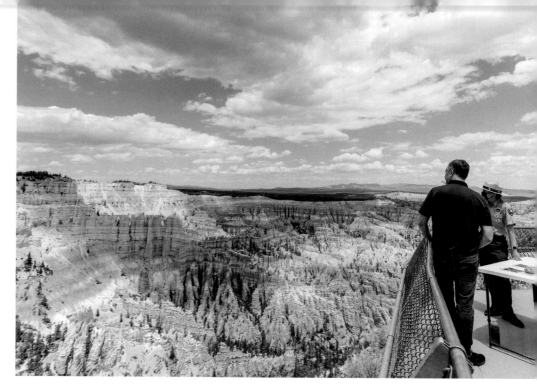

July 2, 2021: Emhoff visiting Sunset Point at Bryce Canyon National Park in Bryce Canyon, Utah, to discuss families visiting national parks during the pandemic. (Cameron Smith)

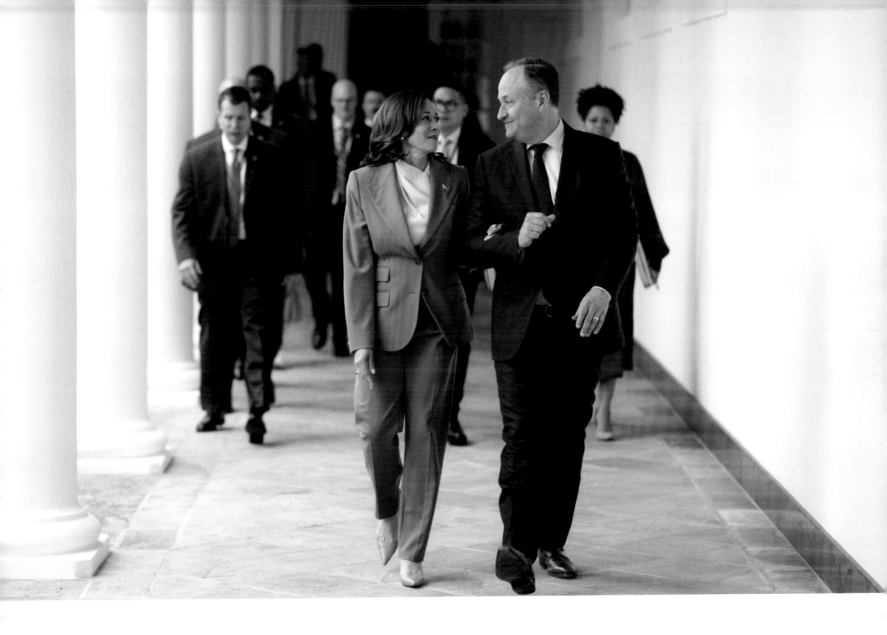

May 9, 2024: Harris and Emhoff walking along the West Colonnade of the White House before greeting the 2024 WNBA Champions, the Las Vegas Aces. (Lawrence Jackson)

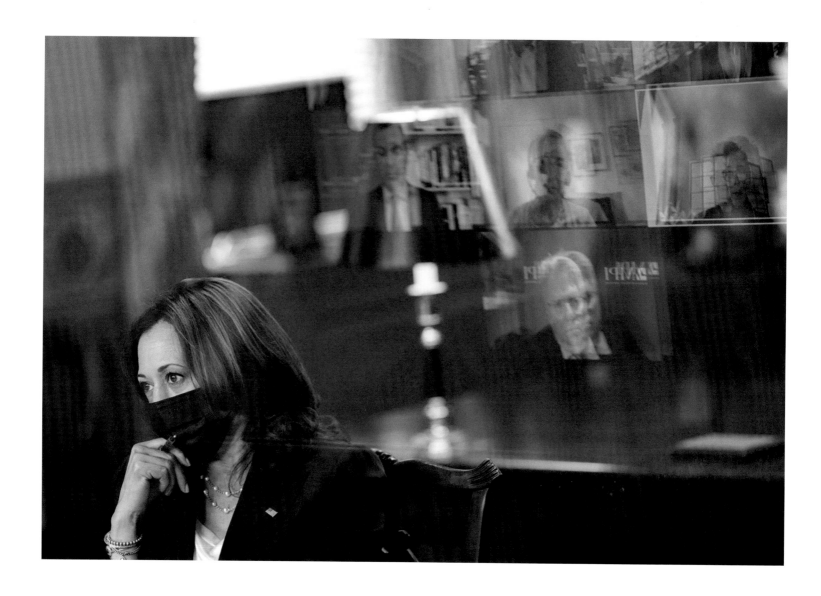

April 14, 2021: Participating in a Northern Triangle virtual roundtable with experts on the region in the Vice President's Ceremonial Office. (Lawrence Jackson)

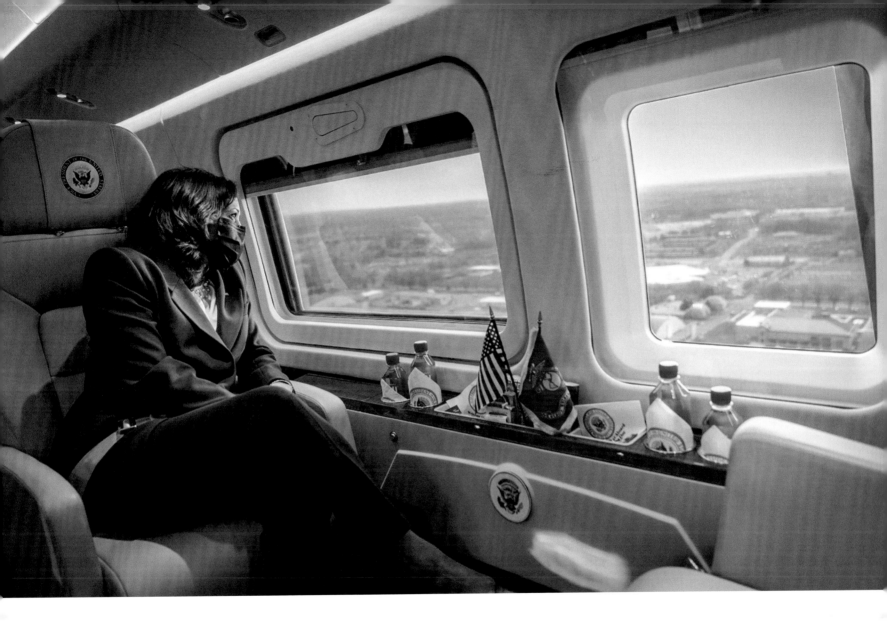

April 6, 2021: Looking out the windows of Marine Two as she flies over Washington, D.C., en route to the Vice President's Residence in Washington, D.C. (Lawrence Jackson)

April 9, 2021: Reviewing notes in the West Wing of the White House. (Adam Schultz)

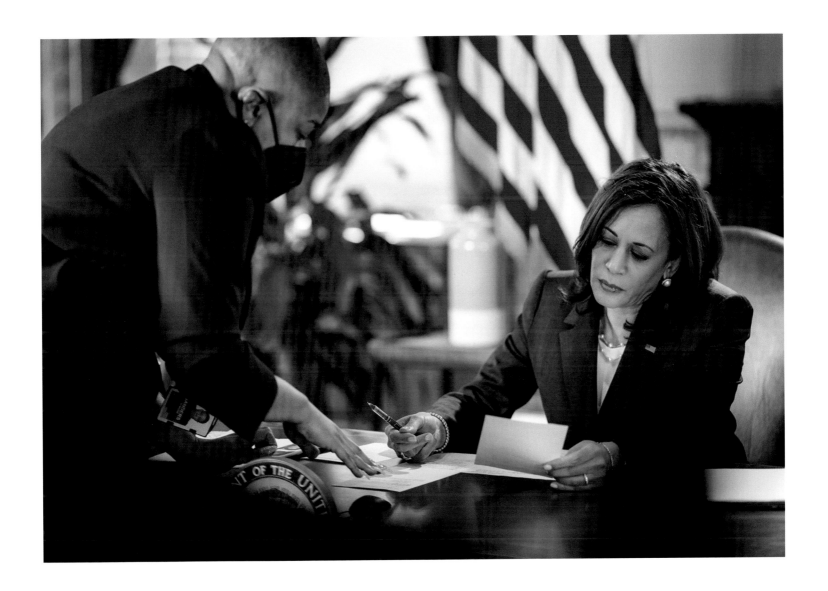

May 12, 2021: Meeting with Symone Sanders-Townsend, former senior advisor and chief spokesperson for the vice president. (Carlos Fyfe)

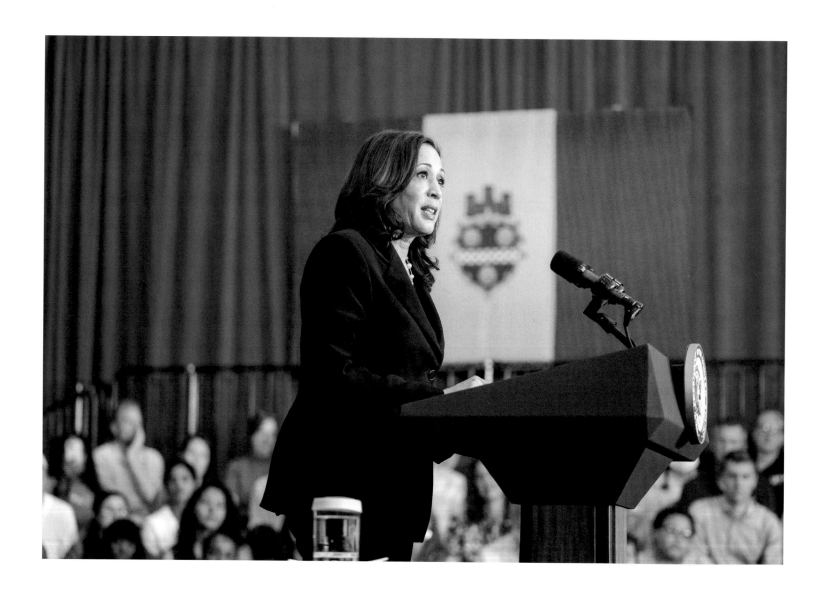

June 21, 2021: Delivering remarks during a Child Tax Credit Awareness Day event at the Brookline Recreation Center in Pittsburgh, Pennsylvania. (Lawrence Jackson)

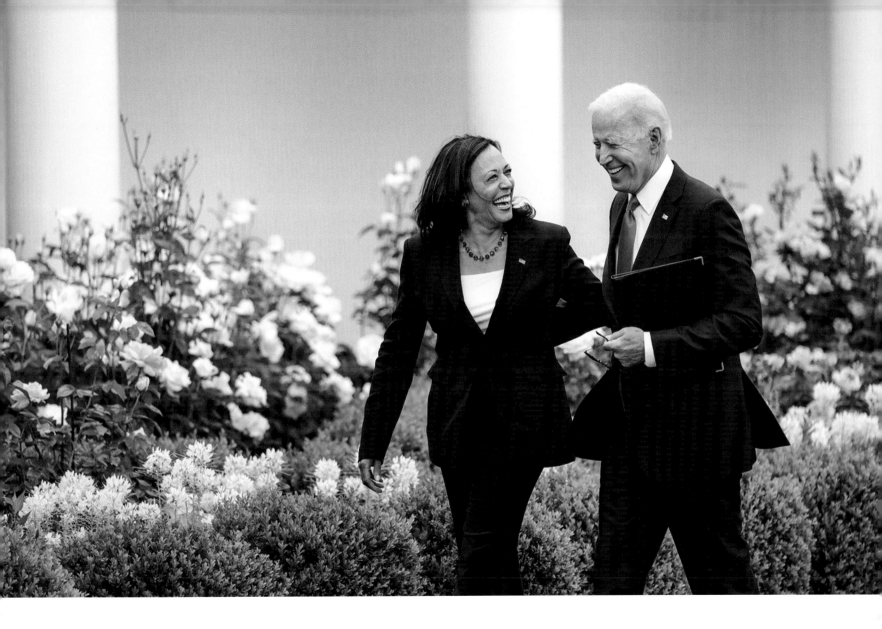

May 13, 2021: Walking alongside former President Joe Biden after delivering remarks on the Centers for Disease Control and Prevention's updated guidance on mask-wearing for vaccinated individuals. (Adam Schultz)

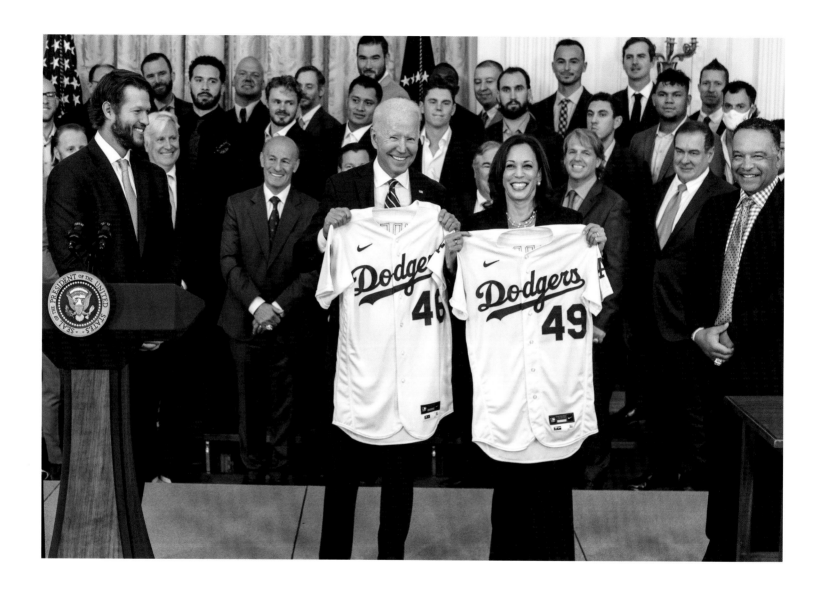

July 2, 2021: Posing for a photo alongside former President Joe Biden with baseball jerseys, during a celebration for the 2020 Baseball World Series Champions, the Los Angeles Dodgers, in the East Room of the White House. (Adam Schultz)

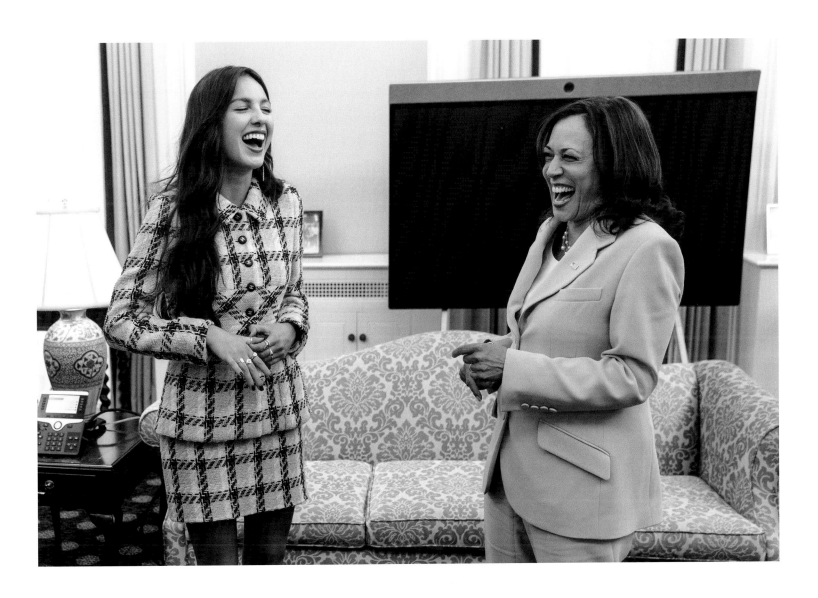

July 14, 2021: Meeting with singer Olivia Rodrigo in the Vice President's West Wing Office of the White House. (Lawrence Jackson)

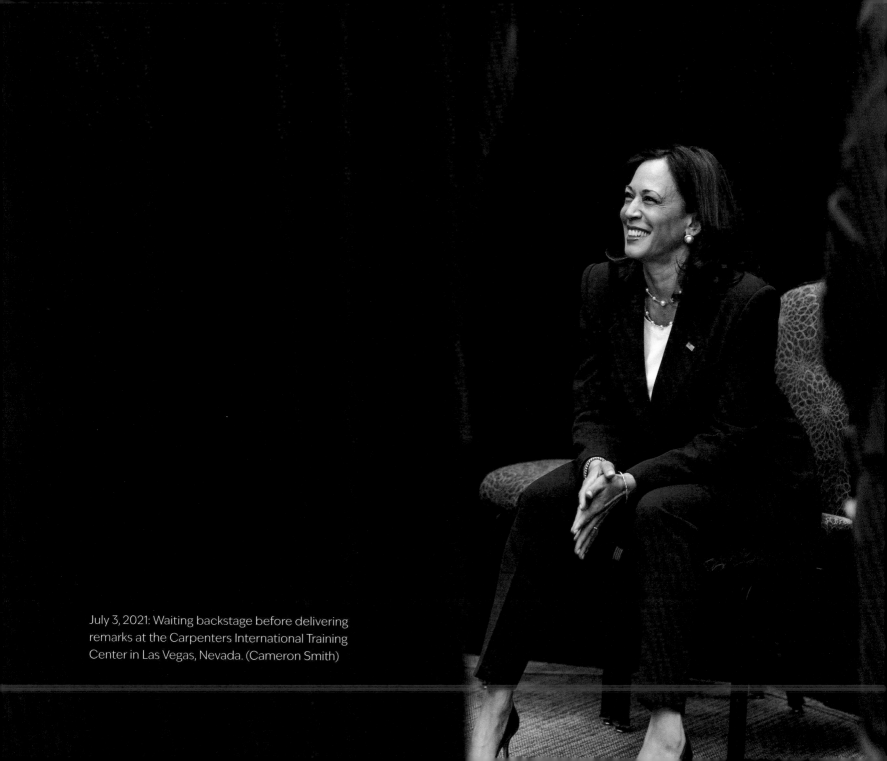

July 3, 2021: Waiting backstage before delivering remarks at the Carpenters International Training Center in Las Vegas, Nevada. (Cameron Smith)

This is not going to be easy.
This is hard work, but we like
hard work. Hard work is good work.

—At a campaign event in Atlanta, Georgia, July 30, 2024

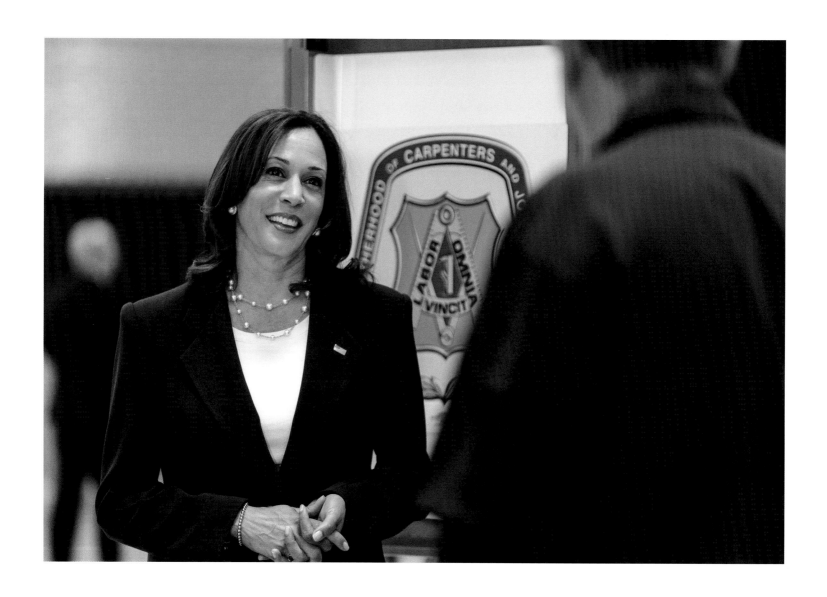

July 3, 2021: Participating in a tour of the Carpenters International
Training Center in Las Vegas, Nevada. (Cameron Smith)

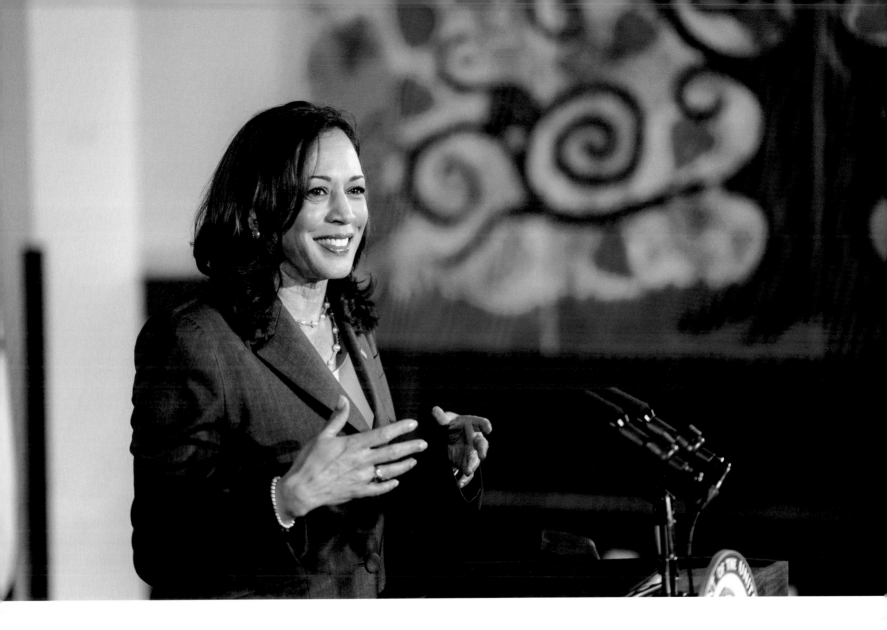

June 11, 2021: Delivering remarks at the CentroNía childcare center in Washington, D.C. (Lawrence Jackson)

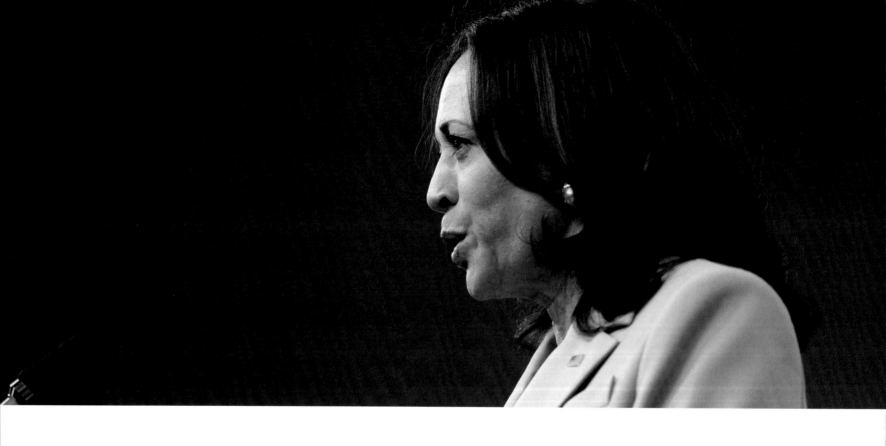

June 30, 2021: Delivering remarks virtually during the
Generation Equality Forum. (Lawrence Jackson)

(Carlos Fyfe, 2024)

We are running a campaign on behalf of all Americans. And when elected, we will govern on behalf of all Americans.

—Introducing her vice presidential pick, Tim Walz,
in Philadelphia, Pennsylvania, August 6, 2024

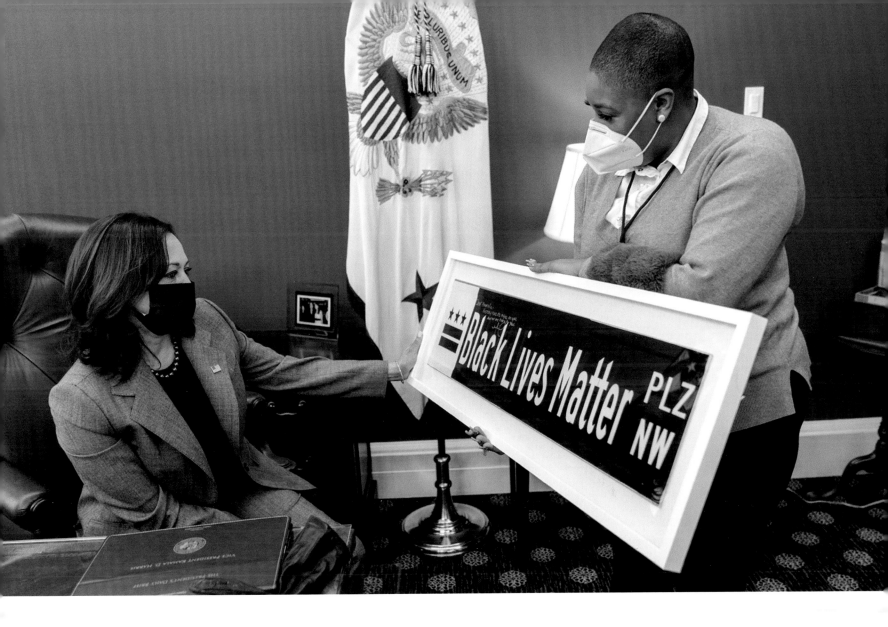

February 16, 2021: Former Chief Spokesperson for the Vice President Symone Sanders-Townsend showing Harris a Black Lives Matter street sign in her West Wing Office of the White House. The sign is a gift from D.C. Mayor Muriel Bowser. (Lawrence Jackson)

April 11, 2022: Applauding Mia Tretta, a high school student who survived a "ghost gun" shooting, as she introduces former President Joe Biden at an event to announce new rules on manufacturing ghost guns. (Adam Schultz)

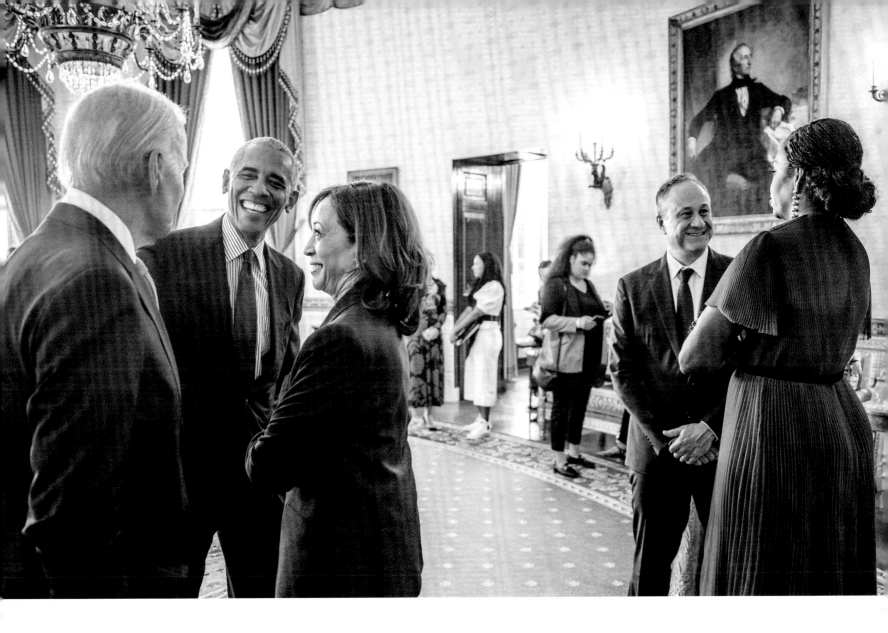

September 7, 2022: Attending a reception with her husband, Doug Emhoff, and former Presidents Joe Biden and Barack Obama, as well as former First Lady Michelle Obama, following the official White House portrait unveiling for the Obamas. (Adam Schultz)

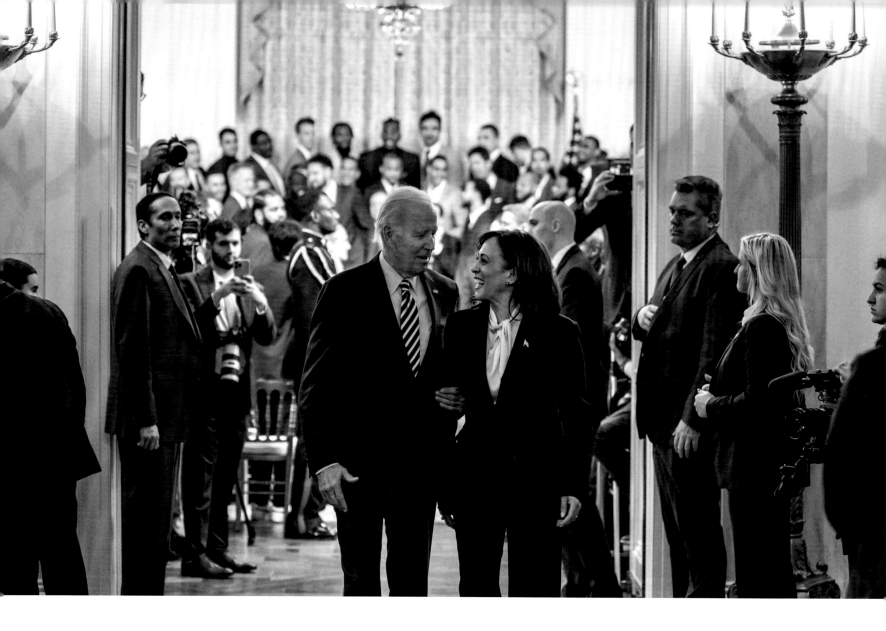

January 17, 2023: Departing the East Room with former President Joe Biden, following an event with the Golden State Warriors to celebrate the team's 2022 NBA championship. (Adam Schultz)

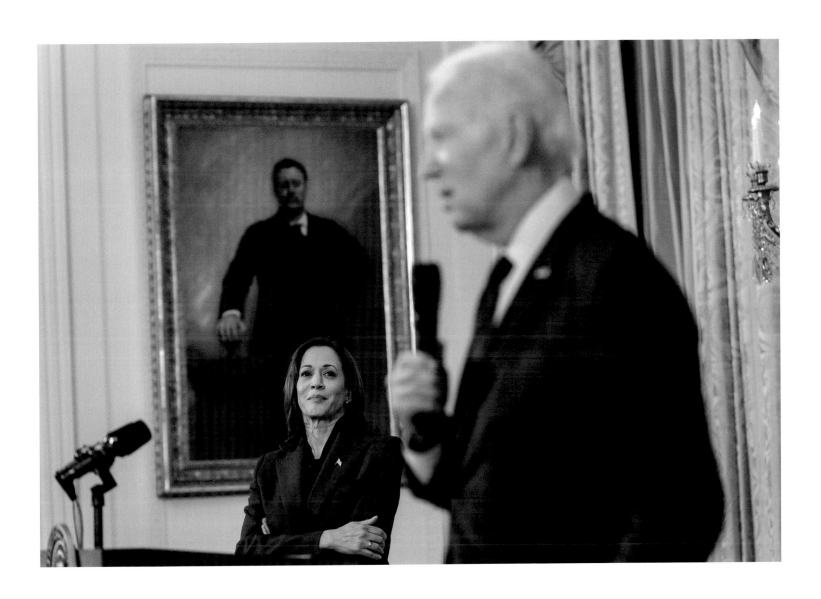

January 24, 2023: Watching as former President Joe Biden delivers remarks at a reception for new members of Congress. (Erin Scott)

Ours is a fight for the future
and it is a fight for freedom.

—At a campaign event in Pittsfield, Massachusetts,
July 27, 2024

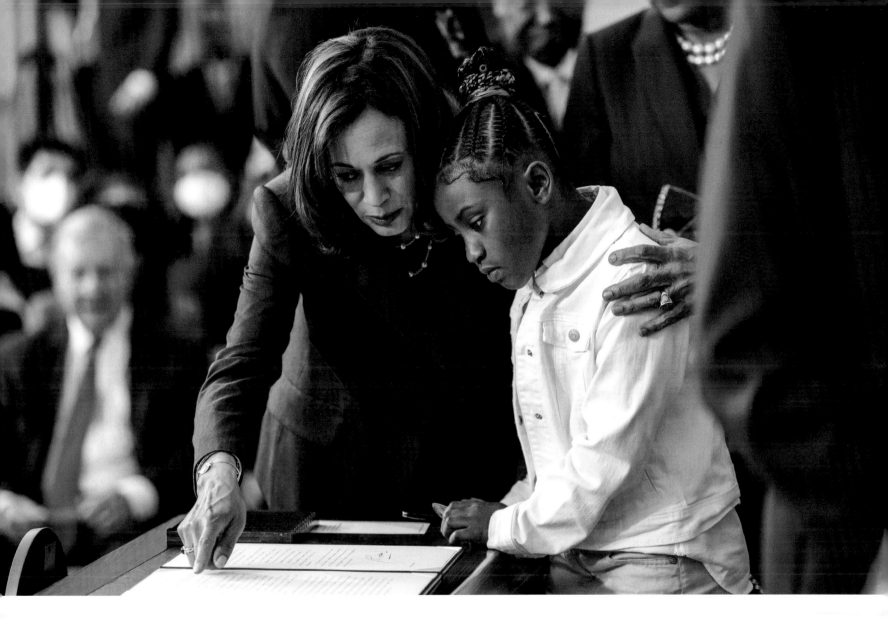

May 25, 2022: Showing Gianna Floyd, daughter of George Floyd, the executive order that former President Joe Biden signed during an event on federal policing reforms. (Adam Schultz)

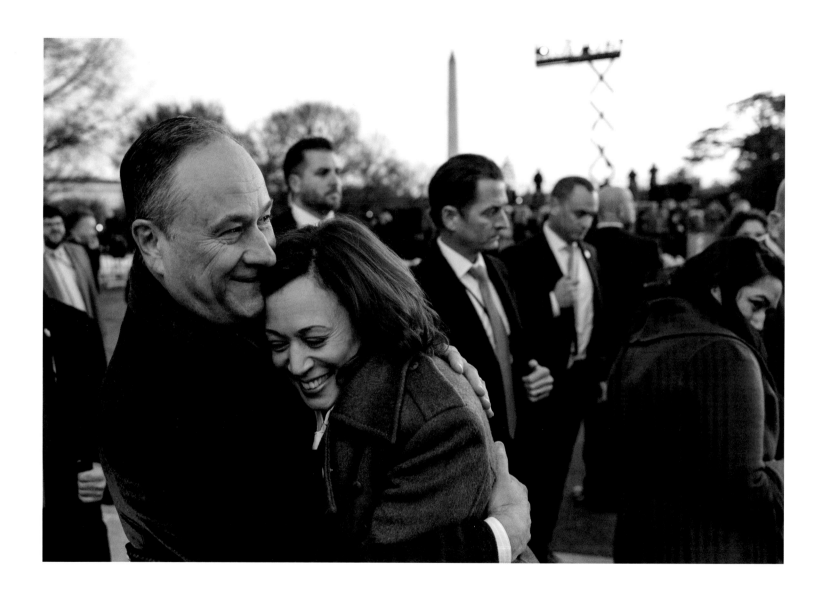

December 13, 2022: Hugging her husband, Doug Emhoff, while attending a bill-signing ceremony for the Respect for Marriage Act. (Hannah Foslien)

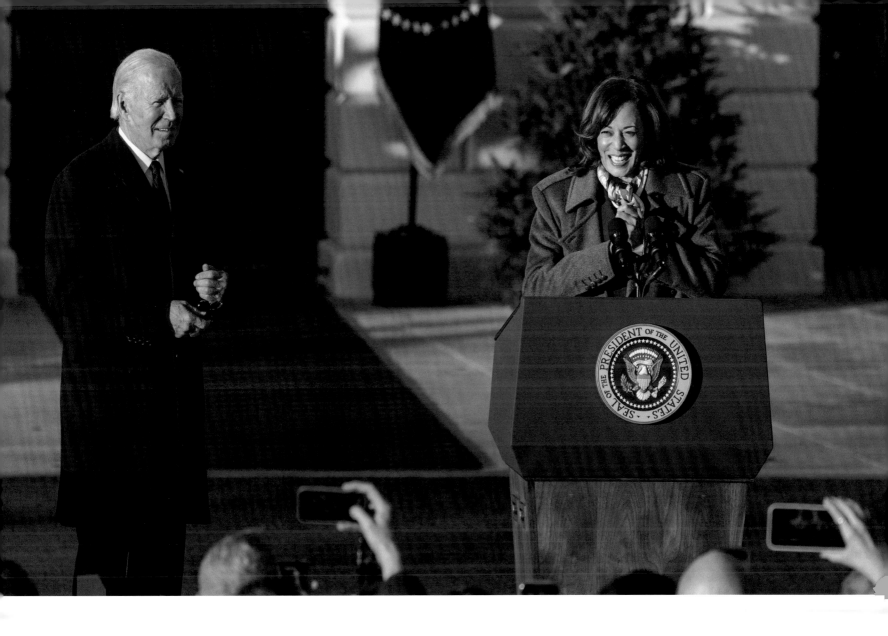

December 13, 2022: Delivering remarks at the Respect for Marriage Act bill signing as former President Joe Biden looks on. (Hannah Foslien)

(Adam Schultz, 2021)

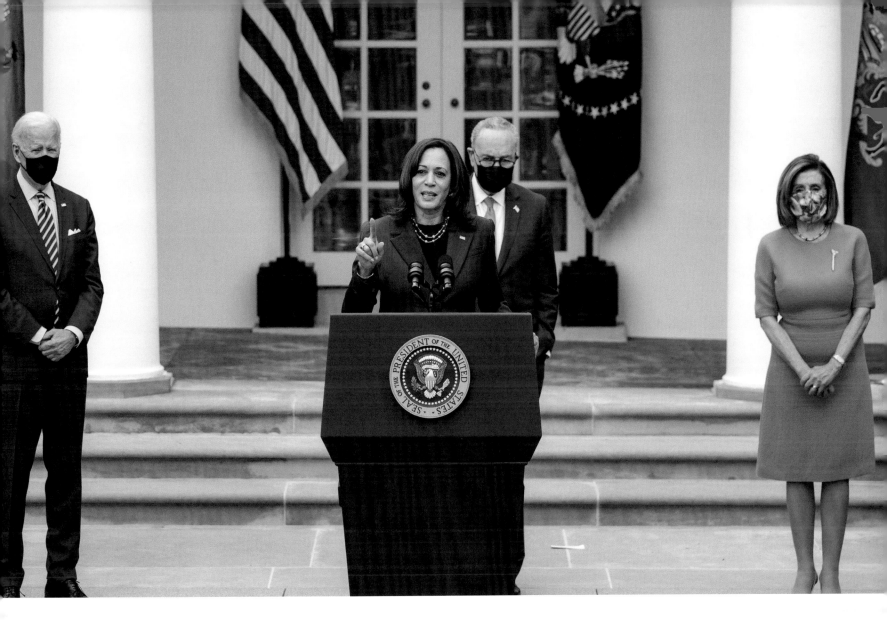

March 12, 2021: Delivering remarks on the American Rescue Plan while former President Joe Biden, Senate Majority Leader Charles "Chuck" Schumer (D-N.Y.), and former House Speaker Nancy Pelosi (D-Calif.) look on. (Adam Schultz)

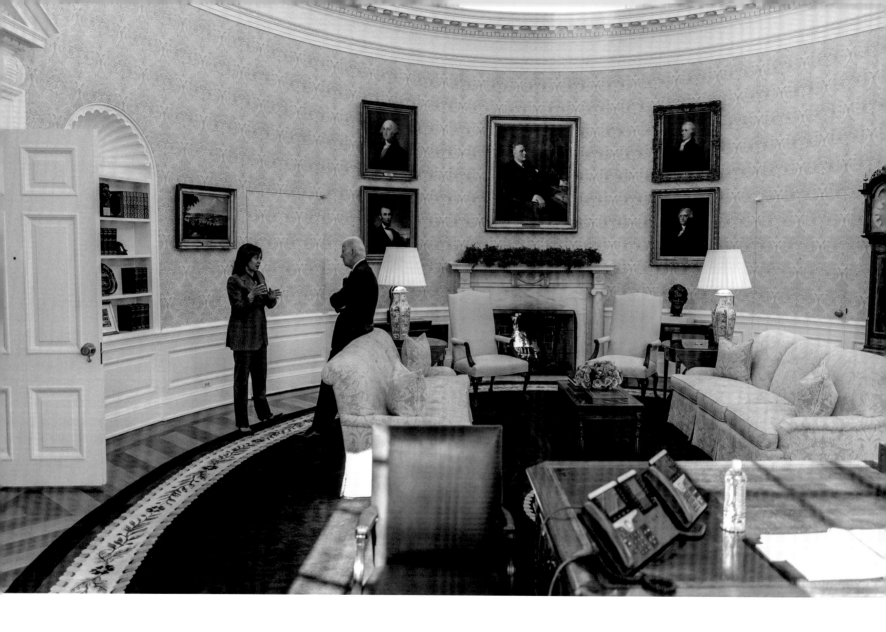

January 5, 2023: Talking with former President Joe Biden in the Oval Office of the White House after delivering remarks on immigration. (Adam Schultz)

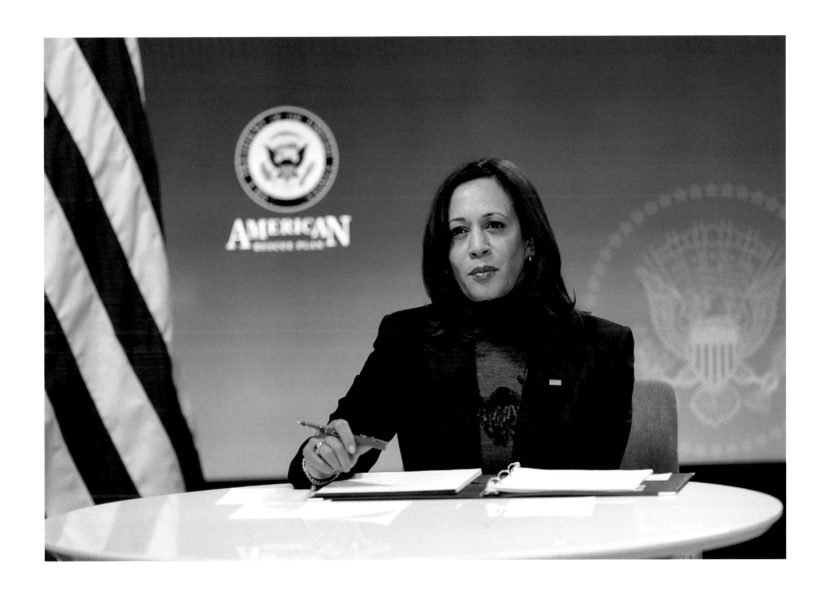

February 18, 2021: Participating in a virtual roundtable on the American Rescue Plan with women's leadership groups. (Lawrence Jackson)

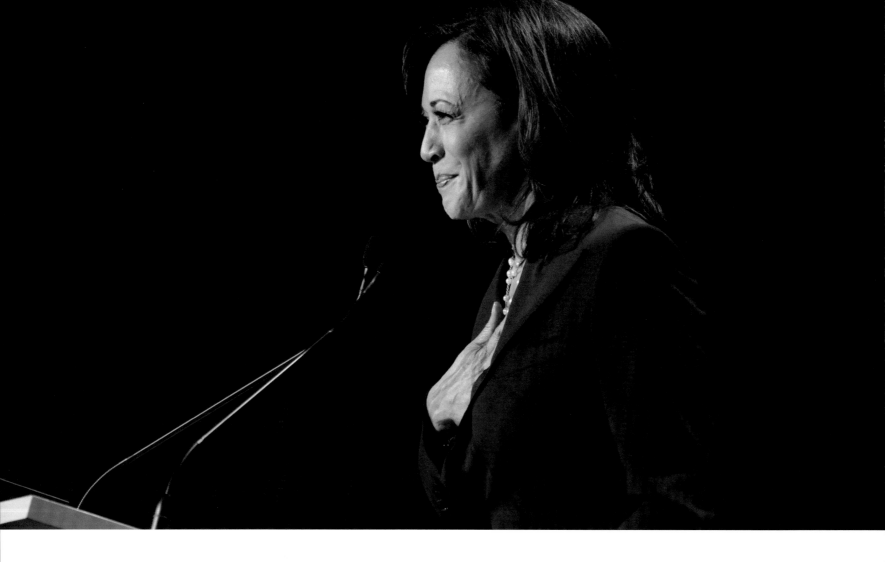

June 1, 2019: Speaking at the 2019 California Democratic Party State Convention in San Francisco, California , during the first Biden–Harris campaign. (Gage Skidmore)

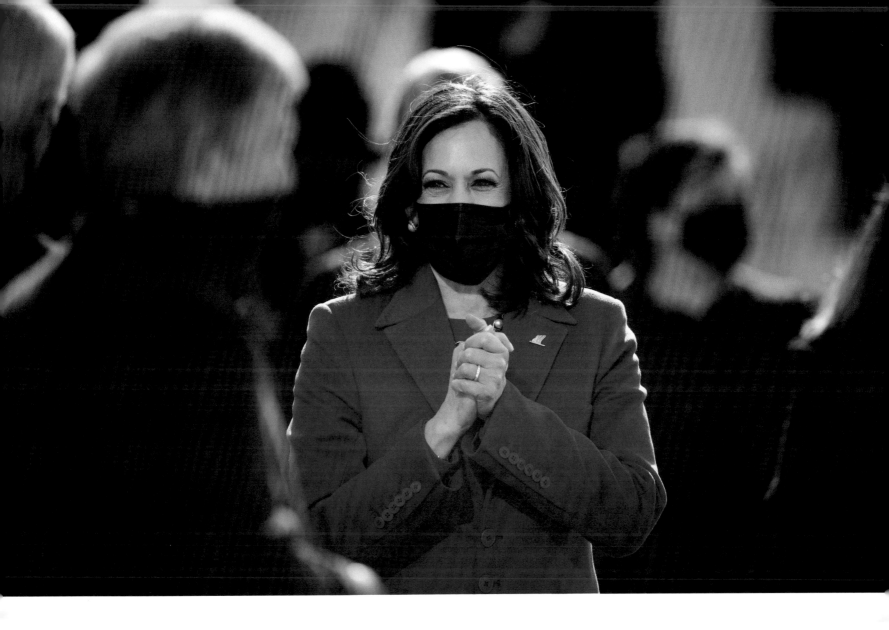

January 20, 2021: Attending the 59th Presidential Inauguration, where she and former President Joe Biden took the oath of office on the West Front of the U.S. Capitol. (Carlos M. Vazquez II)

My mother, Shyamala Gopalan Harris, who is always in our hearts, when she came here from India at the age of nineteen, maybe she didn't quite imagine this moment.

—In a victory speech upon winning the vice presidency,
in Wilmington, Delaware, November 7, 2020

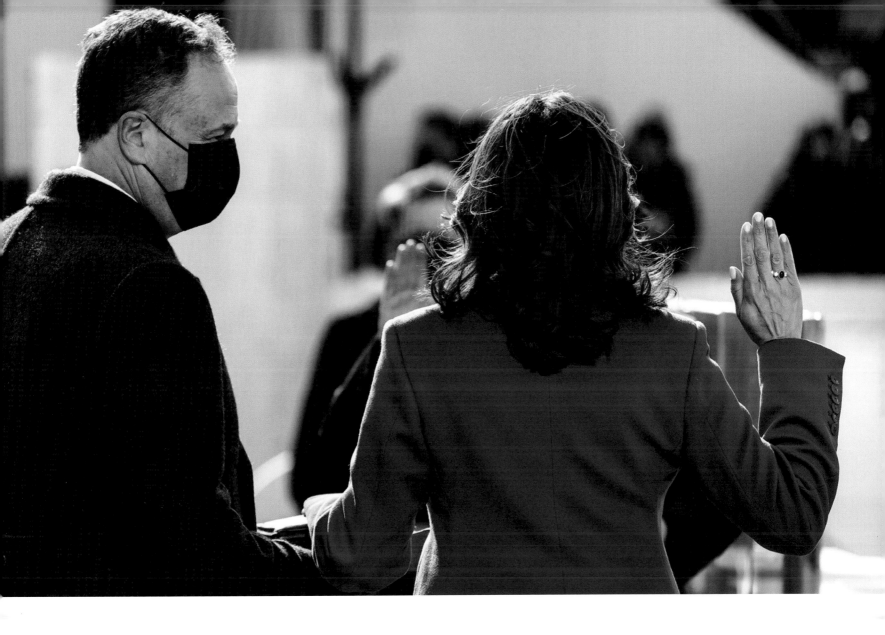

January 20, 2021: Being sworn in as vice president of the United States by Supreme Court Justice Sonia Sotomayor at the U.S. Capitol in Washington, D.C., accompanied by her husband, Doug Emhoff. (Lawrence Jackson)

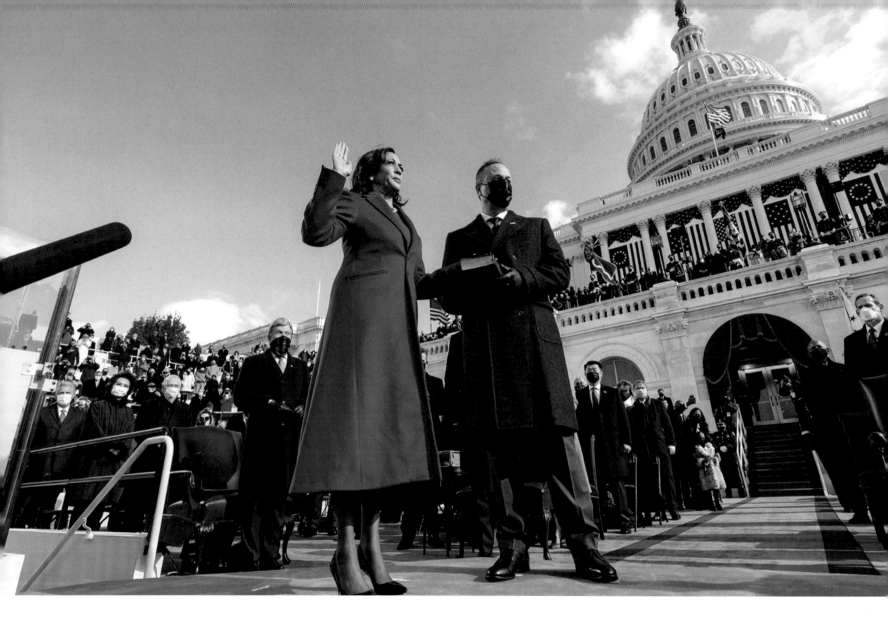

January 20, 2021: Taking the oath of office as vice president of the United States during the 59th Presidential Inauguration at the U.S. Capitol in Washington, D.C. (Chuck Kennedy)

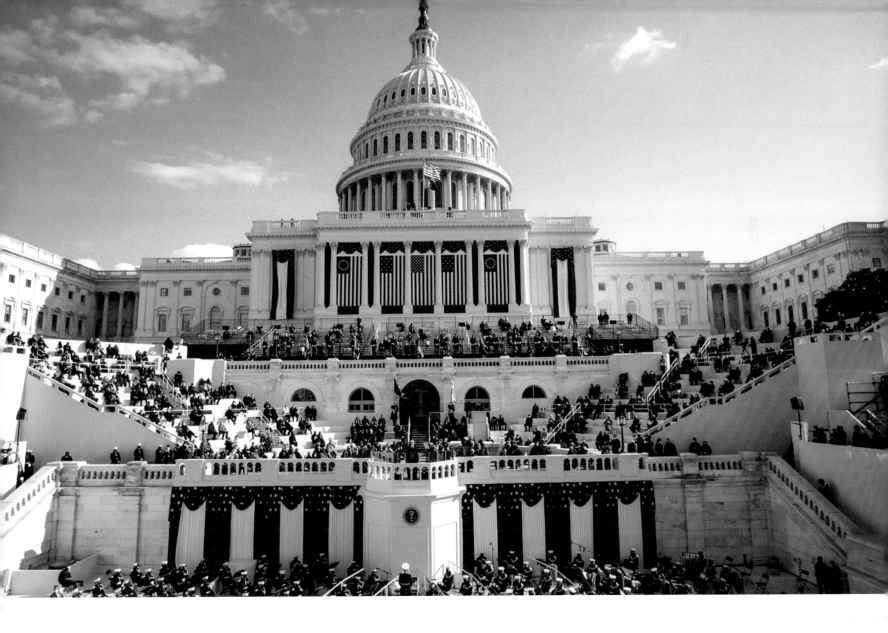

January 20, 2021: Former President Joe Biden delivers his inaugural address during the 59th Presidential Inauguration at the U.S. Capitol in Washington, D.C. (Chuck Kennedy)

(Katie Ricks, 2024)

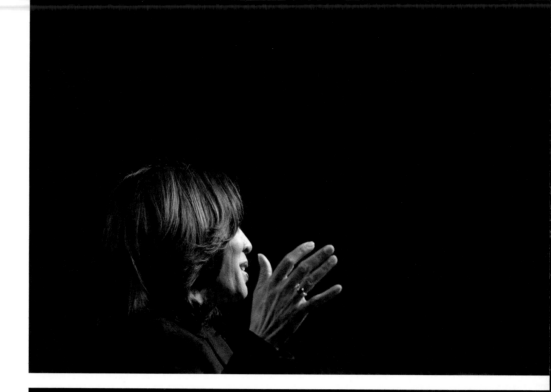

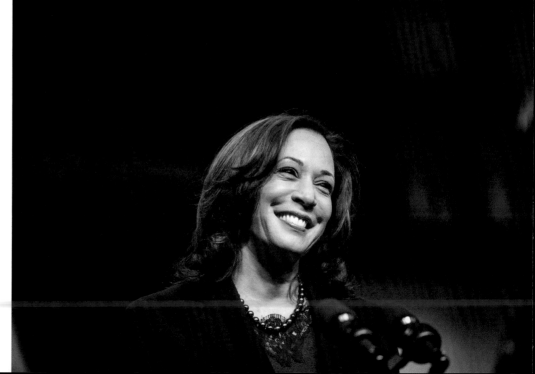

February 27, 2021: Delivering remarks at the 40th annual Black History Month celebration, hosted virtually by Congressman Steny Hoyer of Maryland. (Lawrence Jackson)

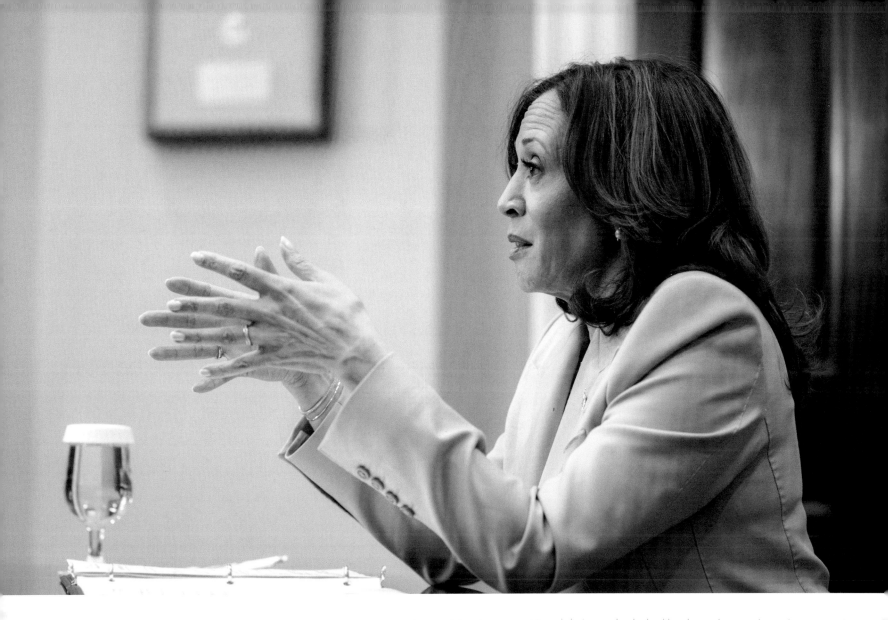

April 25, 2024: Speaking during a Second Chance Month event with celebrity and criminal justice reform advocate Kim Kardashian, Director of Public Engagement Stephen Benjamin, and pardon recipients Jason Hernandez, Bobby Lowery, Jesse Mosley, and Beverly Robinson, in the Roosevelt Room of the White House. (Lawrence Jackson)

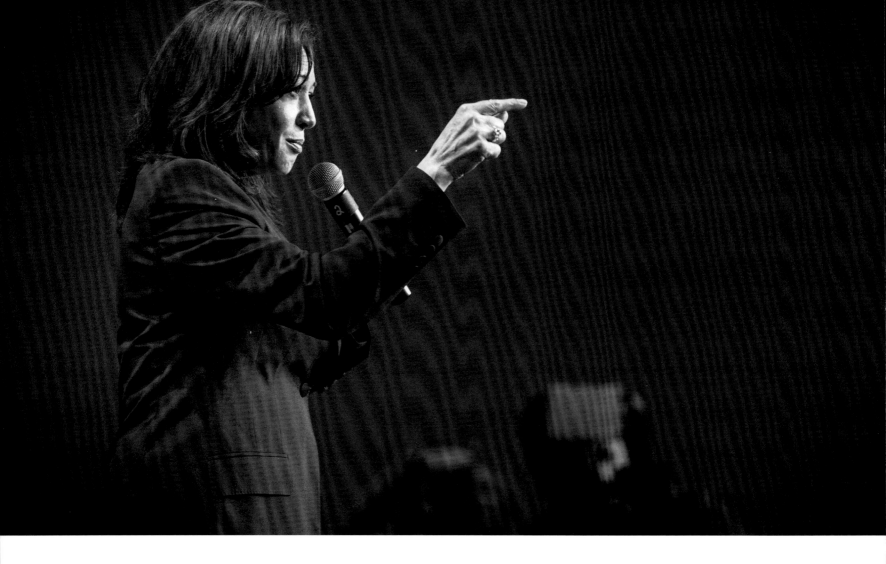

June 9, 2019: Speaking at the 2019 Iowa Democrats Hall of Fame Celebration in Cedar Rapids, Iowa, nine weeks before former President Joe Biden selected her as his vice presidential pick. (Lorie Shaull)

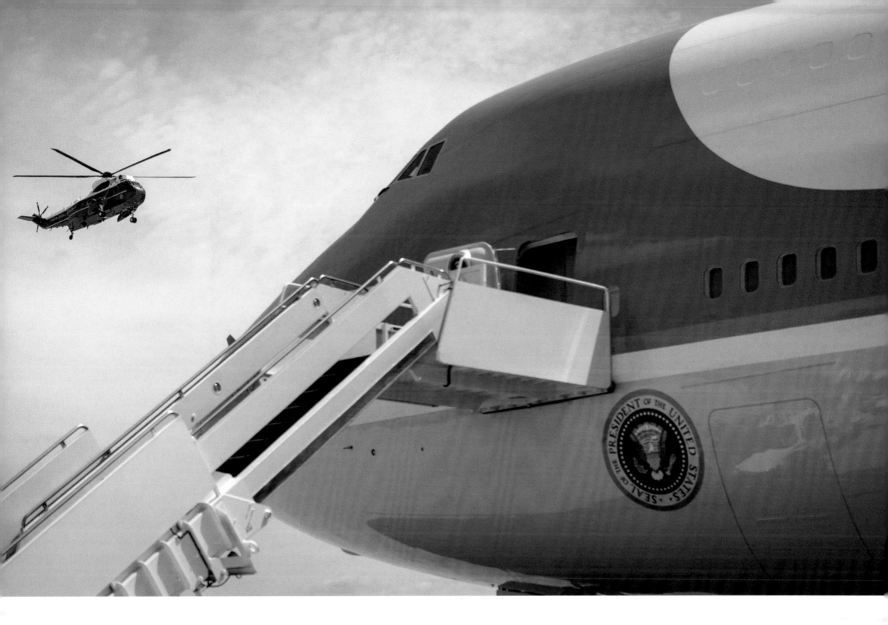

(Adam Schultz, 2021)

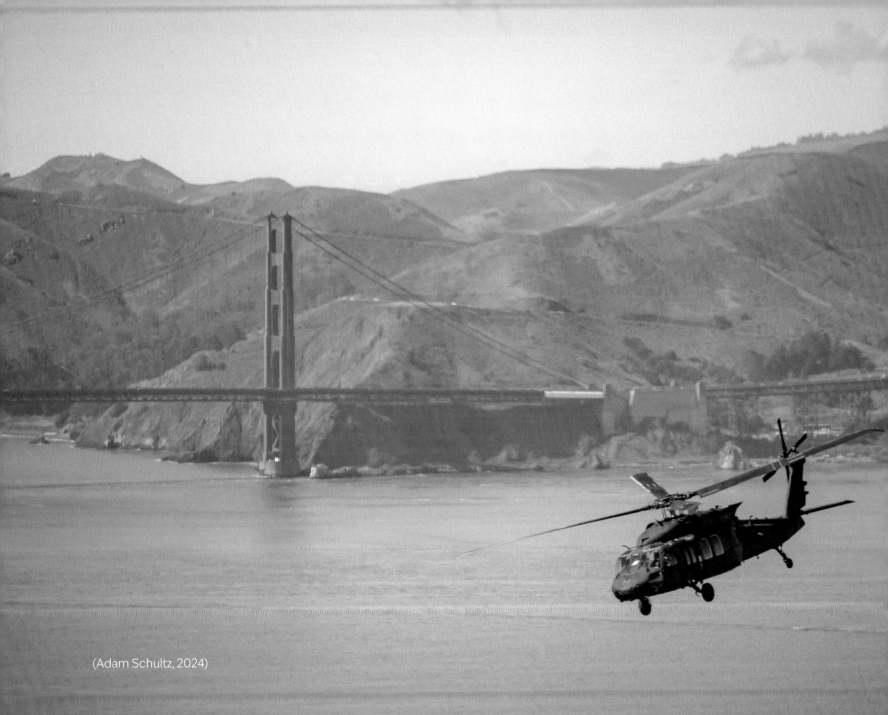

(Adam Schultz, 2024)

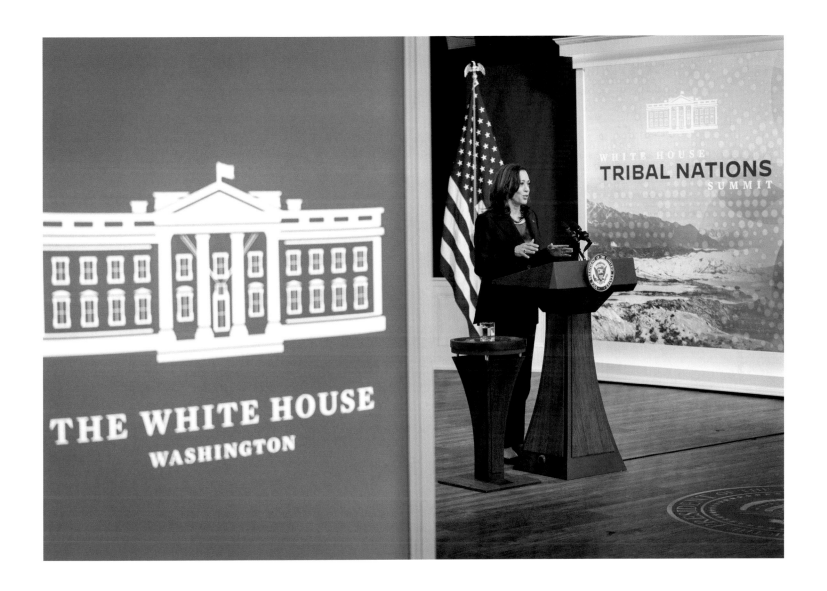

November 16, 2021: Speaking at the White House Tribal Nations
Summit in Washington, D.C. (Lawrence Jackson)

I believe that democracy is our world's best hope, not because it is perfect but because of its principles, because it delivers for the people.

—*At the Summit for Democracy at the Eisenhower Executive Office Building at the White House, December 9, 2021*

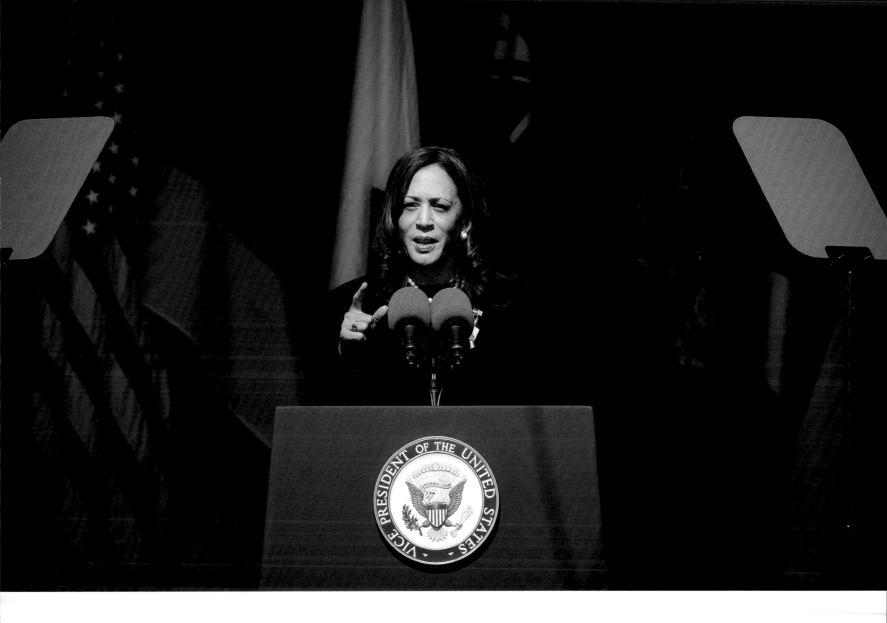

September 11, 2021: Speaking at the Flight 93 National Memorial, in Stoystown, Pennsylvania, for the 20th annual September 11 observance, joining families and guests to honor the passengers and crew of Flight 93. (Governor Tom Wolf)

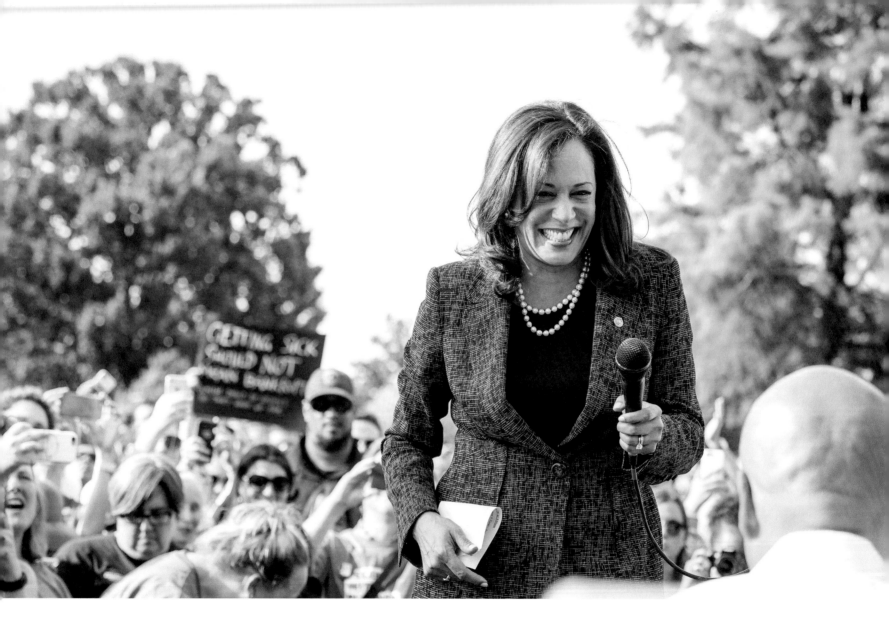

June 28, 2017: At the Linking Together: March to Save Our Care rally at the U.S. Capitol, during her tenure as senator of California. Harris and other Democratic Party leaders spoke to defend the Affordable Care Act and to defeat efforts to repeal it. (Mobilus In Mobili)

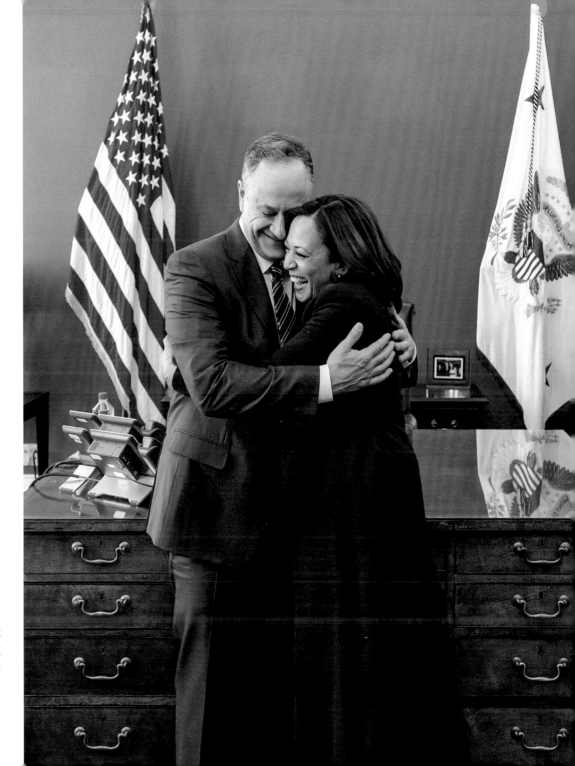

January 21, 2021: Embracing her husband, Doug Emhoff, during her first visit to her West Wing Office of the White House. (Lawrence Jackson)

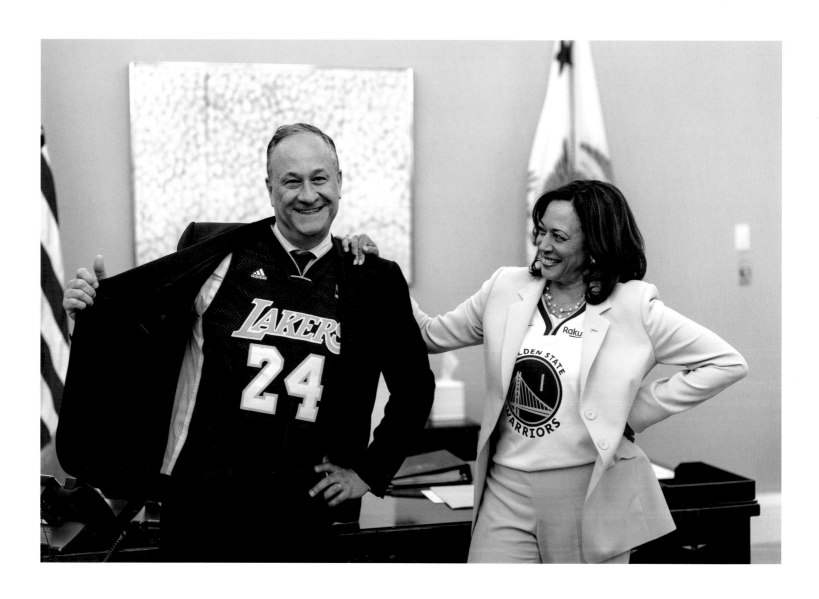

May 1, 2023: Posing in a Warriors jersey with her husband, Doug Emhoff, who is a
Lakers fan, in her West Wing Office of the White House. (Lawrence Jackson)

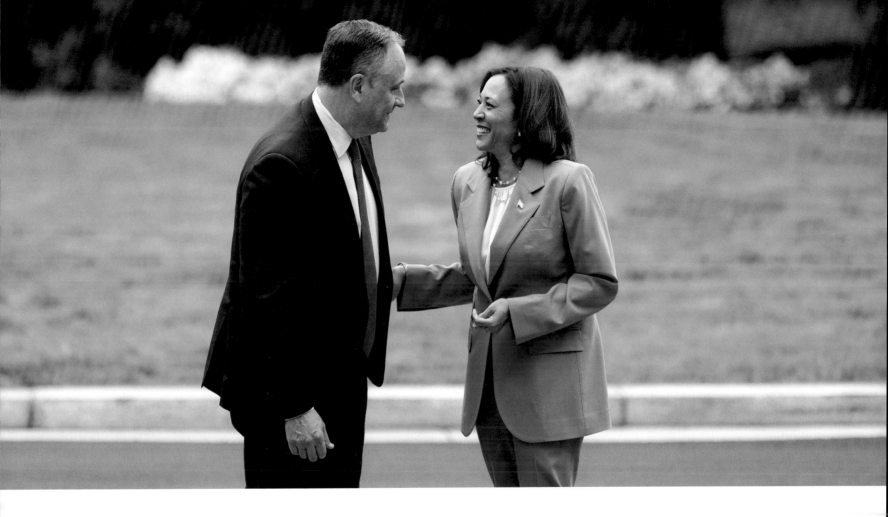

May 2, 2023: Walking back inside the Residence with her husband, Doug Emhoff, after bidding farewell to President Ferdinand Marcos Jr. and First Lady Louise Araneta-Marcos of the Republic of the Philippines. (Lawrence Jackson)

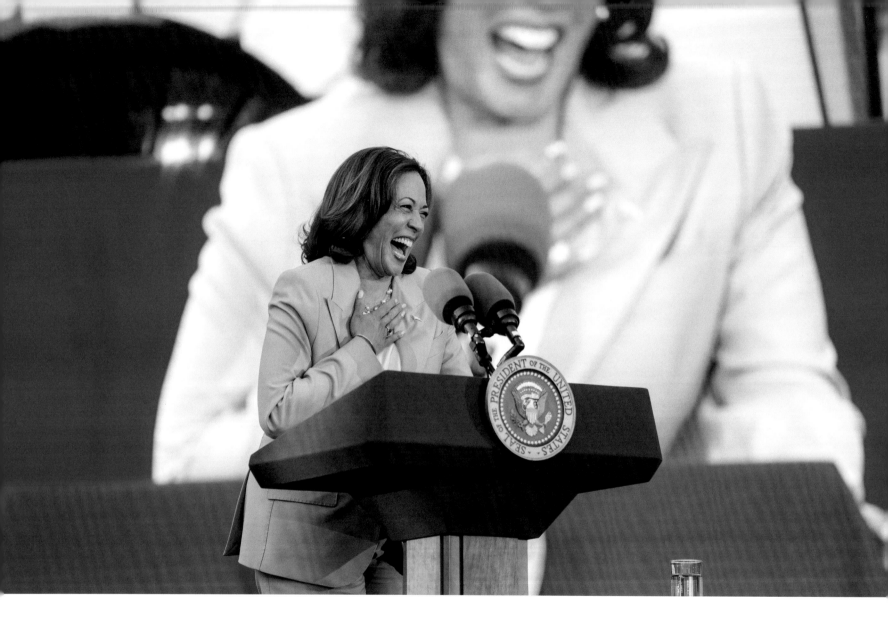

June 13, 2023: Delivering welcoming remarks at a Juneteenth concert on the South Lawn of the White House. (Cameron Smith)

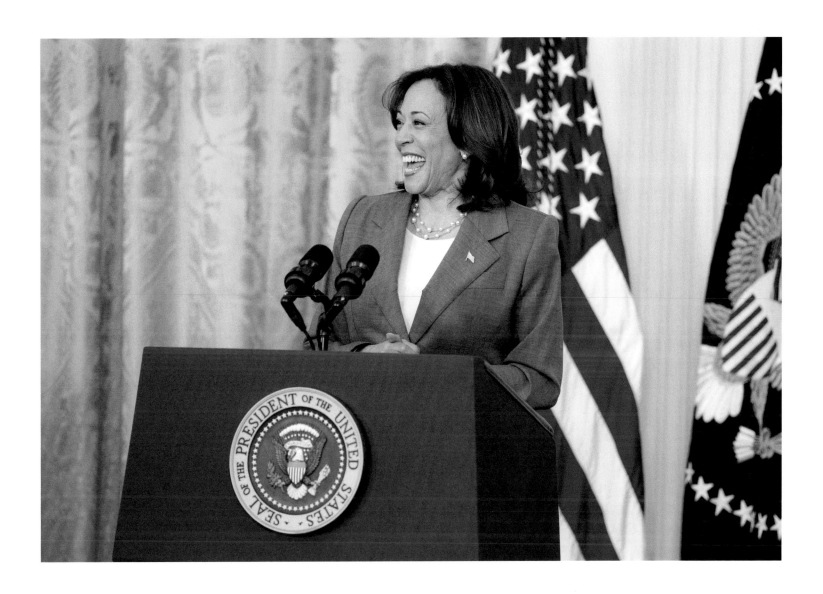

June 26, 2023: Speaking at an announcement event regarding investments in broadband infrastructure. (Adam Schultz)

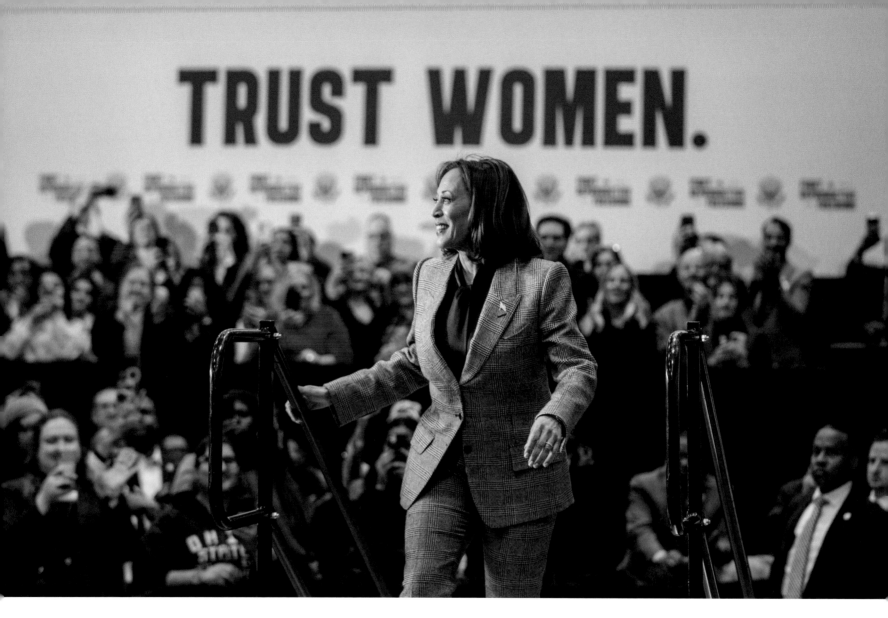

January 22, 2024: Walking onstage to speak at the kickoff for the Fight for Reproductive Freedoms Tour at the International Union of Painters and Allied Trades (IUPAT) District Council 7 in Big Bend, Wisconsin. (Lawrence Jackson)

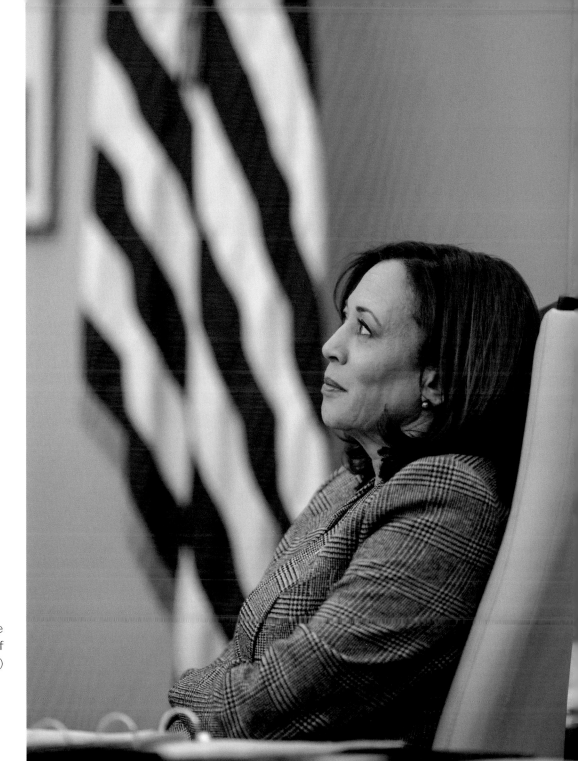

January 8, 2024: Making a phone call to President Isaac Herzog of Israel. (Lawrence Jackson)

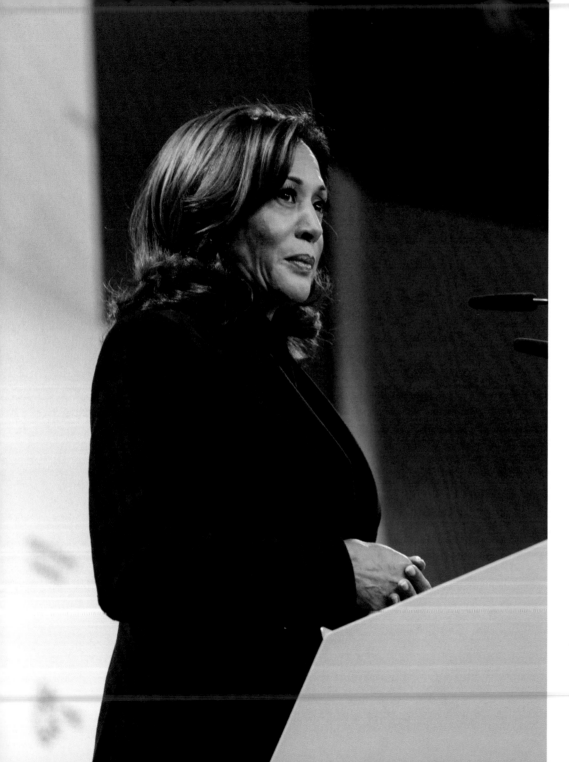

February 16, 2024: Delivering remarks at the Munich Security Conference at the Hotel Bayerischer Hof in Munich, Germany. (Lawrence Jackson)

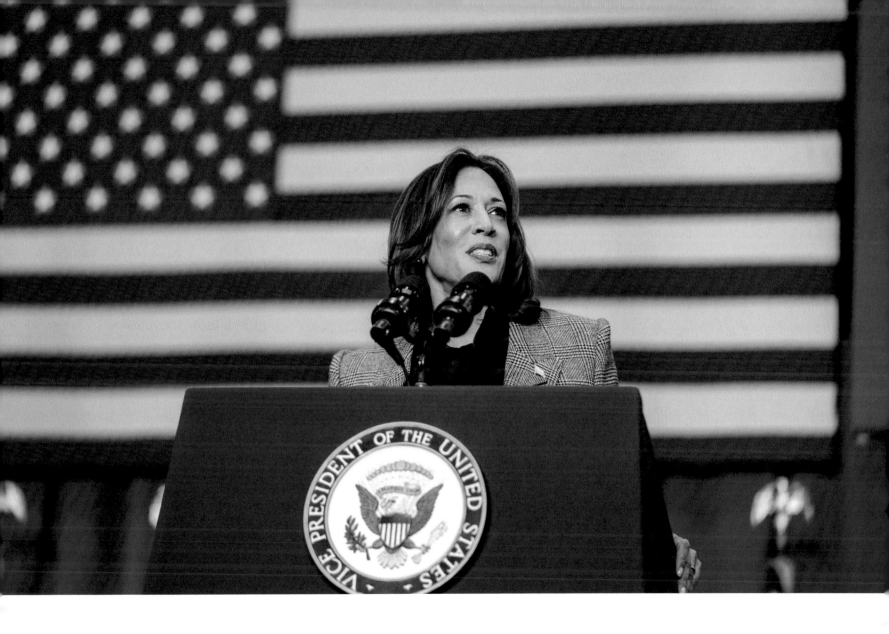

January 22, 2024: Delivering remarks at the kickoff for the Fight for Reproductive Freedoms Tour at the International Union of Painters and Allied Trades (IUPAT) District Council 7 in Big Bend, Wisconsin. (Lawrence Jackson)

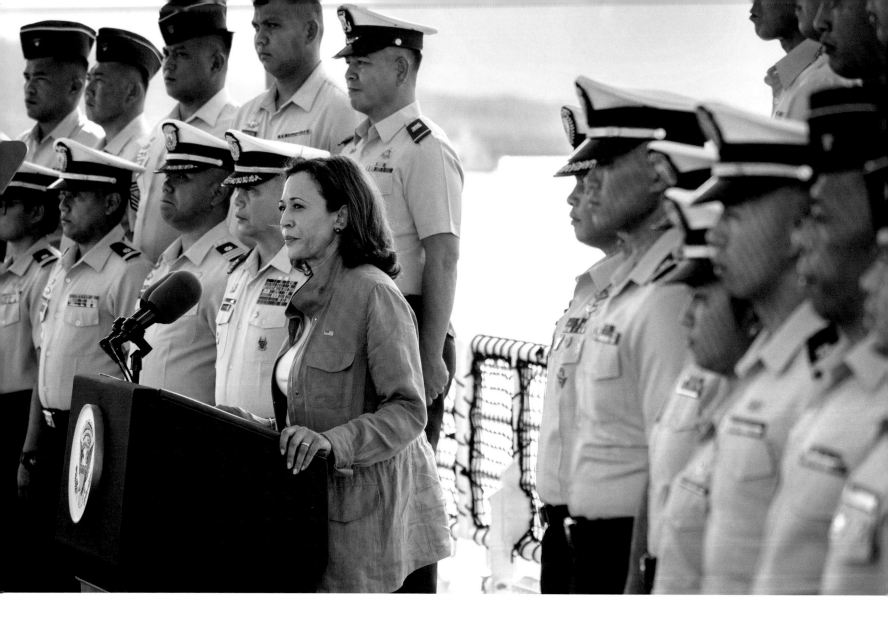

November 22 , 2022: Delivering remarks aboard the Philippine Coast Guard ship *Teresa Magbanua* in the port area of Puerto Princesa, the capital of Palawan island in Palawan, Philippines. (Lawrence Jackson)

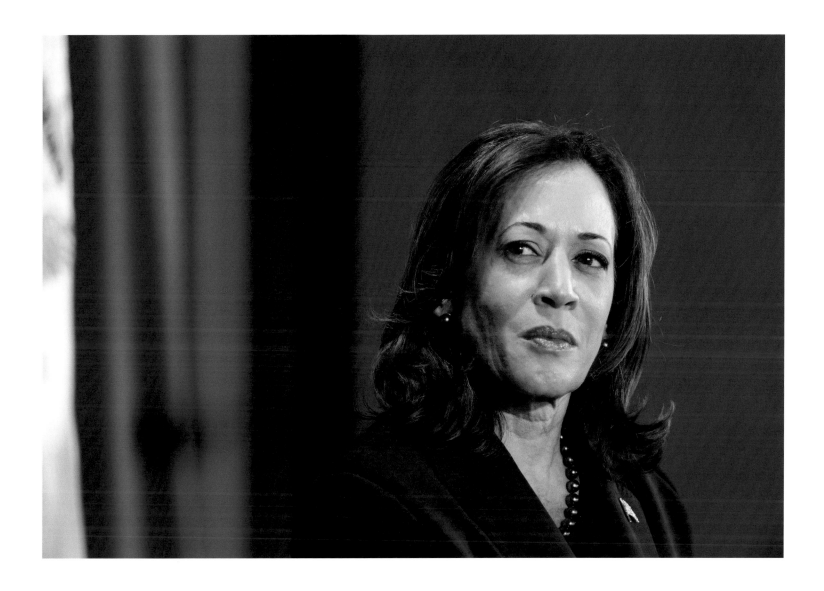

March 16, 2023: Participating in a roundtable on reproductive rights at Grand View University in Des Moines, Iowa. (Lawrence Jackson)

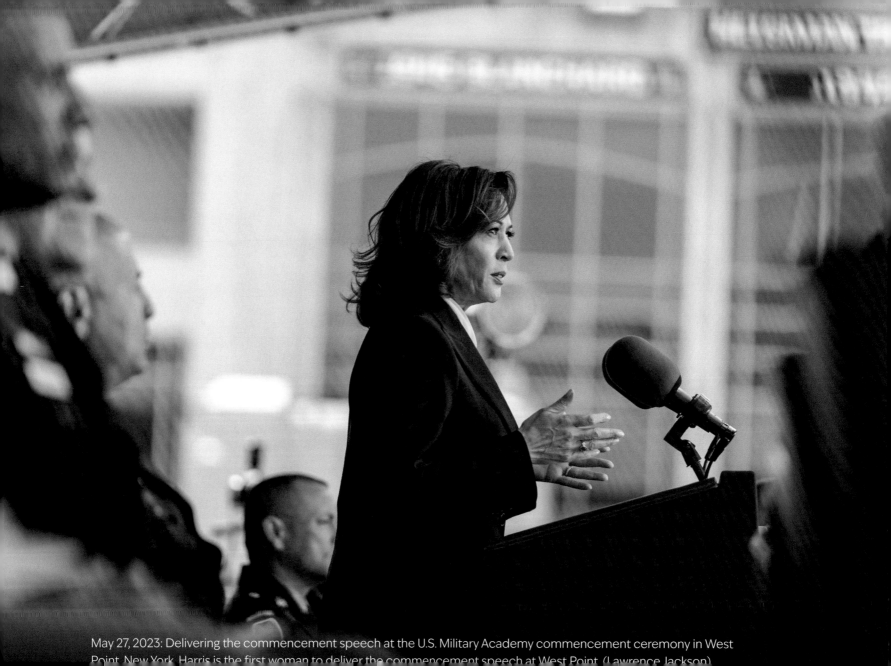

May 27, 2023: Delivering the commencement speech at the U.S. Military Academy commencement ceremony in West Point, New York. Harris is the first woman to deliver the commencement speech at West Point. (Lawrence Jackson)

The strength of our democracy
is tied to the strength of
democracies worldwide.

—At the Summit for Democracy at the Eisenhower Executive
Office Building at the White House, December 9, 2021

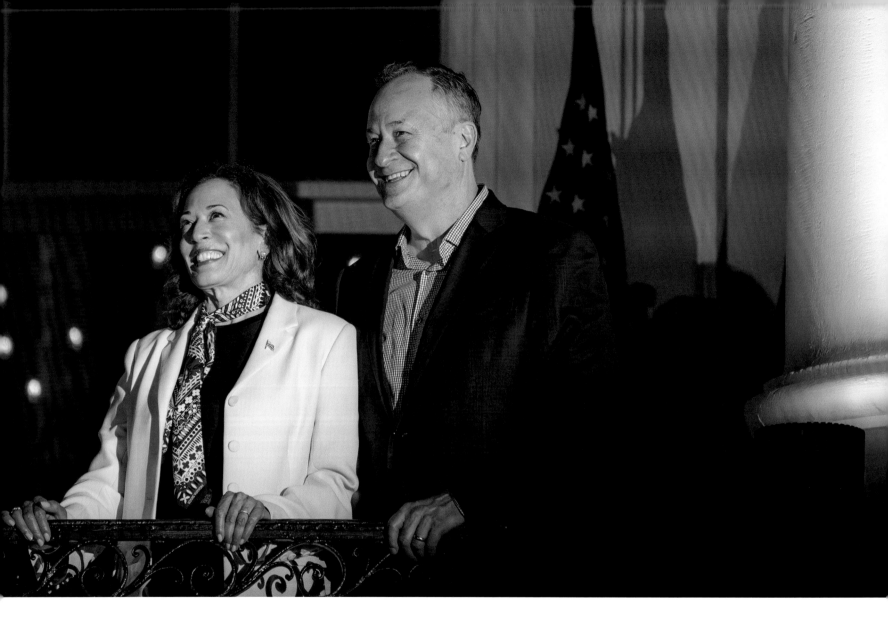

July 4, 2024: Watching the Fourth of July fireworks display over the National Mall with her husband, Doug Emhoff, from the Blue Room balcony at the White House. (Emily Hanna)

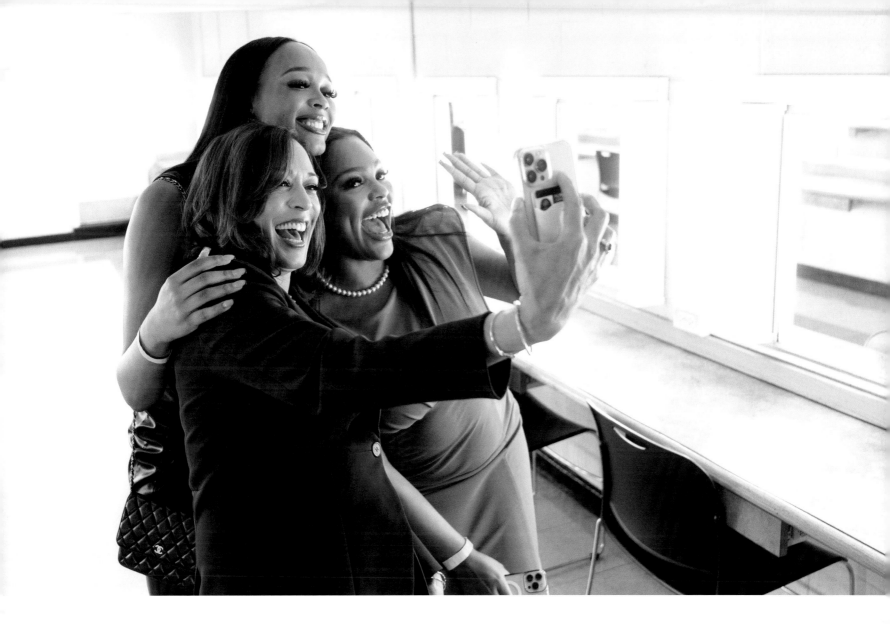

November 5, 2022: Taking a selfie with Howard University students in Cramton Auditorium at Howard University in Washington, D.C. (Lawrence Jackson)

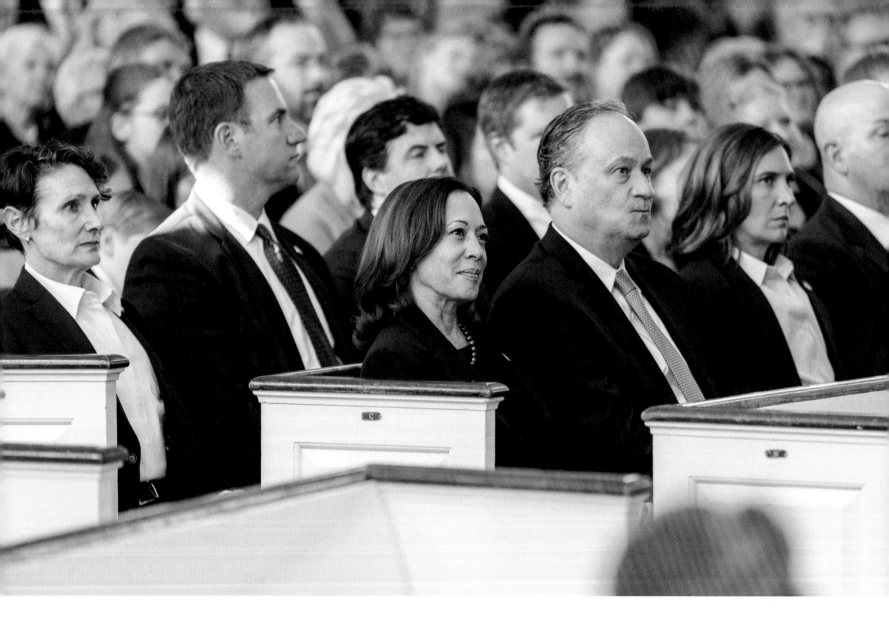

November 28, 2023: Attending a tribute service for former First Lady Rosalynn Carter at Glenn Memorial Church in Atlanta, Georgia. (Adam Schultz)

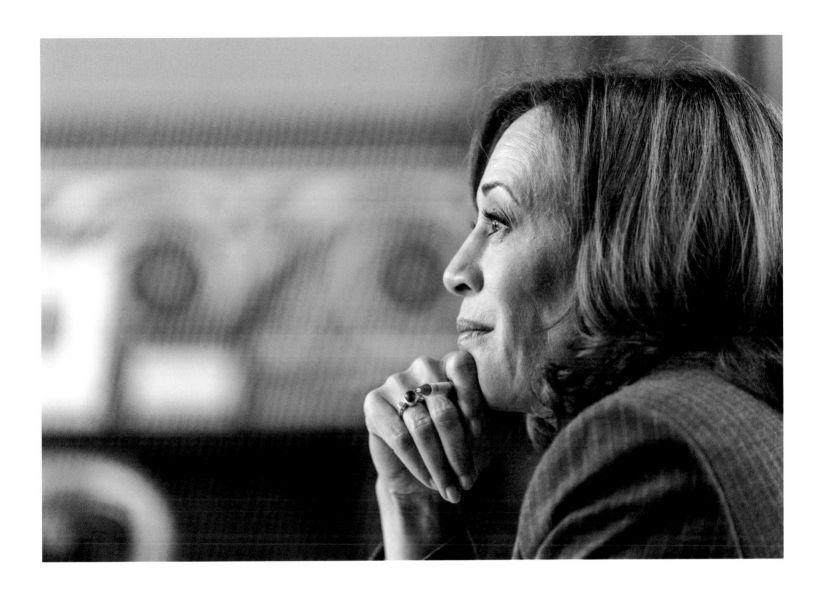

October 27, 2022: Participating in a listening session with experts on young men of color, in the Vice President's Ceremonial Office in the Eisenhower Executive Office Building at the White House. (Lawrence Jackson)

While I may be the first woman in this office, I won't be the last. Because every little girl watching tonight sees that this is a country of possibilities.

—In a victory speech upon winning the vice presidency,
in Wilmington, Delaware, November 7, 2020

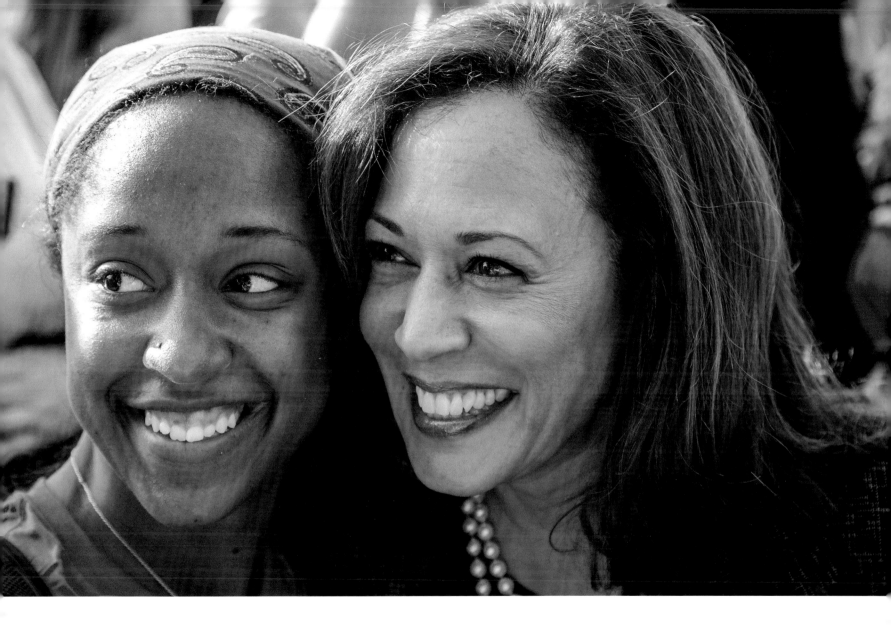

June 28, 2017: At the Linking Together: March to Save Our Care rally at the U.S. Capitol, during her tenure as senator of California. The rally was in support of the Affordable Care Act. (Mobilus In Mobili)

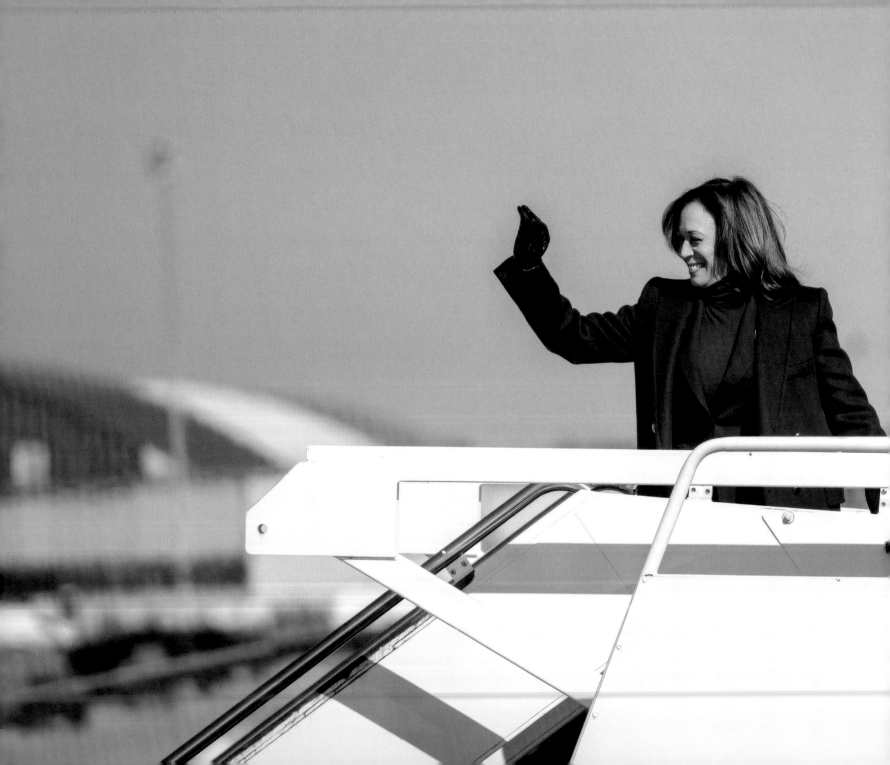

July 23, 2024: Boarding Air Force Two at Milwaukee Mitchell International Airport, en route to Joint Base Andrews, Maryland. (Lawrence Jackson)

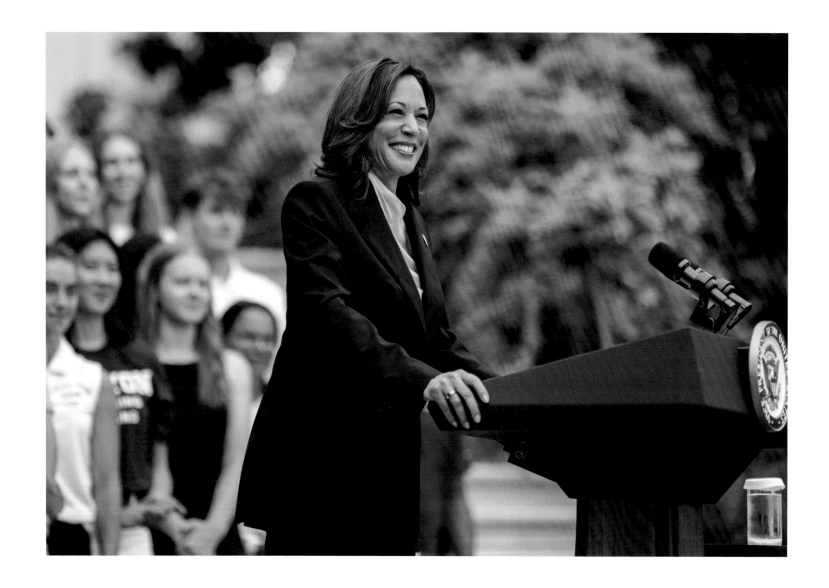

July 22, 2024: Speaking at a White House NCAA Sports Day event on the
South Lawn of the White House. (Lawrence Jackson)

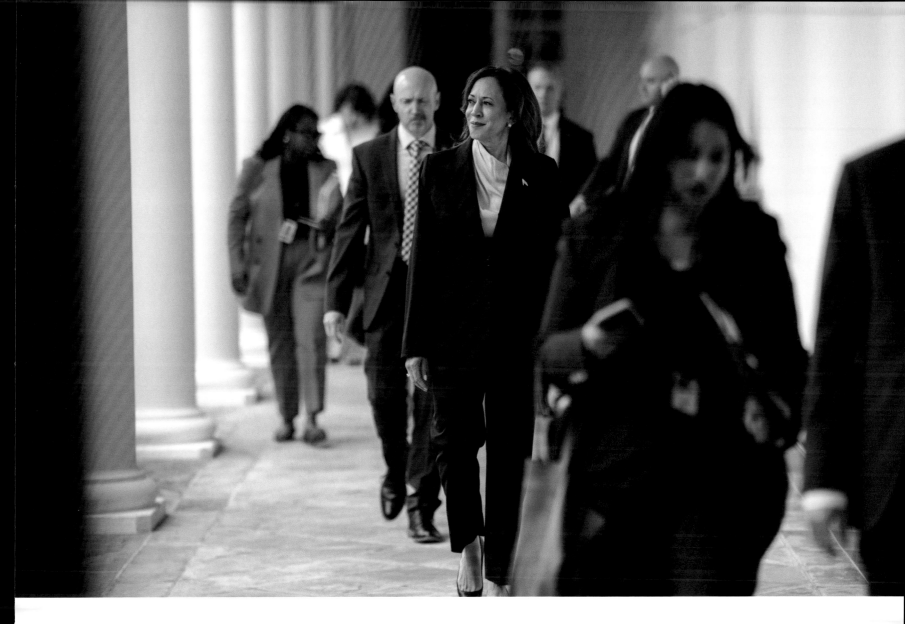

July 22, 2024: Walking along the West Colonnade of the White House before speaking at a White House NCAA Sports Day event. (Lawrence Jackson)

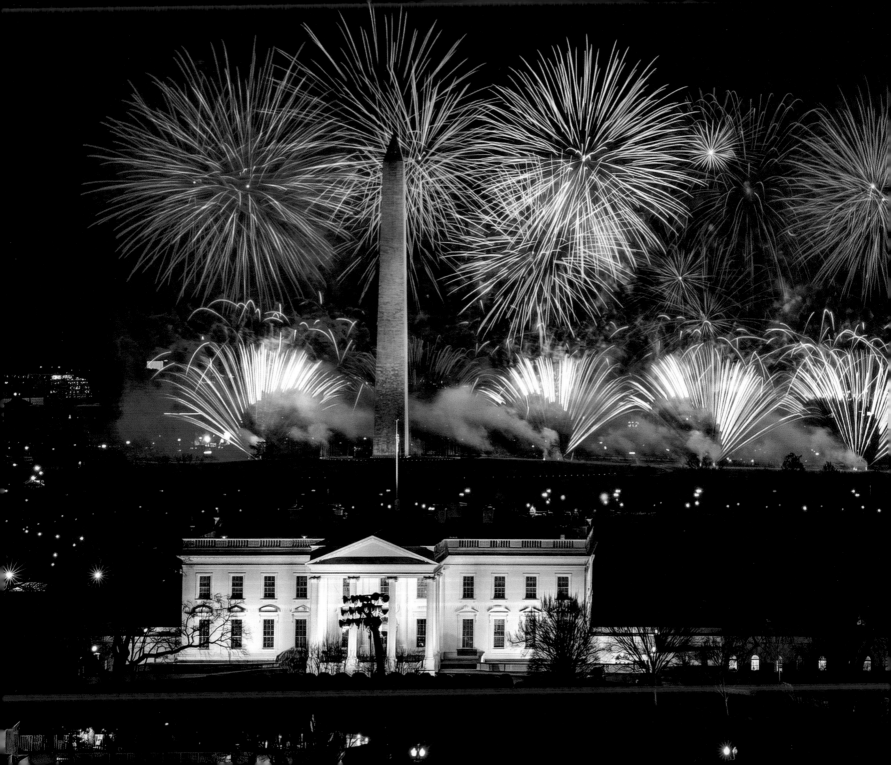

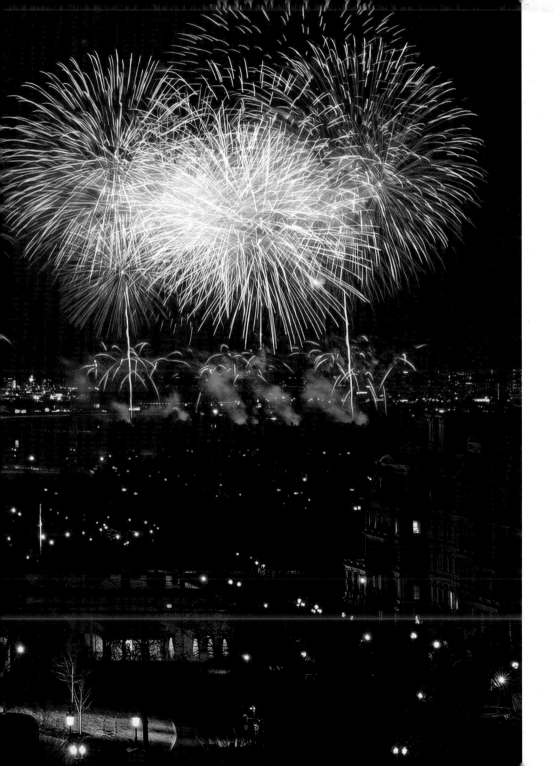

January 20, 2021: Fireworks illuminate the sky over the White House in honor of the inauguration. (Chuck Kennedy)

HarperCollins books may be purchased for educational, business, or sales promotional use.
For information, please email the Special Markets Department at SPsales@harpercollins.com.

The Mariner flag design is a registered trademark of HarperCollins Publishers LLC.

FIRST EDITION

All photographs unless otherwise indicated are copyright © by White House Photo Office.
Grateful acknowledgment is made to the White House Photo Office as well as
the individual photographers credited throughout.

Photographs on pages 12 and 13 © Lorie Shaull, available at
https://www.flickr.com/photos/number7cloud/53942540054/
OR https://www.flickr.com/photos/number7cloud/53942481719/

Library of Congress Cataloging-in-Publication Data has been applied for.

ISBN 978-0-06-344202-3

24 25 26 27 28 TC 10 9 8 7 6 5 4 3 2 1